CW00665392

The Impact and Fut
Humanities I

Paul Benneworth • Magnus Gulbrandsen • Ellen Hazelkorn

The Impact and Future of Arts and Humanities Research

Paul Benneworth
Higher Education Policy Studies
University of Twente
Enschede, The Netherlands

Ellen Hazelkorn
Higher Education Policy Research Unit
Dublin Institute of Technology
Dublin, Ireland

Magnus Gulbrandsen
University of Oslo
Oslo, Norway

ISBN 978-1-137-40898-3 ISBN 978-1-137-40899-0 (eBook)
DOI 10.1057/978-1-137-40899-0

Library of Congress Control Number: 2016957362

Printed on acid-free paper

This Palgrave Macmillan imprint is published by Springer Nature
The registered company is Macmillan Publishers Ltd. London

ACKNOWLEDGEMENTS

We began to explore the issues around arts and humanities research in 2010 just as the Great Recession was beginning to bite across Europe. In an environment in which the focus has been increasingly on value for money, return-on-investment and societal added-value for publicly funded research, our central aim has been to better understand what really matters rather than what is easily measured. We have sought to investigate and interrogate the assumptions made by researchers, policy-makers and civil society about arts and humanities research, to understand what distinguishes its practice and how its contribution and value is perceived and understood by these different stakeholder groups, emphasising "what matters" to all interested parties.

This book is based on research conducted under the HERAValue project, which was originally financially supported by the HERA Joint Research Programme (http://heranet.info), which was co-funded by AHRC, AKA, DASTI, ETF, FNR, FWF, HAZU, IRC, MHEST, NWO, RANNIS, RCN, VR and the European Community FP7 2007–2013, under the Socio-economic Sciences and Humanities programme.

In doing so, we interviewed people in Ireland, the Netherlands and Norway, as individuals and part of focus groups; in total over 100 people were interviewed, as well as an additional ten individuals in the UK as part of a pilot project in 2010. Roundtable discussions and seminars were held in Dublin, Amsterdam and Oslo to exchange understandings and ideas, which also served as part of the evidence gathering. We would like to extend our warm thanks to everyone who participated in

this unique cross-national study—as interviewees and members of the various seminars, conferences and focus groups. Papers and presentations were given at various conferences, inter alia, EAIR (European Higher Education Society), CHER (Consortium of Higher Education Researchers), EU-SPRI Forum for Science and Innovation Policy Annual Conference, and published in *Arts and Humanities in Higher Education* (AHHE), February 2015, 14:1—all of which elicited very helpful constructive criticism and comment. Many thanks especially to Jan Parker and Kelly Coate for their invaluable moral and practical support with this volume.

We would like to express our thanks to our respective research teams for their help throughout this research project, and subsequently during the publication of this book. This includes Andrew Gibson, Martin Ryan and Elaine Ward, Higher Education Policy Research Unit (HEPRU), Dublin Institute of Technology; and Siri Aanstad at NIFU Nordic Institute for Studies in Innovation, Research and Education in Oslo; Jhon Diepeveen at the University of Twente for help in capturing much of the initial data in the form of recordings and podcasts, and Hans Vossensteyn, Center for Higher Education Policy Studies (CHEPS), University of Twente, for additional support necessary to complete the project after the HERA funding formally ran out.

We would also like to thank colleagues who took the time to engage in fruitful conversations about arts and humanities research, and to offer helpful suggestions of various forms, including Eleonora Belfiore, Thom Brooks, Sophie Coulombeau, Geoffrey Crossick, Hugh Dauncey, Anne Dijkstra, Jordi Molas Gallart, Jon Holm, Margaret Kelleher, Eucharia Meehan, Dave O'Brien, David Butdz Pedersen, Julia Olmos Peñuela, Jessica Sage, Thed van Leeuwen, Richard Waltereit, Rene Westenbrink and Astrid Wissenberg. Thanks are also due to the Irish Research Council and the HERA network, which used this project, at various times, as an exemplar. All errors and omissions, however, are ours.

Finally, we would like to extend our thanks to our families. Although science is a team game, perhaps the most important part of the team is that which does not ever get the chance to bask in the credit, the team we all have at home cheering us on and making it possible to dedicate so much time to our labours of love in research. Paul would like to personally thank his wife Leanne for her patience and also his son, Theodore Hendrick, who arrived when Paul should have been presenting a paper

in a HERAVALUE session at the CHER Reykjavik conference in 2011. Ellen would like to thank her family, Eric, Ila and Lisa for their continued support. Magnus would in particular like to thank his daughter Kristine for her patience and understanding. As a team, we greatly appreciate their respective contributions; for this reason, we dedicate this volume to them.

CONTENTS

ABBREVIATIONS

A&H	Arts and Humanities
A&HR	Arts and Humanities Research
AWT	Advisory Council for Science and Technology
BBC	British Broadcasting Corporation
CDA	The Call of Christian Democracy (Dutch Christian Democrat Party)
ERA-NET	European Research Area Network Schemes (Funding Instrument)
ERIC	Evaluating Research in Context
HE	Higher Education
HEI	Higher Education Institution
HERA	Humanities in the European Research Area ERA-NET Programme
HERAVALUE	*Measuring the Public Value of Arts & Humanities Research* Project
IRC	Irish Research Council
IRCHSS	Irish Research Council for the Humanities and Social Sciences
KNAW	Royal Netherlands Academy of Arts and Sciences
NRC	NRC Handelsblad (Newspaper)
NWO	Netherlands Organisation for Scientific Research
OV	Chipkaart Public Transport Electronic Ticket Pass
POST	Parliamentary Office of Science and Technology
PvdA	Dutch Labour Party (*Partij van de Arbeid*, No English Translation)
RAE	Research Assessment Exercise, UK
RCN	Research Council of Norway
REF	Research Excellence Framework, UK

SKG	Selective Contraction and Expansion
SSH	Social Sciences and Humanities
STEM	Science, Technology, Engineering and Mathematics
TVC	Division of Labour & Concentration Policy
UK	United Kingdom
UvA	University of Amsterdam
VU	VU University Amsterdam
WWII	World War 2

LIST OF FIGURES

LIST OF TABLES

Setting Out the Debate

Public Understanding of the Value of Arts and Humanities Research

INTRODUCTION

In this volume, we are concerned with answering the question of what is the public value of arts and humanities research? If we take a look around the world, then it is easy to jump to the conclusion that such a question is irrelevant precisely because its public value (or at least that of the underlying arts and humanities) is so self-evident. If we browse a newspaper on the internet, if we take a walk in public spaces, or visit museums, galleries or popular public art spaces then we are continually confronted with arte-facts, with designs, with discourses, statues, memorials, where the knowledge generated by arts and humanities research has become encoded into the fabric of everyday life. Indeed, researchers from the arts and humanities are themselves highly visible in the media, providing interpretative commentary to help make sense of the world. So it might seem strange to be asking that question given the relative and increasing ubiquity of that knowledge in contemporary society.

But if your starting point is to attempt as an outsider (even as a scholar) to penetrate that research, to read a humanities article or monograph, then the question acquires another, quite contradictory answer. One is immediately confronted with an apparently impenetrable collage of unfamiliar and often foreign vocabulary, or of familiar words used in unfamiliar ways. There may be no apparent scientific method, no robust empirical evidence, just a melange of thought experiments, suppositions and dubious contentions. Those talking heads we see in the media are only rarely

© The Author(s) 2016
P. Benneworth et al., *The Impact and Future of Arts and Humanities Research*, DOI 10.1057/978-1-137-40899-0_1

reporting "serious" peer-reviewed research, but all too often only appear to be using their ill-defined and broad "expertise" as the basis to make a guess on a contemporary theme, perhaps slightly better informed than the average lay-person, but a guess and an expensive one at that. The self-evident answer to our overarching question is then diametrically opposed to our first observational answer: how can it ever be that such unintelligible gibberish can have a value to the public? In the words of one of our interviewees, "what factories are made to smoke through all this humanities research?" Indeed, as we were finalising the manuscript for this volume the American Presidential Primaries paused to take a swipe at arts and humanities research as being frivolous and having no wider value for society (Cohen 2016).

Of course, there is no necessary reason why those two standpoints are incompatible. It could be that through their mysterious workings, the arts and humanities research community nevertheless manage to create knowledge that becomes woven into the fabric of contemporary society. The corollary of that seems to be that we should just let these researchers go their way unfettered, secure in the knowledge of the later benefits that they will bring. At the same time, this sounds like a rather standard case of special interest pleading, to except arts and humanities researchers from the accountability requirements that are now standard across all areas of public funding, particular to but not restricted to the academy (Kickert 1995). Claims for the intrinsic value or the higher worth of arts and humanities research seems like a very convenient way of providing a subsidy to a lucky few who make their livings thinking about arts and culture.

There is certainly thus a very vibrant debate around these issues, about the value that investing in (or subsidising) these researchers has for publics that are at the same time finding the public services that they previously took for granted being cut in some cases to the bone by austerity. But at the same time we note that voices on all sides of the debate are screaming not only that they are right, either that there is a fundamental impossibility that excellent arts and humanities research could ever be what society needs; nor that asking arts and humanities research to state clearly what they do for society could ever be done in ways that do not needlessly overburden and exhaust those researchers. And there are some high stakes—even the right to exist—that are being attached to the outcomes of these debates. We see Japan, the USA and Canada in recent years take various kinds of steps to place limits on the public subsidy for arts and humanities research and to tie it more closely to the service of particular political

agendas. We see the European Commission provide basic research funding for a series of research projects seeking to address the basic question of how can social sciences, arts and humanities contribute to society given the extreme reductionism in the way they were included in the EU's latest research funding programme (see Chap. 2, but also note that this existential angst is not restricted exclusively to the humanities, although they are an area particularly suffering from its worst excesses).

And it is this dissonance in the societal debate about public value that provides us with our starting point in this volume. The positions are so deeply dug in and the stakes are so high that there is much less reflection of the question which for us is more important: why has the debate become so febrile, why have positions become so entrenched, that it is almost impossible to consider the possibility that there may be systematic and structural ways that arts and humanities research contributes to societal improvement and welfare. We also note that there is a common-sense discourse around investments in science, technical, engineering and mathematics research that is happy to digest the assumption that such investments are synonymous with investing in progress and building a better future. So why have arts and the humanities become singled out as being deemed unworthy in ways that not only disadvantage the arts and humanities, but also researchers in other disciplines who create value for societies in ways that do not neatly conform with these common-sense models of how research creates public value?

In this book, we are ultimately concerned with the ways in which knowledge creation benefits society, and in particular the growing dissonance between the reality of many different kinds of impacts, and a common-sense perspective of a biotech researcher creating a new spin-off company that discovers a new cure for a disease. These common-sense models have become so prevalent in the public discourse and so widely internalised by policy-makers that we believe these assumptions need testing. If the trend in the last ten years to align public research efforts behind immediately realisable benefits is in any way misguided, then there has been a huge policy failure. This is far more so the case for the hard sciences than for the arts and humanities and thus we seek to explore this issue by looking at the area where the dissonance seems the greatest, in arts and humanities research. We are neither advocates for the public value of arts and humanities research, nor its critics—before undertaking the research behind this book we were completely neutral, although the empirical examples we have found do persuade us that it

does have many kinds of public value. Our aim in tracing the models by which it creates public value, and the conditions under which that value can be maximised is not just part of a debate about public research funding for the arts and humanities. Rather we seek to answer a wider question about how far the impact agenda should be allowed to develop, and how far it must be insisted that all researchers should plan to make their research solve problems, with funding given to those showing the most immediate promise.

FROM A DEBATE TO BE JUDGED TO A DEBATE TO BE INTERPRETED

If our starting point is the current belief that research should be useful, one might regard the humanities' own take on this—as embodied through historians of science—is that such Whiggish interpretations hide a more convoluted truth. From that perspective, the relationship of science and progress is much more contingent and partial. The contemporary policy discourse appears to make rather heroic claims masked behind an anachronistic language that imputes intentionalities and causalities almost certainly not borne out by the historical record (cf. Wakefield 2014; Weber 2012). The view that science drives progress is clearly a view that has powerful backers, and powerful enthusiasts for the extensive public investments that it brings, and in the post-war period, those backers included the American military-industrial complex. It is often forgotten that Vannevar Bush argued that humanities research was important for America's place in the world, and that the choice for Federal funding for technological research was seen as being something politically expedient and a step to a wider justification for research that would make a National Humanities Foundation possible.

At the same time, the contemporary impact discourse appears to have been purged of any sense that funding arts and humanities research—investments in creating humanities knowledge—gives us, as society, novel capacities by giving us knowledge about who we are, the kinds of societies we have, and our potential to shape where we go as societies. Is it just that—as David Looseley (2011) has argued—that humanities are too modest and self-effacing to ever be able to stand behind such self-aggrandising narratives of progress, even to be able to accept that without those narratives, then humanities is doomed to be overshadowed by its more apparently useful colleagues?

Our concern is not so much the reality of how arts and humanities research benefits society, although that is something that we do cover in our empirics. There are others that have done that in far more comprehensive, convincing and systematic ways than we can manage on the basis of our own reflections (cf. Belfiore and Bennett 2008; Bate 2011; Belfiore and Upchurch 2013; more examples are given in Chap. 2). What we want to do is understand the political-economic processes by which a whole set of assumptions have emerged in which arts and humanities research is not seen as *self-evidently useful*, in contrast to the way that science, technology, engineering and mathematics (STEM) research has (as charted for example by Popp Berman 2011). These assumptions have penetrated to the very heart of the political decision-making process, with a parallel assumption that arts and humanities research is somehow, in the words of Nussbaum (2010) "useless frills, at a time when nations must cut away all useless things in order to stay competitive in the global market" (see the section, "Three Responses Within the Community" of Chap. 2 for a longer version of that quotation).

In order to understand that process, we seek to "open the black box" of science policy and public discourse and examine the dynamics of the representation of the public value of arts and humanities research within that discourse. Through a series of national case studies we aim to understand the ways in which a set of assumptions have become embedded and the ways in which they have been resisted and rejected because of the simplistic and obviously damaging prescriptions they bring in practice, and indeed to trace the outline of how science policy, and public policy, more generally can start to better understand the public value of arts and humanities research. On this basis, we seek therefore to stimulate a more general discussion about the rationality of science policy and its justifications in terms of research creating public value. Our hope is to contribute to policy approaches more rooted in rationality and less in a series of opportunistic policy reactions informed by simplistic versions of state-driven technological modernisation.

In this chapter, we foreground some of the key issues and debates with which we are concerned in the volume, to place the remainder of the volume in a wider context. In Chap. 2, we then reflect on the specifics of the situation in Europe, and we start to decompose the negative emotions which have permeated a supposedly rational policy debate. It is these negative policy emotions which in turn are the wider context which we explore in Part II, offering three national policy debates about the public

value of arts and humanities research. In all three cases, we see that the stereotypical positions set out above—which have formed high level policy narratives—are misleading as descriptions of what actors want to achieve. There is a realisation of the public value of a wide range of practices in arts and humanities research and of the damaging effects of assuming an immediate commercial agenda. But these national debates have yet to transform into the same kind of Vannevar Bush "Endless Frontier" investment rationale (in the language of Benneworth 2014) for arts and humanities research.

In Part III, we pull these ideas together into a policy analysis, focusing on the extent to which arts and humanities research contributes to various kinds of societal innovation processes. We firstly discuss the appropriate model for innovation in arts and humanities research and build on Gulbranden and Aastad (2015) to argue that a better understanding of innovation and societal progress is required, a debate which will enrich STEM as well as arts and humanities research. We then reflect on the policy implications raised by this new model of innovation, and argue that arts and humanities research has the best opportunity to contribute when impact becomes a norm in both scientific and policy communities, and this requires a broad, diverse approach to successfully deliver this. Finally, we set out a manifesto for the public value of arts and humanities research in the twenty-first century and argue that the critical element is re-engaging publics in the broadest sense with the field.

A Multi-Layered Historical Debate: The Loading of "Research" with Multiple Meanings

Our research question in this volume is "what is the public value of arts and humanities research?", which we operationalise into necessitating a discussion of what is meant in asking this question and indeed why does this question arise. Our question does not arise in a contextual vacuum, but rather it is a question which has erupted into the public domain in various ways. Fifty years ago, Plumb was fretting about the effects that the rise of the technological society and its needs would have upon the humanities (1963); the concern here was that an increasing emphasis on the technological dimensions of education would squeeze out the space to study and understand the more human elements of society. But the issue acquired a real boost in the 1980s with the emergence of new and far more instrumentalist approaches to policy-making.

This change can be illustrated by recourse to a stylised *ex post* narrative. In an attempt to rejuvenate lethargic economic systems across Western countries laid low by the oil crises by inflation, industrial unrest and surging public expenditure, a new idea emerged of how to control public spending. Rather than identify the services which had to be provided and then organising them within the framework of the state, states came to believe it was more efficient to identify and specify problems, and then incentivise providers to creatively find and deliver solutions to these problems. Public spending became far more targeted and directed to particular specified ends, and by implication the desirability of particular kinds of public intervention became associated with the degree to which they delivered these specified goals. And the higher education system employed a privileged place within the emergence of the policy repertoires by which this was to be delivered. The tools and techniques of what is now commonly understood as "new public management" emerged in a series of policy experiments. These took place within a number of domains, including a number of countries, and those in higher education were specifically focused on the issue of the massification of higher education. (Kickert 1995, 1997; Kickert et al. 1997). But this narrative also acquires an alternative significance to longer-term debates about the role of higher education.

The public role of higher education had emerged in the post-war reconstruction, when countries were seeking to position themselves to function as advanced economies by ensuring a steady flow of those technically skilled individuals necessary for the functioning of high-technology industries. It is in this sense that we see in the Netherlands, for example, the creation of two new technical universities in the 1950s and early 1960s, in Eindhoven and Twente, seeking to help then-dominant industries and firms to modernise. The consensus of the reconstruction period came to a sudden halt in May 1968 with a series of public outcries across Europe, and critically a number of student mobilisations in protest against the undesirable, anti-democratic consensuses that had built up over time in these universities. As Daalder and Shils (1982) noted, across Europe and North America a new idea of a university emerged, what Delanty would later call the "Democratic Mass University", in which the role of the university was to provide citizens for contemporary societies with a suitable skills set to function not just economically successfully, but also to participate in society.

Within the democratic mass university model there was a clear role and value ascribed to arts and humanities disciplines around a model of

reflection and socialisation, even where research was not seen as a task distinct from the reflection inherent in education. It is sometimes commonplace to talk about certain ethical perspectives in university models (such as academic freedom or peer review) as akin to representing eternal features of the higher education landscape. However, the reality of issues was that they found their expression as a result of universities' attempts to deal with particular emergent pressures, and therefore their contemporary interpretation then often ends up referencing a mythical past. As we will see in future chapters, the idea of the Ivory Tower has had a particular resonance as a critique of humanities scholars' supposed behaviour historically. But Shapin (2012) identifies that the phrase was never an expression of an ideal type of university; rather it emerged in the late 1930s in response to a number of political pressures as a discourse device, within efforts to encourage scientists to be more willing to engage with society.

As Delanty (2002) points out, the Democratic Mass University ideal was almost from the moment of its emergence also a concept in immediate decline and never entirely fully implemented. Although several countries introduced a range of democratic innovations in their governance structures, such as elected university faculty boards, and co-determination committees, under financial pressures dating to the 1970s, these innovations were immediately placed under pressure and rolled back. Contributing to democratic society, whilst a worthy goal in its own end, was rather difficult to articulate and measure in the context of increasingly stringent financial contributions and demands from funders to demonstrate efficiency of funding allocated on the basis of achieved results. In the face of these pressures, universities started to seek ways to directly justify the resources they received. When one looks at education reforms in the 1980s, one is perhaps struck by how mild the supposed reforms were, and in particular there was no simplistic attempt to immediately reduce university outputs on a one-to-one basis to clearly identifiable external outputs. But the 1980s clearly marked a shift in the terms of the debate, in thinking about universities as suppliers of public goods—such as an educated democratic population—to suppliers of particular private goods whose existence was in some way generally beneficial.

Popp Berman (2011) traces in great detail how a particular group of American universities used the opportunities of the 1970s depression to advance a particular reading of how research benefits society. Whilst purporting to be making the case for a reinvention of the argument already alluded to *The Endless Frontier*—investments in science benefiting society

as a whole —Popp Berman's analysis demonstrates how in fact this group of American research-intensive universities worked to mobilise the idea of the "market university". In this reading, university research was not just contributing to a general knowledge pool which would advance socio-economic development, but it formed in a sense the raw feedstocks for advanced economies leading to the creation of new businesses and indeed new high-technology sectors. The corollaries of this were encouraging entrepreneurship as an appropriate behaviour for university researchers, the creation of technology transfer offices to manage universities' intellectual property portfolios, and the creation of Industry Research Centres to allow university knowledge to more closely match the needs of users. In all these cases, as Bozeman highlights (2002), there is a subtle shift in the way that public value is defined, away from the contribution to shared societal knowledge assets to the creation of "transactionable" items (see also Bozeman and Sarewitz 2011). Viewed from this perspective the value of research was no longer measured by the extent to which it made collective contributions to a general good but rather the extent to which it could be codified and transferred through these particular transactions, through entrepreneurship, patenting and consultancy into users.

And despite the fact that this was a particular model of university behaviour that emerged at a very specific place—a set of research intensive public US universities—at a very specific time, this model of the entrepreneurial university became increasingly uncritically adopted and absorbed within policy discourses of research utilisation. Benneworth (2014) traces how these ideas became coded into policy discussions through the metrics adopted by the US Association of University Technology Managers (AUTM, who Popp Berman identifies as being a key part of the legislative-lobby coalition that laid the foundations for the rise of entrepreneurial biosciences in the USA). With public funders (state governments) in the USA keen to see the return they were getting for their appropriations to universities, the AUTM initiated a survey of their members' entrepreneurial activities, focusing on counting the numbers of licences, patents, patent and consultancy income. AUTM did not make the claim that this represented the full public value of their research, but rather an attempt to highlight evidence of where public funds were creating benefits.

In the course of the 1990s, when entrepreneurial science became a policy topic with more urgency than expertise, the AUTM indicator list was seen as an important way of providing a concrete definition of the public value of research. As a result, those context-specific choices were

regarded as essential truths about the nature of research value, and became enmeshed in the multilateral discourse embraced by the OECD and latterly the European Commission, which framed that the very heart of the public value of research lay in these commercialisation indicators. And at the same time, almost invisibly, it embedded a view of transactions as the basis for public value as a central belief within policy debates. Our contention in this book is that it is this framing process—making transactions seem self-evidently central—that is at the heart of the failure to make progress in understanding the public value of arts and humanities research.

Although the discussions present themselves as being neutral, technocratic and about public efficiency, the assumptions of the choice of transactional indicators as measures of research's public value lead to the construction of divisions and dissatisfactions between different groups. To arts and humanities researchers, there is an indifferent exogeneity to the kinds of measures with which they are confronted: these commercial indicators represent ethics and values that are not important to a vast majority of them, even those who are involved in clearly creating public value through other channels such as public debates. To the policy community, humanities researchers are framed as being largely useless because of the lack of clear commercial outputs they produce, and worse, they are seen as being obstructive in refusing to engage with the agenda, making any kind of critique of the underlying basis immediately suspect.

In short, scholars do not believe patent data measures anything of use to them, policy-makers do not trust those who have such a reluctance to demonstrate their wider value, and against this backdrop of suspicion, genuine policy progress is difficult to make. A situation where researchers feel that policy-makers are trying to foist unwelcome norms upon them, and policy-makers in turn feel a resistance that they ascribe to humanities researchers wanting to preserve their archaic featherbedded privileges is not one that is conducive to synoptic, progressive discussion. In a sense, what ought to be a debate about understanding how research creates benefit has become framed in a way that makes conflict inevitable. And of course what is missing within this conflict between two camps is any representation of the voices of the publics that could potentially benefit from that research and the ways in which that can be supported and stimulated by policy-makers. Academics and policy-makers count amongst themselves many sensible and practical types, and therefore debates have progressed in different countries in different ways in different times, exposing the tensions but also clarifying the conditions under which progress can be made. And so that provides

the basis for our three empirical case studies—examples of where the tensions inherent in such a conflictual situation have been dealt with in different—albeit constructive and reflective—ways. Yet, in order to understand and draw inferences from these case studies, it is necessary to understand the magnitude of the tensions between these two camps.

Commercialisation as Exogenous Norms: Humanities' Resistance to Public Value Discourses

The rise of entrepreneurial academic science was a time- and place-specific phenomenon, tied very closely to the rise of biotechnology in the USA. One of the characteristics of biotechnology is that it is producing medical products, and their development and production is a very tightly regulated process. The size of the American market for medicines has given US regulators a key role in determining these processes, and indeed the US Food and Drug Administration (FDA 2014) protocol has become global best practice. The paramount consideration is safety, and therefore pharmaceutical companies have to assemble a dossier of evidence that proves that a proposed new drug is safe and efficacious (it has the desired effect), whilst ethical concerns mean that the drug is tested through a series of scales that start in the laboratory, move into humans, then clinical settings and eventually on large samples. The high costs of this process mean that there is a chain where new ideas are developed and trialled by small companies and gradually are acquired by multinationals with the resources to complete the approvals process. New drug ideas are patented and then move through the trials process as quickly as possible; where universities have discovered the drug, then they may hold the patent and through their technology transfer ensure that they retain some rights—the approvals process allows a clear link to be drawn from the final drug in the marketplace back to the original research laboratory and project where the research was discovered.

But the process by which this real set of activities was understood also evolved into a more general metaphor for the way that university research is commercialised more generally. In this metaphor a piece of research creates an artefact that is then passed onto a user who then transforms it into a market-based product. The societal benefits come at the end of that process, when there is a novel cure for an existing disease, new jobs created, new taxes and dividend paid. The attractiveness of the metaphor is that there is a degree of automatism about it: if the research is packaged in the right way for the user—in this case the patent—then there is a commercialisation journey on which the university knowledge flows

effortlessly into the marketplace with the wider public benefits rippling outwards through these economic transactions.

At the same time there is a widespread understanding that this metaphor is actually a rather weak way of describing in practice how research creates value, not least because the numbers of new drugs that make it from laboratory to the marketplace is incredibly low.

The landmark TRACES study looked at what kinds of research fed into five innovation breakthroughs (Krielkamp 1971) highlighting three key findings

(a) 70 % of the key events leading to these breakthroughs originated in non-mission research (i.e. research not directly seeking to produce innovation outcomes)

(b) interdisciplinary communications were vital to achieving breakthroughs

(c) basic science research was critical to ensuring long-term development of socially beneficial innovations.

The TRACES report said in 1971 that a better understanding of the complex two-way relationship between science and technology development was required, which makes it appear rather surprising that a rather naïve linear transactional model of research impact became suffused into policy discussions and deliberations as a backdrop to the commercialisation discussions as an ideal type. Partly this is because there are a few really eye-catching examples where no one can dispute that the research has created benefits—and it is hard to resist mentioning the case of the University of Leuven where a patent for Tissue Plasmine Activator to Genentech brought in reputedly $1 bn of licence benefits to university principals.

Viewed from the perspective of the humanities research community the prevalence of this linear narrative carries a particular set of connotations in which humanities scholars' core research interests are somehow seen as being peripheral in the era of entrepreneurial science. Stefan Collini memorably put this into words by arguing that the "impact agenda" in the UK was part of a slippery slope that would lead medieval historians to rush to write best-selling cookbooks rather than an article that created new scientific insights. And given that it was in the UK where the Minister of Education famously said that

I don't mind there being some medievalists around for ornamental purposes, but there is no reason for the state to pay for them. (Times Higher Education, 9 May 2003)

It is perhaps unsurprising under these circumstances that the discourse of entrepreneurial science became seen as something exogenous to the scholarly community, a threat and a bogeyman, a set of impossible standards that humanities researchers can never hope to live up to. What is perhaps most worrying for humanities scholars was that it completely overlooked the ways that they engaged with a range of publics in the course of their own knowledge creation and transmission activities. The problem is that viewed through the lens of "entrepreneurial science" they become part of the residual class of "all activities which can't be valued in financial terms", and hence they are undervalued and devalued by policy-makers. The researcher experiences this as an inexplicable alien norm that is suspected of trying to encourage other kinds of activities, and worse, to punish and withdraw funding from those that are unable to comply. This sense of persecution and otherness is only exacerbated through wider political gestures such as those witnessed recently in Japan, where the Government HE ministry attempted to coerce their universities into closing humanities courses and faculties to concentrate on activities with greater national economic merit, or in America, where Congress is seeking to restrict Federal research funding to researchers unable to demonstrate the immediate value of their research to America.

Humanities scholars' response can be partly typified as an emotional response, of researchers feeling themselves that they can never hope to justify themselves in terms of creating impact. This partly reflects the fact that humanities is partly a discipline of value claims and humanities scholars are wary of making "big" value claims that are generalisations. Berubé (2003) summed it up quite neatly thus:

> Most of the university-affiliated artists and humanists I know are profoundly ambivalent about the idea of justifying their disciplines in terms of social utility...by contrast, scientists are relatively unconflicted about defending their discipline in terms of social utility. (p. 25)

Thus, although a range of agencies have commissioned reports that can show materially how arts and humanities research can create public value, and how supportive activities can be integrated in ways that do not threaten the objectivity and independence of researchers, these reports often have little traction in mobilising scholarly communities to "embrace" the impact agenda because they remain alien. It would be extremely strange for researchers to unilaterally reject the claim that in return for public

funding there is need for some kind of accountability and to demonstrate that they have value. But these claims appear not to be experienced by scholars as a demand for accountability by public funders; rather there is a sense that they are a trap, another way that humanities research is under siege from philistines who will only be satisfied when humanistic disciplines have been purged from universities. Under such circumstances where one side is so afraid, a debate about the pathways and mechanisms by which arts and humanities research creates public value becomes impossible. The academic community response can be thus understood as a rejection of an outside threat, something which at the same time only confirms those outsiders' worst suspicions about humanities scholars' utility.

ACADEMIC FREEDOM AS ARCHAIC PRIVILEGE: POLICY-MAKER SUSPICION OF INTRINSIC VALUE CLAIMS

In this imagined struggle, across the table from the aggressive humanities scholars sit those policy-makers who have only asked the perfectly reasonable question of humanities scholars to demonstrate their public value, and in return they have been met with sullen hostility and resistance. To this hypothetical policy-maker, this all too real behaviour from researchers only confirms the suspicion that the humanities have "something to hide". After all, when the question is raised of physicists or engineers, they can mobilise lengthy screeds of how their research knowledge creates widespread societal benefits. So the only reasonable conclusion for policy-makers to draw, seen from this perspective, is that this defensive response is the response of those who have no decent answer to give. And the effect of this is to further back up and justify a series of assumptions that policy-makers may make about the humanities in general, and why they might be so resistant to requirements that are made of all recipients of public funding, namely to be prepared to justify the benefits they receive.

What this does is play to a series of common-sense assumptions that are made of the ways in which humanities function (Olmos Peñuela et al. 2014a), and which emerge in a series of discourses over the public value of research. Olmos Peñuela et al. highlight four kinds of wider discourse where humanities is seen as being less useful than other more scientific research (although they in actual fact find that there is no evidence in scientist behaviour that arts and humanities scholars in reality are less useful than STEM scholars). Firstly, humanities is concerned primarily

with generating understanding about particular situations rather than creating knowledge that is applicable in many situations, which means that it is difficult to upscale that knowledge (e.g. Edgar and Pattison 2006). Secondly, humanities research is used by researchers in other different kinds of ways; it is consumed as interesting knowledge rather than being incorporated in groundbreaking novel innovations (Cassity and Ang 2006; Olmos-Penuela et al. 2014b). Thirdly, there is a sense that humanities scholars tend to be oriented far more towards creating excellent research than being inspired by users' problems and the conditions of users of that research; in the language of Stokes (1997), they have Bohr type identities rather than the Pasteur identities that are seen as being the cornerstone of entrepreneurial science. Finally, there is a sense that the "problem owners" of humanities tend to be other humanities scholars, and the current academic debate, and with an absence of societal and economic interests heard in these debates, it is difficult for that research to respond sensitively to user needs.

In a sense, what the humanities community has often said has merely confirmed those suspicions, particularly those whose arguments can be understood as the claims of the self-interested for special treatment and exemption from accountability norms applied to everyone else. The idea that humanities research has intrinsic value, for example, is precisely such an argument, and indeed one that falls apart on closer examination as a claim for public value (Belfiore and Bennett 2008). An intrinsic value-based justification for arts and humanities research may relate to the fact that it creates wider benefits for society; but in that case, the policy-maker might ask, is it then not reasonable for them to be demonstrable in return for the public support? An alternative reading of intrinsic value might simply be that humanities research is something that those scholars enjoy, in which case the arguments for public support are much sparser. The claim, which seems to be entirely reasonable, is that if humanities research is good for society then there must be some kind of evidence that backs this up, and humanities scholars' apparent refusal to provide that evidence therefore suggests that the intrinsic value of humanities is exclusively to these scholars. This, as Bate (2011) says, easily falls prey to a civil servant who argues that "whilst I enjoy riding on my horse, I don't expect the taxpayer to pay for it" (p. 7): individual (professors') benefits (enjoyment) in studying subjects is not a compelling argument for public support for the activities.

At the same time there is also a problem that although there have been very many noble and compelling accounts told of how humanities creates impact (e.g. Bate 2011; Small 2014; Bod 2013), they appear "small" and insignificant next to the "big" narrative that STEM is able to tell about the way that it is building contemporary technology societies, that it is, in the words of Olmos Peñuela et al. 2014a, elective rather than essential. We see here a connection between the ways in which these discourses that humanities research is "less useful" than STEM have penetrated policy thinking, and the tendency for these clear, plausible demonstrations of humanities public value to be framed as being a "nice extra", pleasant but not essential to contemporary societies. Arts and humanities research is thus set an impossible standard, and hence it is perfectly reasonable that when facing an impossible standard, with nothing to win, humanities scholars have chosen to resist rather than cooperate with these structures that automatically discriminate against them.

What is missing from the discourses are a parallel set of arguments that address the specific issue that humanities does create value, but that the way it creates value is not necessarily identical to the ways that STEM does. So one set of arguments can be made that humanities researchers tend to work with their users in ways that are less visible and formalised, but that does not necessarily make them less valuable in terms of creating societal capacity, for example by mobilising awareness of particular issues that form the basis for political reform or societal mobilisation. Secondly, humanities scholars use their research in a different way—presenting informed opinions to the public on the basis of their work on areas not immediately relatable to their peer-reviewed findings—the fact that they are invited to do so suggests that the public do value this commentary and analytic role. Thirdly, one can argue that humanities scholars work with communities that need knowledge but are ill-served by STEM researchers, such as in policy areas, but also the voluntary and community sector, and even within civil society more generally defined—and without those collaborations and engagement society as a whole would be poorer. A final argument may be made that humanities engagement activities tend to be harder to count because they are not backed by financial transactions, and there are not clear systems in place to follow the transactions by which they do flow to the public.

It is here that we see the potential for the resolution of the issue of the public value of humanities research; it is not enough to assert that value in a vacuum, but rather there is a need to empirically explore whether arts

and humanities research is differently useful, in the language of Olmos-Peñuela et al. (2014), but not less useful, than other kinds of research. The issue for policy-makers should be which of these two positions is true: is humanities research less useful than STEM, or is it simply differently useful? Each of these two bring their own policy consequences: if humanities is really empirically less useful than STEM, then there might be a cogent case for less public funding for that research. But if humanities research is differently useful to STEM, but at the same time is still creating public value even if that value is not so easily directly attributable to economic indicators and hence invisible to contemporary political and policy structures, then synoptic policy-making demands a rethinking of these assumptions, and indeed the development of new frameworks to address this point. And it is this issue—the policy discussions that have taken place in a number of countries where they have attempted to address this issue—that is the core subject of our research. We see in all three countries studied, but also elsewhere, that there are two policy discourses in tension.

The HERAVALUE Research Project

This book reports findings from the HERAVALUE project, "Measuring the public value of arts & humanities research in Europe", about which more is said in Chap. 2. The project was funded by an arts and humanities research programme, the Humanities in the European Research Area ERA-NET programme. As we chart in Chap. 2, HERA had a strong interest in promoting the public value of the research they funded as part of their efforts to justify to their paymasters the value of arts and humanities research. Throughout this project we have been aware of the risk that we could become co-opted into this general process of legitimating arts and humanities research, part of a process of what is sometimes referred to as policy-based evidence-making. To be accountable to our readers, we now offer a short reflection on the HERAVALUE process from our perspective as researchers in order to allow our readership to judge for themselves the extent to which we have been able to work impartially—or at least without undue influence—from our funders and sponsors, without whom none of this would have been possible.

The first point is that we are all ourselves outsiders in the field of humanities, and therefore have relatively little to gain from an uncritically positive study of the public value of arts and humanities research. The lead investigators of the team are from the social sciences, from geography,

innovation studies and policy studies respectively. And although a number of researchers worked at various stages on this project, including the later involvement of INGENIO in Spain, none of those researchers were substantively humanities researchers primarily concerned with creating hermeneutic understanding of individual situations; all come from paradigms where there is a degree of comparability between processes in similar situations from which deductions and more general rules can be drawn. To the team, studying arts and humanities research was more about understanding a specific case of a wider problem, that of how to steer universities and researchers towards socially desirable goals without leading to perverse and undesirable outcomes. Although as individuals we might be drawn to a fundamental belief in the good intentions of our fellow scientists, we note that some of the harshest critiques of humanities have come from social sciences and therefore we did not enter into this project with the feeling that we were there to advocate for these disciplines. As an aside, we are willing to concede that the choice to look at "arts and humanities research" (not just "humanities" research) was guided (probably subconsciously) by the leading role played in the HERA programme by the UK's Arts and Humanities Research Council so in that sense we have not been free from funder influence. Arts and humanities as a term has far more relevance for Ireland than for Norway or the Netherlands (for whom humanities would be more relevant) and has been a source of contention within the project team.

Certainly, this critical perspective was reinforced by the way the team was drawn to the HERA joint research programme (JRP). In the early discussions in 2009 our eyes were caught by what seemed to be some rather heroic assumptions in the activities to be studied in the two funding schemes. Our previous work about universities, societal impact and engagement had to that point always emphasised that there were problems, tensions and issues that precluded the development of straightforward linear public value models. Yet we read the JRP as implicitly absorbing the worst of linear model idealism in seeking to achieve its wider goals of making arts and humanities research politically palatable in an increasingly instrumentalist European research environment. There seemed to be as many risks for the humanities in building up unrealistic expectations of the ways that it could contribute or in unhelpfully framing future debates about contribution as reducing to inputs to the amorphous "creative" sector. Implicit within the HERAVALUE project was a critique of these instrumentalist roles and claims and a desire to explore the consequences

that these one-sided perspectives had for policy seeking in various ways to make the world a "better" place, however defined.

From a purely practical perspective it is hard for us to feel in any way that we were co-opted into the programme through its practical unfolding. We had the feeling from the first programme meeting (of the twenty or so funded projects under the first JRP) that we were the outsiders, who did not fit into the accepted norms and ways of doing things, as would be expected for social scientists amongst humanities scholars. In practical terms we were largely left as a team to "do our own thing", although when we had real requests, we cannot stress highly enough that the JRP secretariat worked hard with us to accommodate our own special quirks as the exotic outsiders, as well as dealing with health problems from one of the principals. The various Humanities Research Councils were—as were all social partners—extremely helpful and supportive as we built up dialogue between the case studies in the three countries and contributed fully to our respective case studies, without ever giving us the feeling they were trying to do anything more than help us do good research and ensure that we acknowledged their much appreciated financial support for our work.

Finally, the story that emerged in our research is not particularly helpful for the funding councils at any level more than understanding the policy problematic of managing impact. In the lifetime of the project the arts and humanities research agenda became part of a wider tension emerging within European science between social sciences and humanities (SSH), and the rest of science. More detail is provided in Chap. 2, but the reality was that A&HR funders sought common cause with social science funders to make the case for a wider recognition of these disciplines beyond science and technology (STEM). A counter-discourse to entrepreneurial science emerged at the European level, that of SSH as a provider of policy knowledge, and STEM as a provider of economic knowledge. With the profiling of the issue in this way at a European level, and the active involvement of arts and humanities research in this through the European humanities learned societies, our immediate usefulness waned, removing any last risk of undue political pressure on our research process.

With this it is not that we want to say that our research has no policy salience, rather that what we have attempted to do in this volume is not a piece of advocacy but rather an analysis. The HERA JRP call for proposals seemed to be riven by the same problems that we saw elsewhere as problematic in the policy discourse—an extremely reductionist and instrumental view to the public value of science. Insofar as we have sought to

understand the public value of arts and humanities research, it has been to provide a referencing of these extant policy discourses and perspectives, to provide some real referents to the claims and ideas mobilised in discussions about policy, instruments, funding and interventions around arts and humanities research. We have found tensions between these real referents and the policy claims in which emergent outcomes have become systematised in formal policy frameworks but also informal policy mentalities. We surmise that these mismatches—although most obvious in arts and humanities research—also afflict other areas of policy making, and tracing these lacunae helps to generate a set of wider policy and conceptual messages. And this forms the basis for our contribution, understanding these wider dynamics as one example of the tensions in a more general challenge, smartly steering science towards strategic societal support.

Towards a More Rounded Understanding of (Arts and Humanities) Research's Public Value

This volume therefore presents a series of mismatches, between the ways that arts and humanities research creates value in particular national higher education systems, and the way that the policy system attempts to steer that research to particular purported ends. The mutual suspicion between the various camps that we trace in the first half of this chapter is not the result of a deep-seated mismatch between intrinsic characteristics of arts and humanities researchers and policy-makers. They are analytic categories that we have imposed in an attempt to make some sense of a noisy debate, and are categories that in many cases are filled by the same people just at different points of their respective career journeys. In the various national contexts we explore, we see contingency and pressure from outside the arts and humanities research system lead to perceptions of problems. These problems drive actors to respond in different ways, revealing tensions and producing outcomes. Over the course of several of these outcomes there is a systematisation of the responses in ways that harden what were formerly much less insignificant distinctions and divides. Over relatively short periods of time, what are in fact a concatenation of contingency become seen as inalienable features of the research landscape rather than the product of chaotic interactions and opportunistic responses.

At the same time, studying those processes provides a means to understand the relationship between the policy system and the reality that it

seeks to influence, of arts and humanities research creating public value in the sense of imbuing with more people to live better lives. The tensions in the policy discourses in various ways spark responses and challenges that help to change the underlying environment—so we see in Norway that a rather high-handed letter from a humanities professor arguing that public value should have no place in humanities research considerations is met by a much broader mobilisation of other humanities professors pointing out the manifold ways in which they are engaged. The creation of an admittedly short-lived research council specifically for social sciences and humanities in Ireland created a space for interesting and heterodox experiments to take place offering new perspectives on how humanities research creates value for different kinds of public. In the Netherlands, a very public dispute and occupation of university buildings by humanities students in response to a dissatisfaction with the technocratic implementation of humanities streamlining unleashed a wider discussion about making appointments to university leadership teams.

The stories we tell in the case studies are all of the tensions that arise in trying to allow sufficient diversity with steering, avoiding imposing from without the academic community or allowing norms of self-satisfaction to emerge from within. A clear message is that this message of diversity and heterogeneity fits uneasily within contemporary management paradigms which seek to offer a level playing field through the use of transparency tools to compare different activities (Van Vught and Westerheijden 2010). Qualitative assessment and comparison techniques apparently offer a potential resolution of this issue, through the use of standardised assessment techniques as pioneered in the Dutch Standard Evaluation protocol process. But at the same time, these qualitative comparisons lack an overarching metanarrative to shape the overall impact debate, which remains dominated by the view that immediately useful STEM disciplines, even those strongly aligned with the industries of today and not tomorrow, are seen as automatically being more useful than those of SSH, with arts and humanities research being the extreme case of these unuseful disciplines.

References

Bate, J. (2011). *The public value of the humanities.* London: Bloomsbury Academic.
Belfiore, E., & Bennett, O. (2008). *The social impact of the arts: An intellectual history.* Basingstoke: Palgrave Macmillan.

Belfiore, E., & Upchurch, A. (Eds.) (2013). *Humanities in the twenty-first century: Beyond utility and markets.* Basingstoke: Palgrave Macmillan.

Benneworth, P. (2014). Tracing how arts and humanities research translates, circulates and consolidates in society. How have scholars been reacting to diverse impact and public value agendas? *Arts and Humanities in Higher Education,* first published on May 14, 2014 as doi:10.1177/1474022214533888.

Bérubé, M. (2003). The utility of the arts and humanities. *Arts & Humanities in Higher Education, 2*(1), 23–40.

Bod, R. (2013). *New history of the humanities: The search for principles and patterns from antiquity to the present* (trans: Richards, L.). Oxford: Oxford University Press.

Bozeman, B. (2002). Public-value failure: When efficient markets may not do. *Public Administration Review, 62*(2), 145–161.

Bozeman, B., & Sarewitz, D. (2011). Public value mapping and science policy evaluation. *Minerva, 49*(1), 1–23.

Cassity E and Ang I (2006) Humanities-industry partnerships and the 'Knowledge society': The Australian experience. *Minerva* 44(1): 47–63.

Cohen, R. (2016, February 21). A rising call to promote STEM education and cut liberal arts funding. *New York Times.*

Daalder, H., & Shils, E. (1982). *Universities, politicians and bureaucrats: Europe and the United States.* Cambridge: Cambridge University Press.

Delanty, G. (2002). The university and modernity: A history of the present. In K. Robins & F. Webster (Eds.), *The Virtual University: Knowledge, markets and management.* Oxford: Oxford Unviersity Press.

Edgar, A., & Pattison, S. (2006). Need humanities be so useless? Justifying the place and role of humanities as a critical resource for performance and practice. *Medical humanities, 32*(2), 92–98.

FDA (2014). Development and approval process: Drugs. http://www.fda.gov/drugs/developmentapprovalprocess/. Accessed 23 Feb 2015.

Gulbrandsen, M & Aastad (2015). Is innovation a useful concept for arts and humanities research?, Arts and Humanities in Higher Education February 2015 vol. 14 no. 19–24.

Kickert, W. (1995). Steering at a distance: A new paradigm of public governance in Dutch higher education. *Governance, 8,* 135–157.

Kickert, W. (1997). Public governance in the Netherlands: An alternative to Anglo-American 'Managerialism'. *Public Administration, 75*(4), 731–752.

Kickert, W. J. M., Klijn, E. H., & Koppenjan, J. F. M. (Eds.) (1997). *Managing complex networks. Strategies for the public sector* (1 ed.). London: Sage.

Kreilkamp, K. (1971). Hindsight and the real world of science policy. *Social Studies of Science, 1*(1), 43–66.

Looseley, D. (2011). Making an impact: Some reflections on humanities in the UK. *Arts & Humanities in Higher Education, 10*(1), 9–18.

Nussbaum, M. C. (2010). *Not for profit: Why democracy needs the humanities.* Princeton/Oxford: Princeton University Press.

Olmos Peñuela, J., Benneworth, P. & Castro-Martinez, E. (2014a). Are sciences essential and humanities elective? Disentangling competing claims for humanities' research public value. *Arts and Humanities in Higher Education,* first published on May 14, 2014 as doi:10.1177/1474022214534081

Olmos-Peñuela, J., Castro-Martínez, E., & D'Este, P. (2014b). Knowledge transfer activities in social sciences and humanities: Explaining the interactions of research groups with non-academic agents. *Research Policy, 43*(4), 696–706.

Plumb, J. H. (1963). Introduction. In J. H. Plumb (Ed.), *Crisis in the humanities* (pp. 7–11). London: Pelican Originals.

Popp Berman, E. (2011). *Creating the market university: How academic science became an economic engine.* Princeton: Princeton University Press.

Shapin, S. (2012). The Ivory Tower: The history of a figure of speech and its cultural uses. *British Journal for the History of Science, 45*(1), 1–27.

Small, H. (2014). The value of the humanities, Oxford: Oxford University Press.

Stokes, D. (1997). *Pasteur's quadrant: Basic science and technological innovation.* Washington, DC: The Brookings Institution.

van Vught, F. A., & Westerheijden, D. F. (2010). Multidimensional ranking: A new transparency tool for higher education and research. *Higher Education Management and Policy, 22*(3), 1–26.

Wakefield, A. (2014). Butterfield's nightmare: The history of science as Disney history. *History and Technology: An International Journal, 30*(3), 232–251. doi :10.1080/07341512.2014.988904.

Weber, A. (2012). Hybrid ambitions : Science, governance, and empire in the career of Caspar G.C. Reinwardt (1773–1854). Leiden: Leiden University Press. https://openaccess.leidenuniv.nl/handle/1887/18924. Accessed 19 Feb 2015.

.

CHAPTER 2

Making Sense of the Debate About Arts and Humanities Research

INTRODUCTION

In the first chapter, we raised the overall question with which we are here concerned, namely how can we understand the public value of arts and humanities research. The antecedent research which went into this book was funded by the Humanities in the European Research Area (HERA) Consortium. The HERA Consortium began life as a European Network of Research Councils involving a number of humanities research funders (either dedicated humanities research councils such as Ireland's Irish Research Council for the Humanities and Social Sciences (now incorporated into the Irish Research Council) or humanities departments within larger research funders, such as Geesteswetenschappen within the Netherlands Organisation for Scientific Research (NWO-GW). Led by the Danish, Dutch and Irish representatives, this working group began to articulate a concern that in the rush to direct public research support to useful science, arts and humanities research was being left behind.

Their diagnosis was a need to reinvent humanities research, and to modernise humanities research funders, to ensure that no doubt could exist over the claim of arts and humanities research to create public value. They felt a need to have a strong voice in the debate able to articulate the wider public value of public research support for arts and humanities research. At the same time, they sought to back up their voice with claims that they were working to improve that public value, by creating new

© The Author(s) 2016
P. Benneworth et al., *The Impact and Future of Arts and Humanities Research*, DOI 10.1057/978-1-137-40899-0_2

practices and norms in the field in which public value were central. They therefore created a research funding consortium, which acquired funding under the ERA-Net scheme, which provides European support for coordinated international research programmes.

But at the same time, they went beyond the ERA-Net norms, and created a common research funding pool, which meant that the pool was allocated across the best proposals, and not on the basis of national contributions. The first HERA Joint Research programme, which concluded in 2014, sought to be highly innovative across a range of fronts. In its first round it had two themes, "Cultural Dynamics: Inheritance and Identity" and "Humanities as a Source of Creativity and Innovation", linked to areas of potential application. The research programme was multidisciplinary and lay much emphasis on knowledge exchange, engaging with non-academic individuals and organisations. In a sense, HERA did not just pay lip service to the idea of a new set of post-Mertonian science norms but actively adopted them in order to try to encourage their spread across humanities research funders more generally.

Behind this enthusiasm amongst research funders for the potential for new scientific norms to revitalise humanities and arts research in Europe appears also to be a fear that arts and humanities research was being left behind by these changes. Many humanities scholars have voiced their own fears about the damage that could be wrought by an unfettered adoption of alien practices and norms for the health of the wider field (e.g. Collini 2009, 2011). Indeed, one of Ireland's responses to the implosion of its public finances was to subsume its IRCHSS into its technical research council, thereby underlining the peripherality of the humanities. This has played to much longer-standing fears of crisis in the humanities as a result of its weak coupling to the interests and needs of an increasingly technologically dominated society, amplified by demands for useful knowledge to solve the grand challenges of the twenty-first century. Arts and humanities research therefore seems to face once more the rather unpalatable dilemma highlighted by Plumb half a century ago:

> Either they blindly cling to their traditional attitudes, and pretend that their function is what it was, and that all will be well, so long as change is repelled, or they retreat into their own private professional world, and deny any social function to their subject. And so the humanities are at the cross-roads, at a

crisis in their existence: they must either change the image that they present, adapt themselves to the needs of a society dominated by science and technology, or retreat into social triviality. (Plumb 1963, pp. 8–9)

We therefore argue that this fear has emerged as a response to this unpalatable choice. To understand why fifty years after Plumb first identified this problem the humanities once more face difficult choices, it is necessary to understand the way in which discourses of usefulness have been adopted within science policy decision-making. In this chapter, we trace the emergence of the discourses of useful knowledge that have emerged in Europe since the turn of the century, discourses that have emerged as the seemingly settled outcomes of public debates regarding the public value of arts and humanities research. We contend that the fear and urgency of these debates in the humanities funding community is in part a result of a mismatch between the way that policy-makers and scholars see public value, and the lack of traction of academics' arguments in those policy debates. The key question which we address in this chapter is why have those debates about the public value of arts and humanities research erupted across Europe in the last decade, and how has this disconnect emerged between the articulation of research's public value and the mechanisms and processes by which humanities researchers contribute public value.

THE INTRACTABLE DEBATES AROUND THE PUBLIC VALUE OF ARTS AND HUMANITIES RESEARCH

When we started the project in 2009, we were inspired by the fact that there had been a huge number of attempts to measure the public contributions of arts and humanities research (Dassen and Benneworth 2011). There was always a recognition that the public value of arts and humanities research was very broad (e.g. AWT 2007) and was not adequately measured by economistic approaches (Broek and Nijssen 2009), and there was a need to quantify those impacts for policy requirements. These attempts all began with the ambition to capture more than purely economic value, and finished with indicators that were too partial to contribute to the debate. There was no constructiveness in the debate, building up towards a common ground of what constituted effective public value measures. In

the absence of "hard facts" to persuade policy-makers, arts and humanities research suffers from a cognitive distance from its core knowledge domains to socio-economic value. Ultimately,

> [a]lthough we may need art, music, and literature, we do not obviously need art theory, musicology, and English literature. Like birds who do not need ornithology to know how to fly, perhaps we do not need humanities scholarship to engage in artistic endeavour and expression in order to learn to appreciate what it is to be human like us. (Edgar and Patinson 2006)

This is a very strong narrative, and has found expression in high-level discourses. It is perhaps worth repeating here the words cited in Chap. 1, of the UK's then Education Secretary, Charles Clarke, who stated:

> I don't mind there being some medievalists around for ornamental purposes, but there is no reason for the state to pay for them.

But at the same time it is important not to portray policy-makers as being somehow devious or naïve; research funders in particular across Europe have had a particular concern for the well-being of their disciplines—the HERA network described in the section, "Introduction" demonstrates how research councils and departments sought to work together to address the perceived side-lining of humanities research in Europe. But at the same time, other higher-level pressures, the rise of the innovation agenda as a meta-language of contemporary governance have restricted the freedom that research funders have had to reflect the interests of humanities and arts in their decision-making. And humanities as a field collectively and individually has not shied away from attempting to fight their corner in these debates. In Part II, we present three national case studies of how these debates have played out in practice, and how settled consensuses have been achieved at the national level of the role of impact and the future of arts and humanities research. There are great differences in the national contexts, with Norway embracing humanities enthusiastically, the Netherlands particularly trying to revitalise exciting humanities topics around digital humanities and creative industries, and Ireland, where crisis has forced humanities to the back of the queue for resources.

The three case studies we present can therefore be understood as an attempt to capture what is going on, the search for ways to express, articulate

and enumerate the public value of arts and humanities research in ways that will be accepted by sometimes rather sceptical policy-makers and funders. On the one side there is an underlying policy perspective that views arts and humanities research as not being useful, as represented by Clarke as quoted above. But on the other side, even within national science policy communities, there is a recognition that it can be extremely undesirable to follow the consequences of this argument and to defund arts and humanities research. France attempted to rationalise its science policy by concentrating it around a series of domains, and only at the end of the process came the realisation that the new proposed funding landscape left almost no room for the humanities (a problem that we will see in the section, "Arts and Humanities Research Does Create Impacts" has predictably been repeated with the case of the European Framework programmes).

Each of the case studies do reflect strong national differences and have evolved to quite different positions in terms of the exploitation of arts and humanities research. But at the same time, each of these debates embody in different ways a set of common tendencies that come together in different constellations to produce these different outcomes. To be able to say something slightly more interesting than that the world is complex and culture matters, we therefore think it is useful to try to trace some of these common tendencies. The first of these is that there is clearly a pressure in the policy landscape towards the promotion of innovation across government, and as part of this, higher education (as articulated through its senior leaders and collective bodies) has chosen to justify itself in terms of the benefits that it brings to "innovation", a second tendency. The third tendency has been the emergence of policies which have internalised this message, and in particular allocated resources to research on the basis of the capacity to stimulate innovation.

The extent to which these systematically disadvantage arts and humanities scholars varies, reflecting national contexts and policy choice. Nevertheless, there has been a perception amongst humanities scholars, their collective organisations (such as the European Academies) and also their lead users, that these tendencies are a threat. Scholars have individually and collectively responded to these threats in a variety of ways which can be characterised as three strategies, challenging-rejecting, compromising-complying, and "hyper-adapting", in some cases going further to make themselves useful than disciplines who find it easier to make a case for their use. What is notable is that in many cases, publics

are absent from the debate. Whilst it is clear that publics clearly value humanities research, and that scholars are actively engaged with publics, it is clear that the public policy debate all too quickly defaults to a rather abstract version of publics, as expressed in terms of a hypothetical (and always miserly) taxpayer or in terms of the value of their time, reflecting a set of fractures emerging in contemporary society that the policy debate has no effective tools with which to engage.

In the remainder of the chapter, we set out the key elements of this landscape that is shaping the contemporary public value of arts and humanities research. In the section, "The Contemporary Policy Landscape: The Innovation Imperative and Useful Science", we set out the background to these debates, a policy paradigm across all government which is focused on delivering efficiency through measurement, in stimulating innovation and paying for results, and explore how universities have adapted to this challenge. We then explore in the section, "Policy Perspectives on Arts and Humanities Research" the consequences that this has had for research policies for arts and humanities research, noting that policy sometimes has a subconscious prejudice leading to the disadvantage of arts and humanities research against other disciplines perceived as more valuable. In the section, "Three Responses Within the Community", we look at the different responses within the extended disciplinary community to these changes, and in particular, their attempts to engage with the policy debate as networks and collectives rather than simply in response to particular policy pressures. Finally, in the section, "The Missing 'Public' in Public Value Debates" we explore the curious omission of the idea of publics from debates of public value, and highlight that at least part of the instability in debates comes from a lack of consensus about where public value lies outside economic contributions to GDP.

. The Contemporary Policy Landscape: The Innovation Imperative and Useful Science

As we have already argued, the urgent policy question of the public value of arts and humanities research has not arisen purely in a vacuum, but has been driven by a series of public debates in which a number of remarkably simplistic discourses of that value have dominated. In Part 2 of this volume, we present a number of national case studies drawn from the Netherlands, Norway and Ireland which explore how these public debates unfolded, confronted that simplicity, and produced more nuanced understandings

of that arts & humanities research's public value. In order to situate those national narratives in the broader trend, it is necessary to understand the emerging discourse around useful knowledge, and how its evolution served to frame humanities and arts research as being somehow less useful than other kinds of knowledge.

Although it is a contemporary truism that public funding for research justifies increasing pressure upon scientists to make their research useful, it is all too easy to assume that thirty years ago, these norms and practices were far from widespread. There is a sense that there has been a generational shift in the academy, with what Lam (2010) refers to as ivory tower scholars being replaced by entrepreneurial scientists, scientists whose interests in research relate both to its successful application outside the academy as well as to its publication in scholarly journals. This shift has been partly driven from within the academy in seeking to justify the public resources that science receives (Popp Berman 2011), but also from policy-makers who, given the huge sums invested in higher education and research, are keen to maximise the returns to their investments.

This shift has been given additional contemporary urgency as a result of problems caused both by short-term financial austerity as well as by a longer-term uneasiness about the so-called grand challenges. Clearly, within Europe, the crisis in the late 2000s had a profound impact on science funding, with the desired €80 bn investments for Horizon 2020 being reduced to €70 bn. This reduction, mirrored in many other European countries in their national science budgets has driven a sense that hard choices have to be made to support only the most useful research activities. In parallel with this has come a realisation that there is also a need to address the grand challenges of the twenty-first century, such as energy and resource security, sustainable transport, and urban social inclusion. There has been a parallel reorientation of resources towards research topics addressing those challenges, reinforcing the sense that useful disciplines and research is research that generates contributions in these areas.

Embedded within these common-sense ideas of how science generates societal benefits is a relatively simplistic model of the relationship between research and those benefits. The reason that the investment model of science has taken hold so successfully is because of its demonstration of unambiguous benefits in terms of economic growth. The heuristic for this is of a pharmaceutical spin-off company, created when a piece of academic

research is licensed to an entrepreneur, then the technology proved and sold onto a global pharmaceutical company leading to a new drug. The product sales generate revenue that supports employment and profits, and tax on all three flows back into the public purse, creating an aggregate economic benefit as a whole (Benneworth 2014). Measuring spin-off companies or even their antecedents in terms of licences provides a proxy measure for the eventual contribution that that research will make.

These metrics have a special allure for policy-makers in the context of a shift towards new public management (Kickert 1995, 1997). The hallmarks of new public management are increasing public efficiency and innovation in public services by creating quasi markets for public service provision. Because many of the goods provided in public markets are unsuitable for direct market competition, governments find themselves having to stimulate competition by comparing providers on the basis of transparency tools and rankings (see van Vught and Westerheijden 2010; Hazelkorn 2015 for an overview). For some kinds of university activities, such as teaching and research, there is some kind of consensus over what constitute effective metrics because they are related to the core purposes of institutions. But the very diffuse range of processes by which research creates public value has made this a rather intractable policy problem for creating quasi-markets in the utilisation of research.

There has therefore been a clamour amongst policy-makers for the generation of metrics which are capable of measuring the creation of public value as a precursor to its management and reward. It is in this context that a relatively limited number of indicators have become accepted as effective measures of how research contributes to creating public value. They are not exclusively focused on intellectual property, but are focused on measuring formal transactions in which an external user signals that they value that knowledge by paying for it, such as consultancy income (Olmos Penuela et al. 2014b) rather than through informal interactions such as media appearances. And the great advantage of income-based metrics is that they do clearly demonstrate a user interest as well as having a direct relation to a wider public benefit (in terms of economic growth).

These metrics are not apolitical—it is clearly possible to trace how they have emerged as part of efforts by a group of American universities to justify their public support (Olmos Peñuela et al. 2014a). Popp Berman demonstrates the intense lobbying that took place in the 1970s by a coalition of research-intensive universities to allow universities to reap the financial rewards of Federally funded research. This led to the (in)famous Bayh–Dole

Act which in turn laid the ground for systematic state funding for public university transfer offices to systematically create, manage and exploit university knowledge as an intellectual property (IP) portfolio (Mowery et al. 2001). In the wake of the Act and the growing ubiquity of university commercial activity, the informal lobby organisation transformed itself into the Association of University Technology Managers (AUTM).

As well as supporting a new kind of university employee, the university technology manager, another goal of AUTM was to continue to demonstrate the benefits which American universities were generating for society, principally in economic terms. In 1987, AUTM surveyed their members in order to gauge the extent of the financial scope of those contributions, and in that survey included items such as numbers of disclosures, patents, licences, spin-off companies and licensing income. Over time, this rather ad hoc set of indicators became seen as an authoritative representation of what "good" university engagement activity was, in part because from the 1990s onwards, with Japan's stagnation, America became seen as a role model for developing economic competitiveness.

Prodded by multilateral organisations including the World Bank and Office for Economic Cooperation and Development (OECD) (McCann and Ortega-Argiles 2013) governments globally started to shift away from separate industrial, technological and education-science policies towards integrated innovation strategies (cf. OECD 2010). Relatively sophisticated concepts like the "Triple Helix" (Etzkowitz and Leydesdorff 2000) transformed into simplistic policy concepts that recommended that governments seek ways to encourage universities and firms to work more effectively together. And for policy-makers looking for practical ways to unleash the potential of innovation to revitalise their economies, it made sense to look to America's entrepreneurial universities, as demonstrated by their impressive performances in the AUTM Licensing Survey (e.g. AUTM 2003).

There has thus been an elision between these very specific examples of the kinds of ways in which universities can create knowledge and understandings of what are the benefits of investing in research. Even in the UK, where something like Research Council UK (RCUK's) impact statement (2011) sets out very clearly that social and cultural contributions are as important as economic impacts, there is evidence that there is a hierarchy of what counts as "valuable impacts". Economic impacts are seen as being indisputable, with individual transactions creating a general high level benefit; conversely, it is much harder to trace how individual research outputs and outcomes can have overall effects on the nature of society and culture.

POLICY PERSPECTIVES ON ARTS AND HUMANITIES
RESEARCH

Arts and Humanities Research Does Create Impacts

It is perhaps striking that the effects of these metrics have been almost entirely symbolic in their nature. Even in the UK, which is widely acknowledged as one of the most advanced science systems in terms of the use of selective, competitive management processes, there has been very little funding allocated according to those metrics (Brown and Carasso 2013). In the HERAVALUE project, we did not include a specific case study from the UK, although the UK was the largest participant in the HERA JRP in general terms. Nevertheless, the UK system is relatively open and reported upon in science policy circles, which makes it relatively straightforward to analyse. It is worth looking at the latest iterations of the UK's research assessment system (the Research Excellence Framework) as it provides insights on how, when a comparative impact system is developed for research funding, humanities need not necessarily suffer with regard to other disciplines.

At the time of writing, the Higher Education Innovation Fund and its predecessors were allocating c. £100m annually to institutions on the basis of their knowledge transfer activities, but the size of that allocation is dwarfed by block grants; the £1 bn of the block grant associated with research activities was until 2014 allocated purely on the basis of within-field research performance (as measured through the various research assessment exercises). From the 2015 round, the grades on which funding is allocated for the first time reflected "impact" as well as research excellence and environment. Nevertheless, the way that impact was judged in the 2014 round was on the basis of written statements from an assessed unit, assessed in disciplinary panels, using the same broad definitions of impact as stated by RCUK (i.e. across a broad spectrum of socio-economic impacts) and gauging reach and significance in a way comparable across epistemically different fields.

A pilot exercise to trial the impact methodology included English Language and Literature alongside Clinical Medicine, Physics, Earth Sciences and Social Work/Policy (REF2014 2010). An attempt was made to give some degree of balance between disciplines and kinds of institutions included, both covering institutions across the UK nations, as well as balancing between research intensive and teaching intensive, broad and

specialist institutions and by institutional age. Each of these fields judged the impact of the pilot submissions according to the common criteria, in panels that were drawn up from specialist academics and expert users. Each submission was given a profile reflecting which percentage of the research group could be allocated to each of five "star" levels, from 4* at the top, reflecting world leading, to 1*, nationally recognised and U (unrecognised). In the REF2014, these profile scores have been combined with scores for research excellence and environment to give overall departmental profiles, and funding council block grants are allocated along the lines of these profiles. Table 2.1 summarises the average impact profile scores for the institutions in each field; a key figure is the percentage of profile rated as with 3* or 4* because these are the only elements which stood to be funded under the then-current arrangements (with 4* being funded at three times the level of 3*).

Under the way the funding formula works, assessment panels that give lower average scores to their units than other panels will see their fields receive a relatively lower share of funding over the course of the funding period (economics suffered particularly in the early 2000s because the panel took a particularly strict interpretation of what international quality was, namely to publish in American orthodox journals leading to lower average scores). So even if funding is not being strictly allocated according to technology transfer metrics, there is a risk that if "impact" was interpreted strictly by assessment panels in those terms, then these technology transfer indicators would affect funding levels. But it is clear that impact was being interpreted in its broadest sense. As a result of that, the chosen humanities discipline, English Literature and Language, was certainly not disadvantaging itself in terms of the impact scores. Both in terms of the profile levels likely to attract funding, and the potential financial consequences of this, it is clear that the REF Impact Pilot results suggested that

Table 2.1 The comparative quality profiles of the pilot institutions impact scores by discipline

	4*	3*	2*	1*	U	3* + 4*	Weighted 4* + 3*
Medicine	17	25	34	12	12	42	38.0
Physics	20	27	26	21	6	47	43.5
Earth Systems	18	28	24	15	15	46	41.0
Social Work/Policy	19	14	38	29	0	33	35.5
English Language and Literature	19	30	30	19	2	49	43.5

the REF was in no way likely to disadvantage the humanities by disregarding societal outputs and outcomes from its research as being less worthy or less valuable that those of other more prestigious disciplines. With the final REF scores now having been announced, it is possible to say that there is no real systematic difference in the reporting of Impact scores between different disciplinary areas (Jump 2015).

The overarching point to make here is that it is clear that arts and humanities research has considerable opportunity to create impact and to have that reported to and accounted for in quantitative evaluation and funding systems. The evidence from the REF Impact pilot suggests that humanities research had every bit as much potential to be recognised for creating far-reaching, long-lasting and profound societal change as had medicine, physics and earth sciences. As we will show in the section, "Three Responses Within the Community", humanities bodies have collectively produced reams of evidence that they create contributions as substantial as those from the sciences. But at the same time there is not a convincing meta-narrative to humanities as there is to curing cancer in medical sciences; its contributions come through a multiplicity of micro-contributions. There is no intuitive integrating vehicle that allows humanities to claim credit for societal change rooted in its research contributions analogous with science and technology disciplines that as a whole are able to bask in the reflected glory for many scientific advances to which they will have at best contributed a minor role (Benneworth 2014).

But It's STEM that Policy-Makers Turn to When the Going Gets Tough

At the same time, it is clear that there has been a shift in the way research funding is allocated that reflects perceptions of what constitutes useful research. Nowhere is this illustrated more clearly than in the way that the European Union's multi-annual research programme Horizon 2020 (H2020) has been drawn up and is now starting to allocate funding between disciplines. Europe's research investments are intended to be complementary with those of the member states. But at the same time, their relative magnitude means that they have a strongly coordinating effect on the field because of the "Matthew effect" of science whereby success breeds success (Merton 1968). At the start of this chapter, we have seen how the ERA-NET instrument has helped to coordinate an evolution across European

arts and humanities research councils to a particular model of excellent arts and humanities research, where user engagement and co-creation are actively embraced for the added-value that they can bring to that primary knowledge creation process. It is therefore reasonable to expect that trends that were being set in place at the time of writing will continue to demonstrate influence upon the way that national funding councils allocate their resources in the medium term. And H2020 has marked a significant break in the way that research resources are allocated between the disciplines, with a resumption of the funding of research on the basis of what that knowledge can do to promote European competitiveness.

From the early 1980s to 2014, European Research funding was allocated by a series of multi-annual Research Frameworks, running from I to VII. Each of the latter Frameworks included a mix of funding for collaborative research activities as well as supporting activities to exploit knowledge, support high-level training and more recently invest in excellent individual research activities (the European Research Council). Collaborative research funding was allocated within disciplinary-domain specific programmes, including health, ICT, nanotechnology, energy, environment and transport. Each of these areas produced medium-term research plans with the key questions requiring answering; each year, specific annual plans were produced setting out the particular projects that were sought to advance and answer those key project questions; in some years, no projects were called for under particular questions. The first frameworks were primarily oriented towards the technological science areas, but since the Fourth Framework Programme (1994–98), Social Sciences and Humanities had been granted one of these Programmes. This was called the Targeted Socio-Economic Research programme in the Fourth Framework, evolving into "Socio-economic sciences and the humanities" by FPVII (2007–14). The Seventh Framework programme funded SSH research activities under seven main headings (DG RESEARCH 2009).

- Growth, employment and competitiveness in a knowledge society;
- Combining economic, social and environmental objectives in a European perspective;
- Major trends in society and their implications;
- Europe in the world;
- The citizen and the EU;
- Socio-economic and science indicators;
- Foresight.

H2020 took a very different approach to the way that its resources were allocated, moving from a disciplinary approach to a focus on "grand challenges". The idea behind this was to orient basic European research to a series of urgent challenges which demanded rapid solutions. Part of the apparent justification for this was to demonstrate to European citizens the value-added of Europe as a whole, by proving that research funding was being allocated to solve problems of concern to the wider European citizenry. Thus, instead of having a specific programme for Social Sciences and the Humanities as in FP IV to VII, there were eight societal challenges which formed the basis for all scientific research efforts (including SSH). It was stated that within these seven challenges (listed below) that social sciences and humanities research would be funded *where it contributed to those projects*, and indeed social sciences and humanities disciplines would be expected to lead the research efforts in the last two of those.

- Health, Demographic Change and Wellbeing;
- Food Security, Sustainable Agriculture and Forestry, Marine, Maritime and Inland Water Research and the Bioeconomy;
- Secure, Clean and Efficient Energy;
- Smart, Green and Integrated Transport;
- Climate Action, Environment, Resource Efficiency and Raw Materials;
- Europe in a changing world—Inclusive, innovative and reflective societies;
- Secure societies—Protecting freedom and security of Europe and its citizens.

However, even before H2020 formally launched, a number of interest groups were expressing concern at the scope that this provided inadequately for the inclusion of SSH projects in these collaborative projects. A high profile conference on SSH in H2020, organised under the auspices of the Lithuanian European Presidency, articulated very clear concerns that in particular humanities would be excluded from projects that were focused on economic benefit (Greenhalgh 2013; Lee 2013). There was a realisation that given the need for multi-disciplinary consortia in which SSH researchers would usually form a minority, there was a risk that they would

suffer adversely in selection processes leading to the de facto marginaliza-
tion of their interests in H2020 as a whole. Less than a month before
H2020 formally came into effect, the All Europe Academies' (ALLEA)
Working Group on Social Sciences and Humanities criticised the room
available for humanities in particular to participate in research activities
(Else 2013). At the same time, the European Commission made it clear
in its responses that these fears would be allayed in the way that H2020
processes would place social sciences and humanities centrally within these
"Societal Challenges".

In 2014, the *Science Europe* think tank published a report from their
humanities working group which sought to examine using the avail-
able data the extent to which SSH, and in particular humanities were
integrated into the societal challenges. Their findings did not mince
their words "We conclude that the actual role of the humanities in the
2014–2015 Work Programme is marginal in quantity as well as qual-
ity" (p. 7). This conclusion was based on an analysis which looked at all
H2020 funding for the amount that could potentially be open to SSH,
and separately humanities, researchers. They found that 75 % was com-
pletely closed to SSH researchers (and 90 % to humanities researchers)
and was being allocated in streams where there was no space for an SSH
partner. They also argued that there was a very instrumental view taken of
SSH, as a means of accounting for the "human factor" in solving societal
challenges, often reducing to numerical behaviouralism. At the same time
there was almost no accounting for what humanities themselves deemed
to be important in terms of the topics, themes or approaches that were
included in the report.

Again, this illustrates the common trend for the demand from the wider
policy environment for innovation to get translated into decisions that
frame the goals of science policy in ways that exclude arts and humani-
ties research from receiving funding. Rolled somewhere into this complex
process of scientific governance, decision-making and the exercise of polit-
ical power becomes embedded a set of assumptions that arts and humani-
ties research is intrinsically less useful than "harder" research. The result of
this is to a degree self-fulfilling because arts and humanities research is not
approached to ask interesting humanistic questions of the research, such as
how people relate to these new technology developments but are instead
pigeonholed into questions of societal acceptance and "nudge".

Any research they may offer that contradicts the founding belief that technological research is the way to solve these challenges (see the section, "Arts and Humanities Research Does Create Impacts") is not engaged with, and simply not taken forward within the policy community (reflected in the rather cyclical rather than constructive nature of a range of policy reports around arts and humanities research alluded to in the section, "The Intractable Debates Around the Public Value of A&HR"). This raises the question of how can humanities communities themselves react to these situations, and challenge the discursive trap within which they find themselves—when they are asked to be useful, they are restricted from doing what would actually be useful and critically challenging the techno-centric assumptions of these rather Whiggishly motivated research programmes.

THREE RESPONSES WITHIN THE COMMUNITY

These two examples set out above highlight very clearly the dilemma that is confronting arts and humanities research with this drive to create impact. Whenever there are attempts to measure impact in the way that humanities disciplines and their users find reasonable, then it is clear that arts and humanities research is just as "impactful" as STEM disciplines, as with the REF Impact Pilot (as shown in the section, "Arts and Humanities Research Does Create Impacts"). However, whenever decisions have been taken recently about the contours of the research landscape, creating new priorities and action themes, policy-makers often take as common sense the "investment" model of returns to science in which arts and humanities very much come second best to those disciplines able to promise returns via patents, licences, and spin-out companies (as shown in the section, "But It's STEM that Policy-Makers Turn to When the Going Gets Tough").

It is perhaps no wonder that arts and humanities researchers have been overtaken by what Belfiore (2013) calls a "rhetoric of gloom" around the rise of the impact agenda; despite swathes of evidence emerging that they can produce impact (as outlined below), policy-makers seem to be prepared to ignore their own self-stated platitudes that it is important as policy-makers to be taking the broadest view of that impact. Instead, in their practices and decisions, policy-makers appear to be resorting to a

belief in simplistic pipeline models that not only fail to capture the wider benefits that arts and humanities research brings, but that also fail when measured against meaningfully capturing the full range of benefits that STEM bring (Crossick 2006, 2009). Nevertheless, we can see that there have been a range of responses by arts and humanities scholars, managers and representative organisations, and understanding these responses is critical to understanding the dynamics of these national debates, which we characterise under three main headings.

The first response has been to reject and critique the salience of the impact agenda, what Belfiore identifies as part of a rhetoric of gloom where academics explain how any consideration of the societal value of research is inimical to the very values that drive arts and humanities scholarship. Indeed, it is worth repeating, at slightly more length than Chap. 1 permitted, the quotation from Martha Nussbaum, who has come to represent the voice of the resistance to this trend when she argues that this might result in arts and humanities being seen as:

> useless frills, at a time when nations must cut away all useless things in order to stay competitive in the global market, they are rapidly losing their place in curricula [...] nations prefer to pursue short-term profit by the cultivation of the useful and highly applied skills suited to profit making. (Nussbaum 2010, p. 2)

The basis of humanities practices is in deep reflection upon meaning, and therefore it is perhaps unsurprising that humanities scholars have turned their attention to develop critiques of the evolving policy environment, characterised by Collini (2011). Viewed from a science studies perspective, it is possible to see that humanities debates can be characterised in lacking "finality"—because of their interpretative nature there is never the final answer to a question (Hessels and Van Lente 2008). Humanities scholars have expended much energy to debating whether it is right to focus on extrinsic or intrinsic values, whilst others have criticised the portrayal of the debate in those terms (McDonald 2011; Belfiore 2013; Small 2013). And these arguments have carried little weight with policy-makers because as well as being inconclusive, and often lacking facts, relying instead on rhetorical quirks, they can also be dismissed by policy-makers as simple special-interest pleading by

ivory-tower academics unwilling to subject themselves to disciplines now applied across universities. Luckhurst summarises neatly the challenge which humanities faces in trying to articulate its value, in the particular context of the UK in 2011:

> It has been harder to find an expression of our core values, because so often the nature of cultural value has been at the centre of our debates and critiques. That is only right, but it is hard to sell to the Treasury wonks who are ordering David Willetts around. (Luckhurst 2011)

A second set of responses have been what higher education scholars call compliance behaviours that are deployed when reluctant academics face incomprehensible management demands. This is a sense of engaging with the debate to try and shape the debate or at least having the voice heard from an academic perspective, to engage with policy-making and try to firm up the conceptual underpinning of public use and valorisation. There has been a huge amount of effort from learned societies and academies across Europe to try to articulate precisely what the public benefits and contributions of arts and humanities might be. The British Academy (the leading learned society or academy for the humanities in the UK) has, for example, over the last decade taken great efforts to advance a strong case for the public value of the humanities (cf. *inter alia* British Academy 2004, 2008, 2010, 2014). In their 2014 pamphlet, they choose also to make common cause with the social sciences, who face similar pressures to demonstrate their value. In the case studies reported in the following chapters, we see a range of examples where national academies have sought to advocate for the value of their disciplines in ways that are recognisable and legitimate amongst members of their community. In the Netherlands, for example, the humanities division of the Royal Dutch Academy of Arts and Sciences (KNAW) pushed hard for an inquiry into the potential "blind spots" (*witte vlekken*) left by a national policy allocating basic research funding to public-private partnerships (the "Top Sector" policy).

This has also been paralleled by an interesting set of academic debates that have engaged with the premises of the policy critique of arts and humanities research, that it is valid to ask what extrinsic value arts and humanities research has for society at large. In contrast to the academic debates that have sought to deconstruct and critique policy-makers' premises and meanings, they have sought to address the issue of the micro-ness of humanities outputs that never sum up to large-scale societal change. In

the UK, the AHRC provided support for a series of scholars to reflect on the public value of humanities research, resulting in Bate's (2011) volume, presenting worked examples of how humanities research created knowledge that was clearly valued by different kinds of publics (ranging from TV audiences to Supreme Court judges). Rens Bod in the Netherlands likewise completed a history of the long-term contributions that humanities research has made to the progressive accretion of socially valuable knowledge, from antiquity (the pioneering grammatical work of Panini influential in the design of contemporary computer languages) to the present day (2010, 2013).

At the European scale, the Siampi project undertook detailed case studies of the ways in which research interacted with societal users via productive interactions (Spaapen et al. 2011a, b). Their argument was that the study of productive interactions provided a means to understand societal value by indicating where ideas flowed from the academy into society. At the time of writing, the IMPACT-EV project, also funded by the European Commission was seeking to explore how social sciences and humanities research contributed to policy processes, and hence realised policy value through improved governance of the public sphere. In 2015, a choice was made for the research consortium to undertake The Coordinating and Support Action "Enabling Innovation—Creating Impact from Social Sciences and Humanities". What all of these various approaches shared in common was an attempt to create a robust understanding of the processes by which arts and humanities research created value in society by demonstrating that use in action. As Chap. 3 shows, the Siampi project and its antecedent Evaluating Research in Context (ERIC) evaluation frameworks were quite influential in viewing the way that valorisation has been seen as a goal for publicly funded research including the humanities. The challenge with these transactional relationships is that although they can be counted and quantified, they cannot be compared, and this runs the risk of them seeming "lesser" to economic benefits that are quantifiable in cash terms (Benneworth 2014).

The final response from within the community and its stakeholders has been what might be interpreted as a hyper-adaptation, seeking to demonstrate that arts and humanities research *can* be as valuable as other kinds of research by creating that value, and even seeking to comprehensively rebuild humanities to deliver that outcome. It is not just in the field of research, but one can see with attempts to develop suitable indices (such as the European Reference Index for the Humanities, which evolved to later

also incorporate social sciences) to count arts and humanities research's scientific impact and participating in large-scale research infrastructures, that arts and humanities research community has responded to these exogenous challenges and incorporated them in ways that are more than symbolic compliance. Indeed, the emerging field of digital humanities emerges in the various national case studies as a clear result of attempts to steer the humanities to make its research practices more similar to other disciplines (such as in terms of its use of large infrastructure, technicians and research associates). Far more prominence is given to humanities scholars who are active in various forms of public value creation, in terms of the kinds of support and recognition they are given from their institutions and funding councils.

But this reconstruction of the field has not always proceeded smoothly, and in some cases those within the humanities community that have attempted to drive reshaping processes have created conflict with other scholars. Perhaps the most telling example of this came from the UK, where the AHRC—the most recently created of the research councils, had sought to underscore its credibility by enthusiastically championing the impact agenda arguably more so than its fellow longer-established research councils (Corbyn 2008; Benneworth and Jongbloed 2009). On 20 December 2010, following the election leading to a new right-liberal coalition government, the AHRC published a new delivery plan, and in that stated that it would contribute to government initiatives on localism. In stating that, it also said the AHRC would contribute to what was called the "Big Society", plans by one coalition partner to reconstruct the state with far greater use of private and voluntary sector service provision (AHRC 2010). This was picked up furiously in the Spring of 2011 by a number of academics who were outraged at the idea of research funding supporting delivering particular ideological positions; a piece in the Sunday *Observer* newspaper served as a rallying point for those who felt this was an unjustifiable intrusion into their academic freedom (Jump 2011). The row deepened over the summer with a series of resignations from the AHRC's Peer Review college (Brecher 2011) before the air cleared and little more was said over the Big Society. The issue here indicates the wider problem, the question of where to draw the line when attempting to steer academics in ways to make them useful, when those academics do not necessarily agree with those kinds of use.

THE MISSING "PUBLIC" IN PUBLIC VALUE DEBATES

In this chapter what we have sought to do is to provide an overview of the raging debates that are taking place around the idea of the public value of arts and humanities research, something which sometimes may get lost in the seemingly anodyne and technocratic search for indicators, metrics and benchmarks of value. In each of the three case studies that follow, we show how variants of these positions have been taken in each country and they have come together to create situations where humanities have evolved rapidly as a field as part of attempts to secure the foundations on which it stands. But perhaps what this chapter has also shown is that "publics" are surprisingly absent from these discussions of public value. What we do see, as Bate argues:

> Imagine a civil servant responsible for the distribution of the research budget. Imagine them saying "I don't lose any sleep at night over the spending of taxpayers' money on medical research, but I do lose sleep over the spending of it on humanities research; I like riding my horse, but I don't expect the taxpayer to pay for me to do so." (Bate 2011, p. 7)

Margaret Thatcher's attributed description of studying Norse Literature as a luxury falls into this category and is arguably more real than Bate's hypothetical bureaucrat (White 2011).

At the same time, A&H researchers are able to cite evidence in terms of book sales, readers of articles, audiences at exhibitions or viewers of TV progress that "consume" their material—as do a number of chapters in Bate's volume. But these are claims that are made about publics' desires being reflected through these proxy consumption indicators. For us, what clearly emerges here is the poorly articulated notion of publics here in the debate—if we have seen a loss of the idea of general public goods, then there is a wider question of which publics benefit, how, why and how is this related to our wider power and decision-structures in society. As with an audience in "public understanding of science", the dynamics of what one might think of as the public understanding of humanities can be seen to operate at a variety of levels. Surveys consistently show that scientists are one of the most trusted groups in society (e.g. Medical Council 2011; Veltri 2011: although the 2010 Eurobarometer survey indicates a growing suspicion of scientists because of their growing dependence on commercial funding sources, CEC 2011).

In the UK, archaeology is extremely popular as a hobby in which people are willing to involve themselves as volunteers, just as people are very interested in science, and consume magazines, books and newspaper information on the topic eagerly. There is an expertise dynamic, with publics often positive about the things that they know about. But the key point here is that in reality, despite an evocation of the "public" as being important in value, the public are not really very important directly in terms of the scientific debate as a means to decide which questions are important and deserve further study. People infer the supposed public value in terms of anecdotes or data, but those publics are constructed—nowhere are the publics directly influencing the governance processes which decides what scientists do (and in which scientists remain along with policy-makers the most important participants). The only occasion where publics really become important in scientific debates and decision-making processes is under crisis conditions where there is a spontaneous crisis of trust and legitimacy, as happened, for example, in the UK around GM foods, BSE and nuclear power (Benneworth 2009), or when it is anticipated, for instance, in the role of nanotechnology research in society.

It is striking perhaps that there are not those crises of legitimacy around arts and humanities research which create a window within which the voices of publics could be heard demanding to have a say. The crises around BSE and GM food in the 1990s in the UK led to the rise of the "Public Understanding of Science" movement which evolved into the notion of public engagement (Wilsdon and Wills 2004; Wilsdon et al. 2006). There has not been a similar controversy which has initiated a public understanding of arts and humanities research, or public engagement in arts and humanities research, along with the bodies seeking to put scholarly perspectives to publics. Part of that is because arts and humanities research does not appear either controversial or contentious—it will not poison our rivers or our children. This means that in debates about arts and humanities research, publics are relatively easily enrolled and deployed by others to supposedly justify their positions. Given how fragmented the environment for arts and humanities research, and the involvement of people in decision-making on the basis of their supposed capacity to deliver (part of the requirements of governance), what we can see here is a mass exclusion of "public voices" in a meaningful sense from the tensions and debates about arts and humanities research. It is to this issue that we will turn in our concluding chapter.

References

AHRC. (2010). Delivery plan. Swindon: Arts & humanities research council. http://www.ahrc.ac.uk/About/Policy/Pages/DeliveryPlan.aspx. Accessed 17 June 2011.

AUTM. (2003). *AUTM licensing survey: FY 2001.* Northbrook: Association of University Technology Managers.

AWT. (2007). *Alfa en Gamma stralen – Valorisatiebeleid voor de Alfa- en Gammawetenschappen.* Den Haag: Adviesraad voor het Wetenschaps- en Innovatiebeleid.

Bate, J. (2011) The public value of the humanities, London: Bloomsbury Academic.

Belfiore, E. (2013). The 'rhetoric of gloom' vs. the discourse of impact in the humanities: Stuck in a deadlock? In E. Belfiore & A. Upchurch (Eds.), *Humanities in the twenty-first century: Beyond utility and markets.* Palgrave Macmillan: Basingstoke.

Benneworth, P. (2009). The challenges for 21st century science. A review of the evidence base surrounding the value of public engagement by scientists. *Science for All* Working Paper. London: Department for Business, Industry and Science. http://interactive.bis.gov.uk/scienceandsociety/site/all/files/2010/02/Benneworth-FINAL2.pdf. Accessed 16 June 2011.

Benneworth, P. (2014). Tracing how arts and humanities research translates, circulates and consolidates in society. How have scholars been reacting to diverse impact and public value agendas? *Arts and Humanities in Higher Education,* first published on May 14, 2014 as doi:10.1177/1474022214533888.

Benneworth, P., & Jongbloed, B. W. A. (2009). Who matters to universities? A stakeholder perspective on humanities, arts and social sciences valorisation. *Higher Education, 59,* 567–588. doi:10.1007/s10734-009-9265-2.

Bod, R. (2010). *De vergeten wetenschappen, en Geschiedenis van de Humaniora.* Amsterdam: Prometheus. In translation as Bod, R. (2013). *New history of the humanities: The search for principles and patterns from antiquity to the present* (trans: Richards, L.). Oxford: Oxford University Press.

Bod, R. (2013) New History of the Humanities: The Search for Principles and Patterns from Antiquity to the Present, Oxford: Oxford University Press (tr. L. Richards).

Brecher, B. (2011, July 3). No more Browne-nosing. *London Review of Books.* http://www.lrb.co.uk/blog/2011/07/03/bob-brecher/no-more-browne-nosing/. Accessed 5 Aug 2011.

British Academy. (2004). *That full complement of Riches: The contributions of the arts, humanities and social sciences to the Nation's Wealth.* London: The British Academy. http://www.britac.ac.uk/templates/asset-relay.cfm?frmAssetFileID=6386. Accessed 20 Nov 2011.

British Academy. (2008). *Punching our weight: The humanities and social sciences in public policy making.* London: The British Academy. http://www.britac.ac.uk/ templates/asset-relay.cfm?frmAssetFileID=7648. Accessed 27 Oct 2011.

British Academy. (2010). Past, present and future. *The public value of the humanities and social sciences.* London: The British Academy. http://www.britac. ac.uk/news/bulletin/BAPPF.pdf. Accessed 11 Sept 2013.

British Academy. (2014). *Prospering Wisely: How the humanities and social sciences enrich our lives.* London: The British Academy. http://www.britac.ac.uk/prosperingwisely/pub/pdf/prospering-wisely.pdf. Accessed 30 Oct 2014.

Broek, S. D., & Nijssen, A. J. (2009). *Impact assessment Geesteswetenschappen.* The Hague: The Netherlands Organisation for Scientific Research. http://www. nwo.nl/binaries/hst%3Ahst/hst%3Asites/nwo/hst%3Acontent/algemeen/ documentation/application/gw/gw-impact-assessment-geesteswetenschappen/GW+%7C+Impact+assessment+Geesteswetenschappen.pdf. Accessed 27 Feb 2016.

Brown, R., & Carasso, H. (2013). *Everything for sale: The marketization of UK higher education.* London: Routledge/Society for Research into Higher Education.

Collini, S. (2009, November 13). Impact on humanities: Researchers must take a stand now or be judged and rewarded as salesmen. *Times Literary Supplement.*

Collini, S. (2011). *What are universities for?* London: Penguin Books.

Corbyn, Z. (2008, January 17). Create wealth as well as art, council chief urges sector. *Times Higher Education.* http://www.timeshighereducation.co. uk/400171.article. Accessed 17 June 2011.

Crossick, G. (2006, May 3). Knowledge transfer without widgets: The challenge of the creative economy. *Lecture to the Royal Society of Arts, Leeds.*

Crossick, G. (2009, October 16–17). So who now believes in the transfer of widgets? *Paper presented to Knowledge Futures Conference,* Goldsmiths College, London.

Dassen, A., & Benneworth, P. (2011, June 23–25). Arts & humanities research between objective values and normative valuations? *Presentation to Consortium of Higher Education Research (CHER) Annual Conference, What are the prospects for higher education in the 21st century? Ideas, research and policy.* Reykjavik, Iceland.

DG Research. (2009). *European research, socio-economic sciences and humanities.* EUR23587. Brussels: DG Research. http://www.eurosfaire.prd.fr/7pc/ doc/1249290567_synopses_fp7_ssh_projects_2007_2009_en.pdf. Accessed 29 Feb 2016.

Edgar, A., & Pattison, S. (2006). Need humanities be so useless? Justifying the place and role of humanities as a critical resource for performance and practice. *Medical Humanities, 32,* 92–98.

Else, H. (2013, December 5). Horizon 2020 provision for humanities criticised. *Times Higher Education.* http://www.timeshighereducation.co.uk/news/

horizon-2020-provisions-for-humanities-criticised/2009603.article. Accessed 29 Oct 2014.

Etzkowitz, H., & Leydesdorff, L. (2000). The dynamics of innovation: From national systems and "Mode 2" to a Triple helix of University-industry-government relations. *Research Policy, 29*(2), 109–123.

Greenhalgh, L. (2013). Humanities and social sciences unsure of prospects in Horizon 2020. *ResearchResearch.com.* http://www.researchresearch.com/index.php?option=com_news&template=rr_2col&view=article&articleId=1338335. Accessed 29 Oct 2014.

Hazelkorn, E. (2015). *Ranking and the reshaping of higher education: The battle for world-class excellence* (2nd ed.). Basingstoke: Palgrave Macmillan.

Hessels, L. K., & Van Lente, H. (2008). Re-thinking new knowledge production: A literature review and a research agenda. *Research Policy, 37*(4), 740–760.

Jump, P. (2011, March, 28). AHRC and the big society: 'You use the language policymakers understand'. *Times Higher Education.* http://www.timeshigher-education.co.uk/story.asp?storycode=415641. Accessed 17 June 2011.

Jump, P. (2015, February 19). The impact of impact. *Times Higher Education.* https://www.timeshighereducation.com/features/the-impact-of-impact/2018540.article. Accessed 22 Feb 2016.

Kickert, W. (1995). Steering at a distance: A new paradigm of public governance in dutch higher education. *Governance, 8,* 135–157.

Kickert, W. (1997). Public governance in the Netherlands: An alternative to Anglo-American 'Managerialism'. *Public Administration, 75*(4), 731–752.

Lam, A. (2010). From 'ivory tower traditionalists' to 'entrepreneurial scientists'? Academic scientists in fuzzy university–industry boundaries. *Social Studies of Science, 40*(2), 307–340.

Lee, P. (2013, October 5). Declaration urges focus on social sciences, humanities. *University World News.* http://www.universityworldnews.com/article.php?story=20131004141016572. Accessed 29 Oct 2014.

Luckhurst, R. (2011) "Exhumed tombs and legendary tales of doom" Times Higher Education, 14th July 2011, p. 25.

McCann, P., & Ortega-Argilés, R. (2013). Modern regional innovation policy. *Cambridge Journal of Regions, Economy and Society, 6*(2), 187–216.

McDonald, R. (2011). The value of art and the art of evaluation. In J. Bate (Ed.), *The public value of the humanities* (pp. 283–294). London: Bloomsbury Academic.

Medical Council. (2011). *Public attitudes survey measuring trust and satisfaction.* Dublin: Medical Council of Ireland.

Merton, R. (1968). The Matthew effect in science. *Science,* 159, (pp. 56–63). In R.K. Merton (Ed.) (1973). *The sociology of science: Theoretical and empirical investigations.* Chicago: University of Chicago Press.

Mowery, D. C., Nelson, R. R., Sampat, B. N., & Ziedonis, A. A. (2001). The growth of patenting and licensing by U.S. universities: An assessment of the effects of the Bayh-Dole act of 1980. *Research Policy, 30,* 99–119.

Nussbaum, M. C. (2010). *Not for profit: Why democracy needs the humanities.* Princeton and Oxford: Princeton University Press.

OECD. (2010). *The innovation strategy: Getting a head start on tomorrow.* Paris: Organisation for Economic Co-Operation & Development.

Olmos Peñuela, J., Benneworth, P., & Castro-Martinez, E. (2014a). Are sciences essential and humanities elective? Disentangling competing claims for humanities' research public value. *Arts and Humanities in Higher Education,* first published on May 14, 2014 as doi:10.1177/1474022214534081.

Olmos-Peñuela, J., Castro-Martínez, E., & D'Este, P. (2014b). Knowledge transfer activities in social sciences and humanities: Explaining the interactions of research groups with non-academic agents. *Research Policy, 43*(4), 696–706.

Plumb, J. H. (1963). Introduction. In J. H. Plumb (Ed.), *Crisis in the humanities* (pp. 7–11). London: Pelican Originals.

Popp Berman, E. (2011). *Creating the market university: How academic science became an economic engine.* Princeton: Princeton University Press.

RCUK. (2011). RCUK pathways to impact frequently asked questions. London: Research Council UK. http://www.rcuk.ac.uk/RCUK-prod/assets/documents/impacts/RCUKImpactFAQ.pdf. Accessed 23 Oct 2014.

REF2014. (2010). *Research excellence framework impact pilot exercise: Findings of the expert panels.* A report to the UK higher education funding bodies by the chairs of the impact pilot panels. http://www.ref.ac.uk/media/ref/content/pub/researchexcellenceframeworkimpactpilotexercisefindingsoftheexpertpanels/re01_10.pdf. Accessed 29 Oct 2014.

Small, H. (2013). *The value of the humanities.* Oxford: Oxford University Press.

Spaapen, J., & van Drooge, L. (2011). Introducing 'productive interactions' in social impact assessment. *Research Evaluation, 20*(3), 211–218.

Spaapen, J., van Drooge, L., Propp T., van der Meulen, B., Shinn, T., & Marcovich, A. (2011) Social impact assessment methods for research and funding instruments through the study of productive interactions between science and society. *SIAMPI Final Report.* http://www.siampi.eu/Content/SIAMPI_Final%20report.pdf. Accessed 25 Feb 2016.

van Vught, F. A., & Westerheijden, D. F. (2010). Multidimensional ranking: A new transparency tool for higher education and research. *Higher Education Management and Policy, 22*(3), 1–2.

Veltri, G. A. (2011). Trust and dialogue between science and society. In Europa (Ed.), *Innovation Union Competitiveness report 2011,* Brussels: European Commission. Accessed from: http://europa.academia.edu/GiuseppeAlessandroVeltri/Papers/681962/Trust_and_dialogue_between_Science_and_Society

White, J. (2011, June 5). Students must now choose between learning and earning. *New Statesman*, http://www.newstatesman.com/education/2011/06/students-university-learning. Accessed 25 July 2011.

Wilsdon, J., & Wills, R. (2004). *See-through science: Why public engagement needs to move upstream*. London: Demos.

Wilsdon, J., Wynne, B., & Stilgoe, J. (2006). *The public value of science: Or how to ensure that science really matters*. London: Demos.

The Public Value of Arts and Humanities Research: National Experiences and Stakeholder Views

CHAPTER 3

Norway: Stability and Change in Science Policy: Challenging the Boundaries of Humanities Research in Norway

A Crisis in Norway?

In an international perspective, Norway is a somewhat odd country. Large parts of the world have been struck by a serious financial crisis with severe implications for employment and growth and also for research budgets. In Norway, high prices until 2015 for raw oil and natural gas implied a continuous economic growth for close to two decades. Research and education have been high on the priority list of all governments, and public expenditure on research has increased by more than 8 % in real terms *every year* since the millennial change. Humanities research has grown too, at around the same level as the average for public science, and the number of people involved in it is much higher in 2016 than just ten or twenty years ago.

This does not mean that humanities researchers (or their colleagues in other fields) are happy about the situation. There has been a recurring public debate about the value, role and financial-organisational situation of the humanities, much more so than about any other field of research. Strong voices have called out warnings against developments and perspectives in contemporary science policy, often seen as instrumental and with too strong weight on applied and short-term research and impacts. The debate has partly taken place within the humanities community, but policy-makers and users have also participated. "Crisis" has been a frequently used word to describe the situation in the humanities. The crisis rhetoric has also been used for societal changes in a broader setting, for

© The Author(s) 2016
P. Benneworth et al., *The Impact and Future of Arts and Humanities Research*, DOI 10.1057/978-1-137-40899-0_3

example, related to climate change and the environment, integration of immigrants and health and social service challenges related to an ageing population and a public health system under stress. Some of these crises have been tied to the humanities—in the sense that humanities research and perspectives are seen as essential for understanding and providing potential solutions to some of the societal issues.

Even if Norway deviates from the story of strained science budgets and financial crisis, at least until the 2015 downturn in the oil and gas industry and related supplier industries, it is not an irrelevant case. Quite on the contrary, it may serve as a good example of the challenges for researchers in a situation of expansion and increasing budgets. For humanities researchers in Norway, as well as for their colleagues in other fields, a central task has been to ensure that their field gets a fair share of the extra funding, probably requiring a more offensive strategy than in a country facing budget cuts. There are furthermore many similar characteristics between Norwegian science policy and that found in other countries. Emphasis on grand societal challenges, innovation, excellence and impact are trends seen in many parts of the world.

Gieryn (1983, 1999) has used the concept of "boundary work" to highlight the ideological and identity-building work of scientists to "distinguish their work and its products" (1983, p. 783) from non-scientific work in order to gain material and symbolic resources and (a certain degree of) autonomy. For humanities researchers, there is a continuing need to highlight the uniqueness of their own disciplines, not only when compared to non-scientific work but also when compared to other fields of research. In the current funding climate, they also need to demonstrate the usefulness of humanities research for solving the grand and wicked problems of society. The concept of basic research, which is central in the debate about the humanities in Norway, is flexible in this respect. Calvert (2006) has shown how scientists engage in "double boundary work"; they use some characteristics of research when applying for funding to demonstrate that it is useful and relevant, yet at the same time highlight how the research remains "pure" and curiosity-driven to uphold a more traditional organisational and financial situation.

A boundary work perspective implies viewing the distinction between humanities research and other activities and disciplines as something that does not "emerge naturally" but is actively constructed in the science policy debate as well as in the activities of humanities representatives. This chapter will show how boundary work plays out in the humanities in the Norwegian

context of increasing research budgets but also increasing demands for relevance and accountability. It draws on interviews with 29 researchers and other stakeholders (policy-makers, users and contractors of humanities research in different sectors), analyses of policy documents and analyses of the public debate in various newspapers and magazines. The aim is to highlight central dimensions in the debate about the role of the humanities rather than to try to cover everything that has been written and spoken.

With this multi-faceted perspective on crisis as a backdrop, the next section discusses briefly what "humanities" refers to in the Norwegian context, including a short historical review of the field's development, identity and funding. The subsequent section deals with the challenges to the field as seen through changes in the research environment, evolution of Norwegian science policy and the humanities debate. In the final part of the chapter, the outcome of these processes is analysed.

The main conclusion is that the boundary work of humanities researchers in Norway has been largely successful. We can find all the three responses to the rise of the impact and innovation agenda outlined in Chap. 2—rejection/critique, compliance and hyper-adaptation—among the Norwegian humanities researchers. Especially the latter strategy aiming to significantly influence indicator systems and funding initiatives seems to have had important effects. New funding mechanisms have been set up that specifically target the humanities, and the disciplines' characteristics have been taken into account when designing a new results-based funding system for publicly funded research. Perhaps paradoxically, these developments have also led to weaker boundaries between the fields of science. With fairly large research council programmes targeting the humanities and with successful scores in the publication count system, there seems to be less need for viewing the humanities disciplines as something that deserves special treatment. This seems to lead to continued tensions and debate, not least within the humanities community itself, and a new Government White Paper is planned specifically about the humanities.

DEFINING, DEMARCATING AND DESCRIBING HUMANITIES IN NORWAY

Norway is not very distinct from other countries when it comes to building up a public research system, but it was to some extent a latecomer with the first university (Oslo) started in 1811, the first and to some extent only technical university started in 1910 (Trondheim) and basic funding

for research only appearing significantly after WW2 (see Gulbrandsen and Nerdrum 2009; Skoie 2005). Barely two generations of Norwegian scientists have seen systematic research carried out within an organisational framework catering for more than tiny elites.

Humanities in the Research System and Society

Humanities were a central part of early public science. Since Norway is a fairly young nation, released from Danish rule in 1814 and (a weaker) Swedish rule in 1905, the first higher education institutions, in particular, the University of Oslo, were important for the nation-building process of the country. History and language were essential for national culture and self-confidence and were taught from the beginning at the University of Oslo alongside philosophy, theology and other humanities subjects.

Applied and mission-oriented research is about as old as the higher education sector with early activities and research institutions within geographical mapping, geology and fisheries (eighteenth and early nineteenth centuries), leading to pioneering studies within emerging fields such as ocean science, fisheries and meteorology. In the three decades after WW2, a large number of applied and mission-oriented research institutes were started focusing on technology, natural science and social science; medical research was strongly supported in the largest hospitals. This is an important boundary for the humanities: unlike all other fields of research, the humanities were and are still mostly found within the higher education institutions rather than elsewhere in a heterogeneous research system that embodies a century-old tension between curiosity-driven and needs-driven R&D activities.

In the first growth period of Norwegian research after WW2, there were two main funding channels: basic funding and research council funding. Both displayed a strong and regular expansion over several decades, corresponding to a general increase in public budgets, growth in student numbers and a political deal which allocated a proportion of the national lottery income to the basic research council. Four more research councils were started, oriented at industrial development (and natural science and technology), agriculture, fisheries and social science. For the humanities researchers, the basic research council was the only major external source of funding. Few questions were asked about utility value and indicators outside the most applied research council departments.

All the research councils were merged into one in 1993, the Research Council of Norway (RCN). It has gone through several reorganisations

and includes a humanities department within the larger Division of (Basic) Science. The most important RCN funding instruments were from the beginning large-scale thematic programmes, often oriented at pressing societal issues and important areas of specialisation for the private and public sector. From the early 2000s, centre funding schemes (Centres of Excellence, Centres of Research-Based Innovation, Centres of Renewable Energy) have become more important, with the centres of excellence open to all fields of research including humanities. Again there is a clear boundary between humanities and most other fields of research, which have had stronger advocates in the research council system and tailored programmes and other funding mechanisms.

Still, the period after WW2 also for humanities researchers implied three decades of steady growth in public funding and opportunities for applying for extra grants from the basic research council. But the first post-war decades had the natural sciences and technological disciplines as an ideal for scientific work, and the humanities and much of the social sciences struggled to gain acceptance for uniqueness and for alternative methodologies and approaches to the main hypothetical-deductive methodology from the hard sciences. In Norway, this took the shape of the so-called "positivism debate" (see e.g. Asdal 2004). Philosopher Hans Skjervheim wrote several widely read and debated essays, arguing strongly for a distinction between the "sciences about nature" and the "sciences about human beings". The first essay—"Participant and Spectator"—was published in 1957, but the debate continued for many years; the essay was reissued in the 1990s and has consistently figured on lists of the most important non-fiction Norwegian writings. Skjervheim's and others' critique of positivism—in this sense the idea that society can be governed by results derived from science and that only results based on hard science methodology are valid—became widely accepted and created a new ideology for parts of the humanities and social sciences. This was unquestionably important for these fields in developing a distinct identity and a greatly increased self-confidence when meeting society's demands and ideas about science. But the strong arguments used in the positivism debate also contributed to creating divides. This was not just a "two cultures" type of divide between the soft and hard sciences, but also a divide within the soft sciences that may have made it difficult to maintain more hybrid positions over time. Observers have argued that the dichotomy between "human" and "nature-oriented" science has been taken a step too far, and have proposed alternative concepts (Asdal 2004).

Many humanities researchers have had a strong and visible role in Norwegian society. A good example is Arne Næss, a philosopher who was a great influence both outside and inside the academy. Initially a "neo-positivist", he changed his orientation during his career and developed a practical-political philosophy termed "deep ecology" or "eco-philosophy" which contributed to the rationale behind green parties all over the world. Næss, a successful mountaineer with an isolated cottage in the Norwegian mountains, was to a large extent a public figure. Interviews portrayed him as combining sophisticated academic ideals with strong Norwegian values of recreation in nature, sports, expeditions and nature preservation. His textbook on logics has been widely read, not least since most Norwegian university students start out with an introductory half-year course where elements from the theory and history of science and philosophy have been central. Næss' books on "the philosophy of life" which contained practical advice and reflection rooted in academic philosophy became national bestsellers, demonstrating that stringent academic analysis and theory, also from the humanities, can be directly tied to people's everyday lives.

Research Organisation and Profiles

In science policy, the boundaries between humanities research and other fields are, simply speaking, defined by the OECD Frascati Manual which describes how to collect and present statistics about the research system, and in a Norwegian classification system developed by the Norwegian Association of Higher Education Institutions. In these documents, "humanities" includes linguistics, literature, cultural studies, history, archaeology, folklore studies/ethnology, musicology, art history, architecture and design, theology and religion, philosophy, and film and theatre studies. All the official numbers on personnel, funding and publications are related to this classification system. There is a large volume of publicly available statistics on research in Norway. A few figures will be highlighted here of particular relevance for understanding the position of the humanities within this larger system. To begin with, it can be noted that the largest discipline within the humanities is simply labelled as "other"—more than half of the research in the field is characterised in this manner. Looking at the classifications over time, the share of "other" has increased. This could be an indication of the large number of mergers between small departments and research groups—an aspect that could also be a source of unrest and dissatisfaction.

Many of the academics and policy-makers we spoke to mentioned that the boundaries within the humanities and between the humanities and other fields are not as clear as the statistical definitions indicate, partly due to the hybrid nature of many fields and partly due to organisational issues in the research system. There are social science disciplines that "in Norway are particularly close to the humanities", such as anthropology, and humanities disciplines that are closer to other fields, for example, architecture and specialities within "digital humanities". Parts of the debate about the humanities are exclusively about the humanities, other parts are about social sciences and humanities as one category. In addition, the statistics show that many people with a humanities background work in centres and departments classified as belonging to another field; these can for example be philosophers, historians and linguists who work with their background discipline within ICT, engineering and social science, or they can be humanities-trained researchers who now work in another field.

There are eight universities in Norway and more than 20 colleges. With the exception of one specialised university, all universities cover a broad range of scientific disciplines, including the humanities. In the three largest institutions—the universities in Oslo, Bergen and Trondheim—the humanities are organised in separate faculties. In all other cases, there are typically joint faculties for the humanities, social sciences and/or educational sciences. Some humanities research also takes place in museums and other units, sometimes with a university affiliation. In total, there are more than 80 museums involved, but most of them have very small research activities. There are a few rather small research institutes with humanities as a major area: the Norwegian Institute for Cultural Heritage Research, the Nobel Institute and the Centre for Studies of Holocaust and Religious Minorities. In addition, many of the large social science applied research institutes have employees with a humanities background. The size of the University of Oslo is noticeable—for example, it has more humanities researchers than all the colleges taken together. However, there is a significant volume of humanities research also at the other three "old" universities (Bergen, Tromsø and NTNU in Trondheim), and more than 100 humanities researchers also at the two largest of the new universities (Stavanger and Agder).

When it comes to research profiles, humanities researchers to a much greater extent than those from other fields define their research as "basic" (based on individual-level surveys, see Gulbrandsen and Kyvik 2010). Their closest colleagues in this respect are not the social scientists but rather the

natural scientists. This does not mean that humanities researchers are only involved in basic research; two out of three state that their research activity also has applied aims (see Kyvik et al. 2011 for more details). Almost as many state that their research includes some aspect of "development work", and 13 % report that this is the predominant label for their activities. This shows the great heterogeneity within the humanities field; some disciplines and specialities are more applied than others, and there are individual-level choices and combinations of different profiles and activities. International comparative data show that Norwegian humanities researchers are more oriented at basic research and less oriented at "socially relevant research" than similar respondents in other countries (Bentley et al. 2015). Figure 3.1 shows the dominant form of research activity in each field.

Funding and Personnel

With respect to funding, it is somewhat difficult to make comparisons because the humanities are spread out on a number of different units in the research system. The statistics manual assigns research expenditure to a department/other unit based on the majority of the work done in that

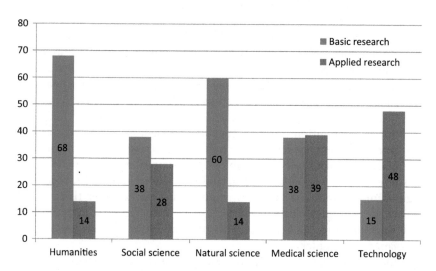

Fig. 3.1 Dominant research activity in each field of science in Norway (development work omitted). Share of all university researchers based on survey (*Source*: Kyvik et al. (2011))

unit. This is especially relevant for humanities research, which is often found together with other disciplines. If a research unit contains humanities research—for example, related to ethical, historical or design/architecture issues—but only as an addition to a main activity found in another field of science, the whole unit's research will be counted as falling within the dominating field even though the humanities part may be significant. This means that mergers and other reorganisations may influence the official data on funding, although the underlying activities might not have changed. For all participants in a debate about a crisis in the humanities, the numbers offer ample opportunities for painting a positive picture or displaying a more negative one.

National expenditure on humanities research in the public sector amounted to around €200m in 2013, which constituted around 8 % of the total, a share that has been fairly stable over the last decade. The field of humanities is the smallest in terms of funding, of a similar size to the category "agriculture, fisheries and veterinary medicine", slightly less than half the size of natural science and social science and about one-third of the size of "medicine and health" and engineering/technology.

Table 3.1 displays the annual nominal growth in the period 1995–2013 for public research for all fields of science in Norway. As can be seen, there has been a tremendous increase in funding of public research across shifting governments. The table shows that the humanities are doing relatively well in terms of funding increases, significantly above the average in the first half of the period, slightly below in the second half and slightly above

Table 3.1 Yearly growth in funding of public research in Norway 1995–2013, by field of science

	Yearly growth 1995–2003 (%)	Yearly growth 2005–2013 (%)	Yearly growth 1995–2013 (%)
Humanities	15.40	14.26	14.83
Social sciences	15.44	15.72	15.58
Mathematics/natural sciences	4.93	12.53	8.73
Engineering/technology	7.62	15.31	11.46
Medicine/health	14.56	26.03	20.29
Agriculture/fish/veterinary medicine	17.64	8.29	12.97
Total	10.51	16.12	13.32

Note: This is nominal growth. Adjusted for inflation, salary increases etc. the numbers would be around half of what they are in this table (*Source*: NIFU R&D statistics (www.nifu.no))

for the whole period. Medicine and health is the field with the greatest increase, particularly since 2005. This is most likely due to a complete reorganisation of the public healthcare system. Four large regional healthcare organisations were established in 2001, and they have over time made considerable increases in their allocation of research funding. At the other end of the scale we find the natural sciences, with a weak growth in particular in the first half of the period. This is also seen for the technological disciplines, which probably reflects the more direct link between student numbers and research funding in this period. Finally, it can be noted that the growth figures for the humanities are very similar to those in social science, a field which traditionally has had strong support in Norway.

A few other aspects of funding of humanities research should be mentioned. First, this field has a higher share of block grant funding than any other field, reflecting that the humanities is concentrated in the university and college sector and that it has a somewhat lower share of external funding. Second, the Research Council of Norway is behind around half of the external funding within the humanities, followed by funding from ministries and other government bodies (around 30 %). Some of it comes from industry (around 10 % of the external funding) and from other national sources, while funds from the European Union is negligible. The reasons are not clear, but are probably related to the thematic profile of EU funding and a general low level of EU funding in Norwegian universities and colleges.

Although the long-term trend is that basic university funding has gone slightly down in favour of competitive external funding, Norway still has one of the highest shares of basic university funding in the OECD area (see Gulbrandsen and Kyvik 2010). External funding increased particularly in the 1980s and early 1990s, but the share of basic funding has been stable since the end of the 1990s. The general (block grant) university funding consists of two parts. One is a basic grant that remains fairly stable over time. The other is a results-based part where the main indicators are related to numbers of students and productivity in teaching, that is, how many students finish their degrees/study points on time. Another set of results indicators is related to research, including research council funding, funding from EU programmes, PhD student completion and scientific publications.

If we look at the personnel, humanities research is a larger field in terms of number of researchers than all the other ones except social science and medicine and health. Funding in natural science, technology

and agriculture is related to more expensive infrastructure and a higher number of support staff. In the humanities there is therefore a greater number of people fighting over, relatively speaking, smaller sums of funding. When we look at who the researchers are and compare to the average, it can be noted that humanities research has a higher proportion of women, a slightly higher proportion of full professors, a lower share of research fellows and a significantly lower share of researchers with a doctoral degree. They are, furthermore, three years older than the average. This may indicate different career patterns in the humanities compared to the rest. There is also a strong tendency that the full professors work in the universities while the lower ranks of personnel work in colleges and research institutes, unlike other fields where the seniors are more spread out. It can be added that although there are more women in the humanities, their share in senior positions is almost as low as the average in Norway.

Humanities Seen Through Numbers

Basic definitions from the OECD Frascati Manual used for gathering statistics on research, as well as the statistics themselves, may seem trivial. Much of the debate about the humanities does not refer to numbers like this, although many participants in the debate—also in Norway—present claims about decreasing funding over time and/or relatively to other fields. This section has looked at some of the figures and some of the large-scale historical developments to see how we can recognise the humanities and what the field's main characteristics are, and through this try to understand why there seems to be a fairly widespread conception of a crisis.

A first point to note is that humanities research is both spread out and concentrated. It is concentrated in the higher education sector with less research activity outside of this sector than what is found in any other field, and it is very much concentrated in the largest universities. But humanities researchers work in many different parts of this sector and in a large number of museums and research institutes, and many of them seem to be attached to research units within other fields. The main classification of humanities research is "other" rather than linguistics or history (two of the largest disciplines), showing that the humanities departments and centres are unique and heterogeneous.

Secondly, the humanities are often a close organisational and intellectual neighbour to the social sciences. Many research departments and faculties

combine these two fields, especially outside of the largest universities, and they have had a similar development in terms of funding. Interviewees gave numerous examples of areas that combine humanities and social science perspectives and methodologies, from disciplines like social anthropology to sub-fields of media studies, sociology, psychology and others. But in some other respects the humanities are similar to the natural sciences. Both these fields have a strong emphasis on basic research and on the international dimension of research activities. As such the humanities seem the furthest away from medicine and health and the technological disciplines, although the interviewees gave many examples of connections here as well.

Thirdly, humanities constitute a small research field in the overall system, even when we only look at the public side of it. The field receives around 8 % of the total funding (excluding industrial research), but it contains almost 15 % of the researchers. However, the growth the last fifteen years has been significant and above that of the national average. There is no general indication that policy-makers have become less interested in funding the humanities, quite on the contrary. But there are some signs that fields that may be seen as close to national problems and interests such as medicine/health and technology/engineering, have been given particular priority in the most recent period. This may reflect policy shifts towards "grand challenges" and "innovation". But humanities research has grown slightly more than the average, and some external observers have found the crisis rhetoric puzzling in light of this.

But the sense of a crisis is not necessarily related to funding alone. On the organisational side, mergers could create uncertainty and may generally not be welcomed (by all involved). The concentration of humanities in universities and colleges and their stronger dependency upon internal funding may on the one hand be seen as beneficial if it implies less vulnerability to success in external competitions for funding. On the other hand, it may reflect fewer external opportunities and a vulnerability to tough internal university politics and strategic decision-making. A general funding increase moreover does not mean increase for everyone, and the many linkages between humanities researchers and others means that there are plenty of comparisons with fields and research units that may be better off in the current funding climate. Some may feel a relative deprivation even in a situation of overall funding increase, and the increase itself creates opportunities that may require coordinated and complex responses from the humanities community.

CHALLENGE TO THE HUMANITIES FROM SOCIETY

A central explanation for crisis and discontent, and probably not just in the humanities, is related to external changes in the way science is governed and funded. This has been expressed through changes in the research environment and the science policy landscape, trends in various policy documents and opinions in the public debate.

Users, Quality and the Third Mission

From the 1970s, the Norwegian research funding system came under pressure from public budgetary constraints, the expansion of a regional college system, and not least the strong needs related to the build-up of oil and gas related activities in the North Sea. Imbalances were seen in the higher education system; there were thousands of vacant positions for engineers and natural scientists, while a worrying number of graduates from the social sciences and particularly the humanities faced a labour market with few relevant job openings (Gulbrandsen 2011). Critical questions were asked about whether the system produced the knowledge and candidates that the country really needed.

In the 1980s several fundamental shifts happened in the research system. First, there was a decline in basic funding to the universities, colleges and research institutes, increasing the competition for acquiring external resources. Second, there was a significant increase in targeted public funding to broadly defined national priority areas such as health and energy, accompanied by large-scale and often fairly applied research programmes in these areas, Third, the status of the universities and colleges changed. They gained more autonomy, including responsibilities for hiring scientific staff (which until then had been regulated by the ministry), and they were formally given a greater responsibility for ensuring that their research would benefit society. The special protected status for professors was removed, making them into regular civil servants. Finally, there was a strong growth in industrial R&D and consequently a sharp increase in the volume of industrial contract research in the public research system. This was predominately related to the oil and gas industry, but the spread of computers and information technologies also fuelled private investments in research, as did the emergence of other science-based industries such as fish farming.

Already in the 1980s it was clear that the humanities lacked both an "industry" and a strong ministry, a situation which continues to this day.

Firms have indeed expressed interest in humanities perspectives and knowledge, mostly large manufacturing and service firms operating in international markets. But the cultural industries did not and perhaps could not play the same active user and funder role as firms in other industries did for research in natural science, engineering and parts of social science. And the Ministry of Culture has generally not been very interested in research activities compared to, for example, increased funding for the performing arts, and it has only recently become interested in scaling up support for research.

Science parks and other mechanisms for increased university–society interaction were established from the second half of the 1980s. Despite their technological and life science orientation, it was often expressed that the humanities and social sciences were "also important" for innovation. For example, an incubator set up to support new firms oriented at arts and humanities students was established in Oslo in the mid-1980s. The University of Oslo's Rector during most of the decade, theology professor Inge Lønning, expressed that the university's goal should be "to make sure that every top management group in Norway's firms includes at least one philosopher" (Gulbrandsen 2011). Although one cannot say that this ambition succeeded, the underlying message was that the university research community wanted the humanities to be part of the new initiatives related to the science parks and other innovation support.

Fluctuating student numbers have led to variations in research budgets for the many small departments in the field. This has led to reorganisations and mergers to create larger humanities departments, especially within the big universities. Another rationale for the reorganisations has been the term "quality", high on the agenda during the 1990s after a string of national evaluations showed that Norwegian research in many disciplines was fragmented, poorly managed and with few internationally leading units. "Is it possible to have ambitions in Norway?", Gudmund Hernes, sociology professor and Minister for Research and Education, asked in a newspaper comment on New Year's Eve in 1989. Hernes initiated a small-scale centre of excellence programme, giving one professor each from natural science, social science and the humanities a year of uninterrupted research time with a generous budget for guests and travels; this is still running alongside the much larger ten-year Centres of Excellence scheme established later. In 2003, a "Quality Reform" was implemented, incorporating major restructuring of degrees in line with the Bologna

protocol. For some academics, not least within the humanities, this led to increased teaching loads.

The last legislative changes were implemented in 2003 when two laws were altered. The Law of Universities and Colleges was changed to give the higher education institutions a stronger and more explicit responsibility for ensuring that their research "comes to use in society". It is stated that the higher education institutions shall:

- Contribute to disseminating results from research and scholarly and artistic development work;
- Contribute to innovation and value creation based on results from research and scholarly and artistic development work;
- Facilitate participation by staff and students in the public debate;
- Cooperate with local and regional societal and working life, public administration and international organisations; and offer adult/further education.

The Law of Worker Invention was also amended so that the higher education institutions gained ownership over the intellectual property rights based on employees' research results. The so-called third mission was thus expressed in new legislation and subsequently in new technology transfer offices and support programmes. It was explicitly stated that property rights did not involve books and other publications, which meant that most humanities researchers probably saw these changes as not very relevant to themselves. On the other hand, the development may have signalled to many humanities researchers that policy-makers and society at large were still not very interested in their unique contributions to society. The rhetoric of commercialisation, including patenting and entrepreneurship, seemed poorly tailored to the humanities and their understanding of personal enlightenment ("Bildung") as a major outcome of research and teaching activity, often carried out at a "critical distance" to society. There was widespread protest against the "commercialisation" of academia, and in the large university cities, academics organised torch rallies with banners arguing against what was seen as a university system moving towards domination by goals of profitability and economic utility value. Behind the protests we can probably see a complex and combined rationale of dissatisfaction with funding decline (for some), new governance mechanisms and indicators, teaching reforms and other aspects.

New Funding Mechanisms

As mentioned, the first fifteen years of the new millennium have marked a period of strong growth in public funding of science, both in terms of basic funding to universities but even more so in funding to competitive schemes in the research council. Increasingly the heading has been "societal challenges", "grand challenges" or "global challenges", and researchers in all fields have had strong incentives to relate their activities to such challenges. Overall the research council has strongly expressed that social science and humanities are needed to come up with responses to the challenges, but mainly through large-scale collaborative efforts with other fields of science.

For most of the period the main competitive funding arena for the humanities has been the open non-thematic research programme FRIHUM of the research council, an arena with very tough competition and a rejection rate often exceeding 90 %. In addition, several of the centres of excellence—a major RCN effort started in the mid 2000s, have been established within the humanities, and researchers from this field participate in calls related to "Young Excellent Investigators". The humanities' share in these funding mechanisms is similar to the field's size in the overall system. Humanities research is also found within some of the thematic programmes as well as some of the industry and innovation-oriented efforts, for example, related to architecture and design.

Based on criticism from the humanities community about lack of funding channels, a humanities-focused thematic programme—SAMKUL (cultural conditions underlying social change)—was established largely with support from the Ministry of Research and Education in 2011:

A basic assumption of the SAMKUL programme is that the humanities in particular entail knowledge and perspectives that can enhance insights into societal development and its cultural prerequisites through studies of the interaction between people and their environments. At the same time, the complex challenges to society and needs for knowledge must to a greater degree be addressed through inter- and multidisciplinary cooperation between humanities scholars, social scientists and researchers from other fields ... The SAMKUL programme does not want to overstate the distinction between basic, applied and policy-oriented research. There is no inherent tension between the SAMKUL programme's long-term focus and prioritisation of high quality research on the one hand, and the objectives to conduct research that is relevant and useful for decision-makers,

policymakers and other users as well as for the public debate on the other. The programme board regards these as complementary objectives that promote high quality in research. (RCN 2012)

SAMKUL thus represents several major trends. First, through its establishment the humanities are treated more similarly to other fields of research with its own open funding arena and its own thematic programme. Second, the programme represents a strong link between research priorities and what is seen as the major societal challenges. Third, the distinction between different types of research is problematized and there is a strong emphasis on cross-disciplinarity. Within SAMKUL the competition has been hard, with high rejection rates in most calls. The first call was made in 2012 with a total budget of around €12m, and SAMKUL is expected to run to 2020.

A final yet important change in the context of humanities research is the way the results-based funding component was changed from being based on student numbers only, to a greater number of indicators where the publication count has received the most attention by far. This was introduced in 2006 and became known as "tellekantsystemet", the "edge count system" with reference to military discipline where officers check that the clothes are neatly stacked in each soldier's locker every day. Other aspects of the results-based funding component are bonuses for attaining EU and RCN funding, completion of PhDs and completion of student credit points (rather than student numbers per se), but they have received very little attention compared to the massive publication indicator debate. The publication indicator was developed by the Norwegian Association of Higher Education Institutions (UHR) on request from the Ministry of Research and Education, perhaps an example of the consensus-oriented Norwegian policy-making model where the higher education representatives themselves are asked to suggest the practicalities of an important change in the funding system.

The basic idea behind the publication indicator was to introduce an incentive directly related to research (output) rather than just student numbers, which had been the system until then (see Sivertsen 2009, 2010). An important premise was that the system should only be used to compare higher education institutions and redistribute a small portion of their basic funding (around 0.7 % of the total), not compare smaller units or individuals. It should also only use peer-reviewed publications (including articles, books and book chapters) and be based on a new self-reported

database rather than the existing databases such as ISI/Web of Science, which were seen as too narrow, especially related to the social sciences and humanities.

In addition, the system was set up to make a very rough distinction between ordinary and excellent publication channels. Level 1 became known as the "normal" level and Level 2 the excellent one, where around 20 % of the leading outputs for each field should be counted. A list of approved scientific publication channels at each level—journals and publishing houses—is maintained by the Norwegian Association of Higher Education Institutions. Anyone can nominate a journal to the system, and the approval and nomination to Level 2 is done by the Association's National Publication Committee in consultancy with its disciplinary boards/panels.

A journal article yields 1 or 3 points depending on level, while a book chapter yields 0.7 or 1.3 points and a book/monograph 5 or 8 points. Points are adjusted for co-authorship and multiple author affiliations—for example, if there are two authors on a publication and they each list two different affiliated institutions, each institution would get a quarter of the points. The high credit for books and the expanded list of approved publication channels were decisions made to accommodate the special character of social science and humanities. The leading Norwegian-language journal for history was also initially placed at Level 2 but later moved, while the *Scandinavian Journal of Literary Research* has remained at Level 2.

The publication indicator system has been evaluated with largely a positive result for the indicator itself but some criticism concerning in particular the distinction between levels and the effects of the point system and co-authorship adjustment on different disciplines (Aagaard et al. 2014). The evaluators highlighted in particular the favourable situation of the humanities, finding that humanities professors on average had 2.5 times more publication points than medical professors of similar age and tenure. In 2016, this led to a more complex equation for distributing points for co-authored publications, which was seen as the main underlying reason.

In other words, the publication system was designed to take the special nature of the humanities into account; the field has been the source of 15 % of all publication points in the higher education system, despite receiving roughly half of this share in terms of funding. Debates have nevertheless been tough, not least concerning the distinction between the two levels and whether the indicator is able to say anything about the quality of the work (not initially intended, cf. Sivertsen 2010). Some participants

have clearly been highly critical of a system that counts publications (or anything) at all, using titles such as "the war on the edge count system" (Grønstad 2008; Hagen and Johansen 2006; see also Sivertsen 2008). There is thus an interesting parallel between the debate about a crisis of funding and the debate about the publication indicator system. In both debates, humanities researchers are very active participants, to some extent the main and the most critical participants in the publication indicator debate, despite the fact that the results for the humanities are favourable and the field's special characteristics have been taken into account. One reason might be that the humanities faculties at the large universities early on started to use the publication indicator to allocate funding for travels and other expenses at the individual level.

Humanities in White Papers and National Plans

Increasing the overall level of national R&D investments is a shared ambition in the four Norwegian white papers on research that have been published since the late 1990s. There is a general emphasis on strengthening basic research and in the latest ones on increasing funding to the independent projects schemes of the Research Council of Norway. A recurring theme is nevertheless the usefulness of R&D in terms of industrial and societal development and the need to give priority to some areas or goals. The marine sector, medicine and health, and energy and environment represent strong priorities for at least two decades. These areas are largely tied to R&D within medicine, science and engineering. Science and engineering are furthermore given priority as fields; the 2005 white paper explicitly states that increases in basic research funding should be targeted mainly towards mathematics, science and technology. This is justified by the significantly lower growth experienced in these fields since the 1990s compared to social sciences, the humanities and medicine, as Table 3.1 shows.

While the humanities generally receive little attention, there is specific mention of the field in all the white papers. The 1999 one stresses that research has both an economic and a cultural function, and links the humanities primarily to the latter. It is argued that the main objective of the field is to improve our understanding of our own and other's culture. Humanities research is also assigned a critical role in providing us with alternative ways of understanding. This, in turn, is held to help counteract narrow-mindedness and thus contribute to an open and tolerant society. But the point is also made that the humanities matter for innovation,

with references to technological developments related to digitalisation and to the important role that the humanities together with arts, design and social sciences play as content providers in various forms of innovation. According to the white paper that was published in 2005, "[n]ew linkages between science and the humanities may be one of the key features of the scientific development of the 21st century." It states that although science and engineering are generally seen to have the greatest innovative potential, humanities and social science matter as well. Still, the issues of what makes humanities research important and which role it should play are not addressed directly. This white paper does, however, propose to strengthen research of significance to renewal in the public sector, and in this context it points to several areas and topics of relevance to the humanities, including welfare, democracy, migration and integration of immigrants. Some of these areas have seen major thematic research council programmes.

In early 2008 the research council published a national strategy for humanities research (RCN 2008) on the initiative of the Ministry of Research and Education which had noted concern about the lack of attention to the humanities in the two previous research white papers. In the strategy, humanities research is defined as the study of what, in a broad sense, it means to be human, and its value is fairly closely tied to its usefulness:

> Humanities research plays a key role with regards to welfare and development in Norway. Growth, knowledge production and value creation are commonly associated with important characteristics of Norwegian society: a high educational level, democracy and social stability. Perspectives and values from the humanities are central elements in this picture. Through the development and use of basic research, and through variation in scientific perspectives, the humanities contribute to competences that are necessary to meet central societal challenges.

Emphasis is put both on the ability of humanities-based knowledge to understand and deal with societal and cultural changes and challenges, and on the importance of the humanities in cross-disciplinary partnerships related to areas such as the environment, emerging technologies and health. Many examples of this type of research partnerships are mentioned. The strategy plan concludes that the quality of humanities research seems to be fairly good but that there are two major challenges ahead.

First, quality can still be significantly improved and the humanities—like other fields—are fragmented into many small sub-units in a multitude of institutions which is seen as problematic for improving quality. Second, the societal relevance can be strengthened by improving coordination and making stronger priorities. Four priority areas for humanities research are suggested: improved collaboration and networking, improved researcher (PhD) education and recruitment, increased overall research funding, and strengthened visibility and use of humanities research. The strategy plan for humanities research clearly represents a new social contract for this field: in exchange for increased funding, the field must demonstrate its usefulness to a greater extent and it must demonstrate that it is able to make organisational changes. It may be argued that this is the social contract found in other fields through a change that took place a decade or two earlier.

Later in 2008 Norway's first (and so far, only) white paper on innovation was published. There is hardly anything explicit on the humanities, although the white paper does stress the importance of various forms of creativity for innovation and contains several sections on design. An earlier white paper on "culture and industry" is referred to, where the cultural industries are seen as "important" but with very weak traditions for R&D.

The 2009 white paper on research is the one where humanities research receives the most attention. It points to the great contribution that research has made to our civilisation, and through this presents the humanities (and social sciences) as instrumental for understanding and solving societal challenges. It argues that the cultural and instrumental roles of research are blurred and not a fruitful starting point for funding mechanisms and other policy instruments. The humanities plan from RCN is an important reference point here.

A new set of goals for Norwegian research is the most important element of the 2009 white paper. A number of "vertical" thematic goals related to societal challenges are identified: the environment and climate, oceans, food safety, energy, health (including lessened social differences in health and high quality health and care services), science-based welfare state policies, knowledge-based industries in all parts of the country, and industrial development in particular within food, marine and maritime sectors, energy and environment, biotechnology, ICT and new materials/nanotechnology. Four "horizontal" goals are defined that are seen as important for reaching the vertical ones: a well-functioning research system, high quality research, high degree of internationalisation, and

efficient use of research resources and results. The most radical shift was the reduced emphasis of the long-standing goal of spending 3 % of GDP on R&D in favour of a stronger accent to quality and impact.

The 2013 white paper on research largely repeats the goals of the previous one, and puts an even stronger emphasis on quality in the form of "excellent" and "world-class" research units. It states that research is important for society's ability to react to changes, but also that renewal and changes in the research system itself may be necessary to realise its potential for developing innovations in the private and public sector. This white paper is the first one to deal more explicitly with teaching, normally an aspect with its own white papers. It argues that the need for quality in teaching and for developing the competences that society needs are aspects that to a much greater extent should be integrated into science policy. The problem of many temporary workers in research organisations and in particular in the universities is noted, and the white paper suggests a new tenure track mechanism to recruit "particularly talented researchers". A first attempt at this was established a short time later earmarked natural science, engineering, medicine and odontology.

The conservative government that came into power in 2013 stated that it would increase the time between white papers on research and instead develop "long-term plans" for research and higher education. The first one was published in 2015, and the thematic and science policy priorities are very much in line with the two previous white papers, highlighting in particular increased competitiveness and innovation ability, solving grand societal challenges, and developing excellent research units. Increased funding (re-emphasising the 3 % target) especially related to research infrastructure, new PhD positions and Horizon 2020-related funding are the clearest priorities, but industry-oriented programmes and support for commercialisation of research are also signalled as important. A main idea of a long-term plan is improved coordination between science and education policy as well as improved predictability for the research and education institutions. The humanities are not mentioned much in this document which is a lot shorter than the white papers, but it is several times stressed that the field "is very important" and that all fields should engage in more cross-disciplinary partnerships.

In the same year, a white paper on structural reform of the university and college sector was published, with high ambitions for mergers and larger units in the sector. The aim is that Norway in the future will have "significantly fewer" than the thirty-three independent universities and

colleges seen in 2015. The white paper describes four large-scale ongoing mergers and sets up an incentive structure for more mergers in the future. Quality, robust research units and efficient use of resources are the most important underlying aims. A white paper on quality in higher education, to be published in 2017, is expected to push for more mergers.

A comprehensive evaluation of humanities research was also announced in 2015. The last evaluation with similar ambitious was carried out thirty years earlier, and the new evaluation, expected to start in 2016 and finish the following year, will put special emphasis on impact and societal contributions of humanities research, as well as on the interplay between research and education.

Finally, a new white paper specifically about the humanities was announced early 2016, to be published in 2017. The relevance of the humanities will be the central topic in this document, and relevance is defined related to four areas. First, academic relevance: How good is Norwegian humanities research in terms of originality and international contributions? Second, to what extent do the humanities contribute to meeting society's grand challenges? Third, how can the humanities improve their relevance to working life and improve their candidate's chances in the labour market? Fourth, what is the humanities' contribution to the school system which has historically been seen as crucial? A few open meetings have been held to kick-start the work with this white paper, which will be the first one ever explicitly about one field of science.

HUMANITIES RESEARCH IN THE NORWEGIAN PUBLIC DEBATE

A central arena for the debate about the humanities has been the weekly newspaper *Morgenbladet*, which for a decade or more has published opinion pieces, articles and other news about the humanities in particular, in large periods of time every week. In some periods the "humanities crisis" has been used as the headline. This section will give a general overview and show some examples from the debate in *Morgenbladet* and other media.

The white papers on research from 1999 and 2005 were met with strong reactions from researchers and research managers within the humanities. The main criticism was that the government expressed few ambitions for the humanities and that research within this field by and large was left out of the greater science policy discussion. Limited attention to the

humanities was related to what was felt to be a strong policy orientation towards value creation in a strict economic sense. Policy-makers, it was argued, reduced research to an instrument for the state and for industry, and focused more or less only on research that could contribute directly to technological innovation and economic growth. This argument was not just related to the white papers but also, for example, to the Quality Reform in higher education.

Humanities representatives argued that their field plays a central role in preserving national cultural heritage and collective memory, and in developing historical and cultural understanding. The latter, it was stressed, is essential in today's multicultural society. It was moreover pointed out that the humanities clearly have industrial relevance and economic impact, for example through competences related to language, cultural understanding and aesthetics. Many of the points from this debate were echoed in the later white papers and the research council's strategic plan for humanities research.

A general response from policy-makers was that the humanities representatives had little to complain about. In a reply to the criticism of the 2005 white paper, the Minister of Education and Research, Kristin Clemet (conservative party) referred to statistics showing that the humanities (and social sciences) had experienced much stronger growth in funding over the recent period than the natural sciences. This, she argued, justified the explicit priority of natural science. Later contributions to the debate expressed doubts about the R&D statistics ability to reflect the research activity and opportunities within the humanities. The minister also commented that the humanities representatives had made few contributions in the process leading up to the white paper, but seemed to give priority to post-publication criticism.

The more positive and proactive view on the usefulness of the humanities found in RCN's strategic plan for the field was met with support as well as criticism. Some humanities researchers praised the council's attempts at talking about the humanities in light of societal challenges and other science policy concepts and goals. Other researchers argued that the strategy went too far in defining humanities as a "supporting discipline" for other fields of research. A central underlying problem in their view was that the humanities had not been good enough at justifying their field on their own terms and in a language of their own, and instead became subject to a terminology from other domains or spheres. The research council countered that the humanities were not viewed as supporting disciplines, but that the strategy and its many cross-disciplinary examples had sought

to identify new areas for humanities research. In addition, council representatives argued that the significance of the humanities could be understood also in how it relates to fields such as life science and emerging technologies. This debate was intense and also led to publication of a book on the nature and value of the humanities, where it was argued that the concepts of "text" and "history" are key for understanding what the field is about and how it can contribute in cross-disciplinary settings (Asdal et al. 2008).

Less criticism was seen in the wake of the 2009 white paper on research, although some humanities faculty leaders argued that the humanities yet again received "step-motherly treatment". A central point in the criticism was that the high importance assigned to the humanities in the white paper had not seemed to result in any clear and new funding commitments.

The ministry sent this challenge back to the researchers. In the spring of 2010, the Minister for Research and Education Tora Aasland (socialist party) wrote a comment in *Morgenbladet* where she encouraged the humanities and the social sciences to take a more active role when it comes to addressing the grand, global challenges related to climate, environment, energy and health. The formulation of good policies, she maintained, relies on the integration of social science and humanities perspectives into the knowledge base of policy-makers. Knut Olav Aamaas, then editor of culture and debate in the largest Norwegian newspaper, *Aftenposten*, asked why humanities researchers are not more central agenda setters. Himself a humanities PhD holder, he later criticised humanities researchers for being averse to change and too defensive. Nina Kristiansen, chief editor of forskning.no, a major publicly funded website oriented at dissemination and popularisation of research, described that she had attempted to get researchers involved to make a list of major achievements in humanities research in 2011. She felt the website was dominated by the hard sciences and wanted to draw more attention to the humanities. But her requests were met with scepticism rather than enthusiasm and a strong reluctance to perform any kind of "ranking" of research results. Other journalists echoed that they had experienced similar difficulties in getting humanities researchers to talk about "important" research results.

Deans of the humanities faculties welcomed the Minister's invitation and the challenge from the forskning.no editor but argued that the Minister's challenge would require relevant research council programmes to be made more open, for example by including humanities researchers in the development of work programmes and in boards and panels. After the

forskning.no criticism a humanities blog was established on the website with frequent presentations of research achievements in the field, often of a strong national nature.

However, a profiled humanities researcher, US-based literature professor Torill Moi followed up in *Morgenbladet* by attacking the "soulless" language of the research council and the science policy authorities. She argued that the language of the research bureaucrats with its focus on "innovation processes" and "the knowledge needs of society and industry" is so alien to humanities researchers that they have difficulties understanding what is wanted from them. Research in this field should be valued based on its methodology and object of study, not its usefulness. Within the humanities, Moi maintained, considerations of usefulness or relevance will almost always be in conflict with quality considerations, and the researchers therefore face a dilemma. This contribution spurred a lot of debate—and interviewees expressed both admiration and frustration with Moi's arguments.

In response, the Minister invited humanities representatives to contribute actively with depictions on how they view their role in the research system and society. One central response was another book, edited by a group of younger researchers at the University of Bergen (Øyen et al. 2011), aiming to formulate a "positive programme" for the humanities. Here the crisis word was not used, but the book still described a challenging change process in a situation where the traditional humanities roles related to *Bildung* and the nation state have become less relevant. A central argument in the book is that the critical and alternative perspectives offered by humanities research play a crucial and multifaceted role in modern society.

A reviewer argued that the 2008 and 2011 books were strongly adapted to the modern science policy language rather than a language that would be more useful for really discussing the future of the humanities (Enebakk 2011). He found the 2008 book to be strongly related to RCN's humanities strategy, and the 2011 book to the establishment of the plan for the SAMKUL programme, and called for a debate about the future of the field that was much sharper in its definition of what the term "humanities" encompasses and what the field's internal challenges are—more independent of what policy-makers ask for.

The debate about the humanities and whether there is a crisis or not has been rekindled every few weeks or months. Apart from the treatment of the humanities in policy documents, participants have, as mentioned, worried about the effects of the 2003 Quality Reform and possible negative effects of the publication indicator. An interviewee in a faculty leadership position

described what he called the "humanities faculty squeeze" in which tight budgets make it necessary to reallocate funds from strong research areas to smaller and weaker ones in order to keep the latter alive, which in turn leads to a general weakening across the entire field. Some humanities researchers have rejected the crisis language and the claims that only immediate and direct impacts of research are valued in the current policy climate. The SAMKUL board leader expressed in *Morgenbladet* that no one expects all research to have an economic impact, and that the debate about whether or not research has to be seen as useful is based on a false dichotomy. A new report on the value of the humanities was presented in 2014, arguing that the field represents a form of "preparedness" for crises and unforeseen societal developments (Jordheim and Rem 2014).

The debate first and foremost shows that there is significant disagreement within the humanities about the current situation and whether the major science policy trends mostly represent threats or offer exciting opportunities. Most of the participants in the debate that are not active researchers subscribe to the latter view. Many of them express strong support of the humanities, some of them also frustration about the arguments used in the debate at least by some of the participants.

Policy changes, systemic changes and the public debate highlight three different challenges to the humanities. The first can be termed the funding challenge, related to increasing emphasis on indicators, excellence and larger collaborative effort equally in all research fields, which challenges the image of the humanities' uniqueness. Innovation can be termed the second challenge, reflecting how the demands to research impact and usefulness to society have become ever stronger and more explicit. This may challenge the boundary between basic and applied research orientations, a distinction that traditionally has been more important in the humanities than most other fields. Finally, the policy challenge refers to changes in the policy system and to science policy itself, highlighting aspects such as excellence and contribution to grand challenges. This is perhaps the most central aspect of Norwegian science policy in the new millennium, and it rejects a clear distinction between science and society and a detached form of research.

A FIELD OF SCIENCE LIKE ALL OTHERS?

This chapter has shown that humanities research in Norway in many ways is a success story. It has received its share of a significant increase in funding over almost two decades, both in the form of basic funding, a share

of major new initiatives like Centres of Excellence, and a new thematic research programme targeting the humanities in particular. A new system for redistribution of basic funding based on a publication indicator was designed to take particular characteristics of humanities research outputs into consideration. The system gives a significant amount of points for books and in practice rewards publications with few authors. White papers on research have increasingly highlighted the humanities and the field's value and contributions, the Research Council of Norway has made a strategy for the field, and a new white paper will be published in 2017 which will exclusively deal with the humanities. It is clear that humanities research has many external supporters and that representatives of the field have been good at manoeuvring in the changing policy landscape, The debate shows signs of rejection/critique, compliance and adaption to a new situation.

In the beginning of the chapter, boundary work—demarcating a field vis-à-vis other fields and vis-à-vis non-research—was seen as an essential part of the identity and ideology of researchers. Changes in the science system and in policy, perhaps also the success of the humanities, have problematized some of the traditional boundaries of the field. The distinction between basic and applied research has been challenged and become less distinct, and like other fields the humanities is increasingly valued for its societal contributions rather than intrinsically or with a cultural argument. Although there are numerous examples of contributions from the humanities—many interviewees talked at length about how the Norway terrorist attacks in July 2011 had demonstrated how important new humanities insights are to the whole country—the language of these contributions seems underdeveloped. "Dissemination" appears insufficient and many are uncomfortable with "innovation", but no consensus has emerged around new terms and justifications. Parts of the lively humanities debate concerns such issues. A particular challenge emerging from interviews with users of humanities research is that they do not seem to distinguish clearly between concepts such as "knowledge", "perspectives" and "research". This creates some uncertainty about whether humanities are needed primarily for their teaching activities rather than for new and original research.

To some extent the developments can be seen as representing a new social contract for humanities research (cf. Chap. 6), and a contract similar to the one seen in other fields. There has been a process of convergence in Norway with humanities appearing more like neighbouring fields. It is found in all major funding instruments of the research council, it is

increasingly collaborative rather than individualistic, it is represented in programme boards and other arenas where science policy is implemented and shaped, and it is discussed more and more thoroughly in policy documents beyond statements that the field is "very important". The double boundary work in discussions about science, that is, striking a balance between presentations of usefulness (to gain resources) and arguments about the need for critical distance (to gain autonomy) has become as difficult and complex in the humanities as elsewhere.

This convergence and the broader inclusion of humanities representatives in all parts of the science policy system are probably important explanations for the perpetual debate about the humanities and their role and uniqueness; there is a continuing need to explore common grounds and arguments. Although the Norwegian debate shows significant disagreement within the humanities, the heated debate probably also represents a valuable discussion for maintaining a strong identity in a new policy climate.

But there are still some special features about the humanities research in Norway. Unlike other fields it is concentrated in the higher education sector and more intimately tied to the policies and politics of universities and colleges, even though leading researchers may have more hybrid roles and be engaged in many activities and organisations outside of research. The field has many friends but perhaps fewer clear users than the others, where changes in the level and organisation of industrial R&D, changes in the knowledge demands of the public welfare state and technological transformations in the health and care system are trends with strong long-term impacts on research funding and organisation in natural science, social science, technology and medical research.

With societal challenges on top of the policy agenda, the contribution of humanities research seems evident to all stakeholders for some challenges such as immigration and globalisation. But to some extent the major political issue in Norway is related to the transition from an oil and gas dependent country to something else. What the role of the humanities in this process should be, remains to be seen and debated.

References

Aagaard, K., Bloch, C., Schneider, J. W., Henriksen, D., Ryan, T. K., & Lauridsen, P. S. (2014). *Evaluaring af den norske publiceringsindikator*. Aarhus: Dansk Center for Forskningsanalyse.

Asdal, K. (2004). Positivismekritikk kontra post-konstruktivisme, Hans Skjervheim kontra Bruno Latour. *Sosiologi i dag, 2,* 27–46.

Asdal, K., Berge, K. L., Gammelgaard, K., Gundersen, T. R., Jordheim, H., Rem, T., et al. (2008). *Tekst og historie: å lese tekster historisk.* Oslo: Universitetsforlaget.

Bentley, P., Gulbrandsen, M., & Kyvik, S. (2015). The relationship between basic and applied research in universities. *Higher Education, 70*(4), 689–709.

Calvert, J. (2006). What's special about basic research? *Science, Technology and Human Values, 31*(2), 199–220.

Enebakk, V. (2011). Humanioras fremtid. *Salongen nettidsskrift for filosofi og idéhistorie.* www.salongen.no/?p=1239. Accessed 26 Feb 2016

Gieryn, T. F. (1983). Boundary-work and the demarcation of science from non-science: Strains and interests in professional ideologies of scientists. *American Sociological Review, 48*(6), 781–795.

Gieryn, T. F. (1999). *Cultural boundaries of science: Credibility on the line.* Chicago: Chicago University Press.

Grønstad, A. (2008). Eit forsøk på å oppsummere den evigvarande tellekantdebatten. *Prosa,* 1/2008, 62.

Gulbrandsen, M. (2011). Kristian Birkelands spøkelse: Universitetet i Oslo og innovasjon. In P. Anker, M. Gulbrandsen, E. Larsen, J. W. Løvhaug, & B. S. Tranøy (Eds.), *Universitetet i Oslo: Samtidshistoriske perspektiver* (pp. 275–366). UniPub: Oslo.

Gulbrandsen, M., & Kyvik, S. (2010). Are the concepts basic research, applied research and experimental development still useful? An empirical investigation among Norwegian academics. *Science and Public Policy, 37*(5), 343–353.

Gulbrandsen, M., & Nerdrum, L. (2009). Public R&D and industrial innovation in Norway. In J. Fagerberg, D. C. Mowery, & B. Verspagen (Eds.), *Innovation, path-dependency and policy* (pp. 61–88). Oxford: Oxford University Press.

Hagen, E. B., & Johansen, A. (Eds.) (2006). *Hva skal vi med vitenskap? 13 innlegg fra striden om tellekantene.* Oslo: Universitetsforlaget.

Jordheim, H., & Rem, T. (Eds.) (2014). *Hva skal vi med humaniora?* Oslo: Fritt Ord.

Kyvik, S., Gulbrandsen, M., & Bentley, P. (2011). *Forskningspraksis ved norske universiteter i et internasjonalt perspektiv: En sammenligning av 14 land, Report 41/2011.* Oslo: NIFU.

RCN (2008). Humanistisk forskning. Nasjonal strategi. Norges forskningsråd, October 2008.

RCN. (2012). *Samfunnsutviklingens kulturelle forutsetninger, SAMKUL programme plan 2011–2020.* Oslo: Research Council of Norway.

Sivertsen, G. (2008). Norsk vitenskapsindeks: Forslag til en felles database for vitenskapelig publisering innenfor et nasjonalt system for forskningsinformasjon. Innstilling fra en arbeidsgruppe oppnevnt av Kunnskapsdepartementet. NIFU Report 33/2008.

Sivertsen, G. (2009). Publiseringsindikatoren. In Ø. Østerud (Ed.), *Hvordan måle vitenskap? Søkelys på bibliometriske metoder* (pp. 11–38). Oslo: Novus forlag og Det Norske Videnskaps-Akademi.

Sivertsen, G. (2010). A performance indicator based on complete data for the scientific publication output at research institutions. *ISIS Newsletter,* 6(1), 22–28.

Skoie, H. (2005). *Norsk forskningspolitikk i etterkrigstiden.* Oslo: Cappelen Akademisk Forlag.

Øyen, S. A., Müftüoglu, B., & Birkeland, F. I. (Eds.) (2011). *Humanioras fremtid, Kampen om forståelse av menneske og samfunn.* Oslo: Cappelen Damm Akademisk.

GOVERNMENT WHITE PAPERS AND OTHER SOURCES

Stortingsmelding nr, 36 (1992–1993). *Forskning for fellesskapet*
Stortingsmelding nr, 39 (1998–1999). *Forskning ved et tidsskille*
Stortingsmelding nr, 20 (2004–2005). *Vilje til forskning*
Stortingsmelding nr, 22 (2004–2005). *Kultur og næring*
Stortingsmelding nr, 7 (2008–2009). *Et nyskapende og bærekraftig Norge*
Stortingsmelding nr, 30 (2008–2009). *Klima for forskning*
Stortingsmelding nr, 18 (2012–2013). *Lange linjer – kunnskap gir muligheter*
Letters, commentaries, op-eds and articles in *Morgenbladet* and *Aftenposten*, primarily between 2009 and 2014

National strategy for humanities research. (2008). Oslo: Research Council of Norway, Strategy document and some of the debate can be found at: http://www.forskningsradet.no/no/Nyheter/Nasjonal+strategi+for+humanistisk+forskning/1222932092154

Planning documents for the upcoming humanities white paper available at: https://www.regjeringen.no/no/tema/forskning/artikler/humaniora/id2466135/

Various documents related to the upcoming evaluation of humanities research, available at: http://www.forskningsradet.no/no/Artikkel/Evaluering_av_humanistisk_forskning_i_Norge/1254011399850

Ireland: Valuing the Arts and Humanities in a Time of Crisis and Beyond

FROM ECONOMIC NATIONALISM TO THE GREAT RECESSION

Ireland's first place of higher learning can be said to have been founded by Pope Clement V, who issued a bull in 1312 for an institution attached to St Patrick's Cathedral, Dublin. It was to follow the model of the *studium generale*, like institutions already recognised in Bologna, Paris and Oxford. Such places of higher learning were attached to cathedrals, with a curriculum comprising the seven liberal arts as well as theology. This first Irish university never flourished after officially being "opened" in 1320, however, remaining in effect a "paper university", and had disappeared by the time Trinity College Dublin (TCD) was founded by royal charter in 1592 (Rashdall 1936, pp. 324–328). Accordingly, TCD is widely regarded as Ireland's first university. Following the model of collegiate universities of Oxford and Cambridge, it differed from these in that there has only been one college, and as such "Trinity College" and "University of Dublin" are synonymous. Throughout the centuries, TCD was historically regarded as a testament to English colonial hegemony in Ireland, the intellectual mainstay of the ruling Anglican Protestant ascendancy. Although Catholics and Dissenters were permitted to enter the university from 1793, restrictions on their numbers remained until 1873 and the Catholic Church forbade its adherents from attending—without permission from their bishop—until 1970.

*This chapter was co-authored by Ellen Hazelkorn and Andrew Gibson.

89

P. Benneworth et al., *The Impact and Future of Arts and Humanities Research*, DOI 10.1057/978-1-137-40899-0_4

This was the historical backdrop to the foundation of the Catholic University of Ireland in 1851, with John Henry Newman (later Cardinal) as Rector, and other universities in Belfast, Cork and Galway. The Universities Act (1908) established the National University of Ireland (NUI) with three constituent University Colleges: Dublin, Galway and Cork; Maynooth, already a pontifical university from 1795, joined in 1910. Higher education in Ireland retained this form until economic growth began requiring more post-secondary opportunities. In terms of both form and content, this phase of Irish higher education had little of the Humboldtian focus on research and science. Indeed, in terms of their impulses, Irish higher education in this period has been characterised as "theocratic" (O'Sullivan 2006) given the religious nature of the foundation of different institutions, and the role each had in educating the sons of these denominations. Further distance from Humboldt's model can be seen in the fact that the Catholic University of Ireland (later to become University College Dublin) had Newman as its first rector. Ireland's higher education was not to be focused on research for the purposes of discovery, or economic application, or for the state, or for any other "applied knowledge". Indeed, Newman let his views be known in his lecture addresses to audiences in 1852 before being installed as Rector of the Irish Catholic University, stating that "[i]f the Catholic Faith is true, a University cannot exist externally to the Catholic pale, for it cannot teach Universal Knowledge if it does not teach Catholic theology" (Newman 1933, pp. 209–210).

Political independence from the United Kingdom came in 1922 but the pace of subsequent change was glacial. Emerging from colonial rule, political nationalism promoted a combination of cultural-religious identity and economic self-sufficiency heavily reliant on import-substitution industrialisation (ISI) and high tariff barriers (Kirby and Murphy 2011, p. 17). In the absence of a native capitalist entrepreneurial class capable of sponsoring key infrastructural and industrial projects, the state filled the vacuum by promoting, regulating, deregulating and, often, re-regulating sections of the economy. Beginning with electricity in 1929, the state became the major provider of electric, gas and turf power, rail, air, sea and road communications, telecommunications, etc. Not satisfied with stimulating infrastructural development, the state also played a formidable role in cultivating, preserving and promoting a "way of life", with the Land Commission, throughout the 1930s and 1940s, seeking to implement the constitution's vision of a country populated by small family farms.

Ireland—due to wartime neutrality, and subsequently to post-war isolation—failed to participate in the growth that marked the British and continental economies. This was attributable to two factors, namely the Catholic Church and the reigning Fianna Fáil party, neither of which desired a modern economy which would be a threat to their power bases. This amounted to a "politics of cultural defence", which left both the economy and cultural life in a state of enervation, such that "Irish intellectual life [...] hit some kind of nadir" (Garvin 2004, p. 69). By the late 1940s, it was evident that government policies, underpinned by nationalist rhetoric, had left the country reeling from composite problems of having little indigenous manufacturing, under-utilization of natural resources, small-scale and inefficient agriculture, weak infrastructure, and persistent high levels of unemployment—hallmarks of a peripheral, late-developing nation (Hazelkorn 1992). A new strategy in later decades was to mark a *volte-face* away from ISI, and tied Ireland's economic fortunes ever since towards world markets and foreign direct investment (FDI).[1] The establishment of the Industrial Development Authority (IDA) in 1949 was followed by the *White Paper on Economic Development* (1958) which laid the basis for the First Programme for Economic Expansion in 1959; a Second Programme in 1963 was based on the liberalisation of trade and incentives for FDI. It also focused on education, with a doubling of expenditures planned, though this increase was discontinued in 1967.

These developments signalled a significant move away from idealism towards embracing a pragmatic approach. They marked the beginning of a strategy that saw Ireland join the European Economic Community in 1973, and then become one of the strongest advocates for the European project, embracing the discourse and policy of the knowledge economy in the 1990s. Within two decades, Ireland was rapidly transformed from a traditional, agricultural society with a class structure based on family property to an urban society increasingly based on hi-tech and internationally traded services. In basing its economic development on FDI, Ireland became the first state in Europe, and arguably the world, to do so (Wickham and Boucher 2004, pp. 378–379), effectively bypassing the phase of industrial development, which had been concentrated in the six counties of what became Northern Ireland. The continuing legacy of FDI is seen in Ireland's export-oriented, knowledge-intensive economy, exemplified in computer services making up 42 % of total exported services in 2013 (CSO 2015).

At the beginning of the twentieth century, 3200 students were enrolled at six universities on the island of Ireland, with a strong connection between social status and university attendance. It was only after the years of consolidation with the first post-independence generation, however, that educational changes started to be felt, beginning in earnest with the *Education Investment and Planning Programme*, leading to the landmark *Investment in Education* report in 1962 (Walsh 2009, pp. 64–65). Conducted under the auspices of the OECD, *Investment* firmly connected economic growth with the massification of education. It had a transformational impact on Irish society, not only setting out an ambitious view for the future by signalling "a long-term commitment to investment in education from the 1960s, largely absent in the first generation of statehood" (Loxley et al. 2014, p. 189; O'Connor 2014). To meet the economic imperative for technically qualified people to underpin industrial development, regional technical colleges (RTCs) were created, giving Irish higher education its binary character (Hazelkorn et al. 2015). The socially "top-heavy" features of Irish higher education began to change slowly with the establishment of 14 RTCs (later Institutes of Technology; henceforth IoT) and two National Institutions of Higher Education (NIHE) in Limerick and Dublin (later University of Limerick and Dublin City University, respectively), between 1970 and 2000 (Barry 2014, p. 218). These new institutions were intended to respond to economic, labour market and demographic demands. They shifted the focus of teaching and research in a more utilitarian direction, away from the historical habitus of the laissez-faire of non-interference. As of 2013/14, 45 % of all full-time undergraduate students are in this institute of technology sector (successor to the RTC system).

These developments paved the way for the government's firm embrace of the knowledge economy paradigm, which, along with membership of the European Union and the access to structural funds, underpinned the Celtic Tiger phenomenon and defined the next stage of Irish higher education. Labour shortages and international competitiveness were already causing concern, however. Whereas at one point higher education was merely viewed "as a source of skilled technical labour, after 1995 reports from the government's educational and industrial development arms stressed the importance of higher education to economic growth" (Harpur 2010, p. 77). To address these needs and to increase the supply of human capital, tuition fees were halved in 1995 and then abolished in 1996. But recognition of the strategic importance of human

capital development was only part of the story; the other component was research. However, prior to 2000, Ireland had neither a national research policy nor an investment strategy; researchers accessed limited opportunities at home or via EU programmes but had little domestic status or international reputation.

The *Programme for Research in Third Level Institutions* (PRTLI) (1998–2015) marked a historic turning point. First, it was the beginning of a period of concerted government funding for research, with a total amount of €1.2 bn invested (of which almost 15 % came from Atlantic Philanthropies). Compared with peers elsewhere, Irish higher education lagged behind, being one of the worst supporters of HERD of all OECD countries (Harpur 2010, p. 66). Second, it anticipated subsequent investment that would be based, as in other countries, on a reciprocal commitment from both government and higher education to "redefining and reshaping the knowledge base of Irish society" (Lindsey 1996, p. 2). Third, PRTLI under the direction of the Higher Education Authority (HEA) affirmed the vital association between higher education and university-based research in contrast to others in government who argued for a stronger link between research and the economy through the creation of independent research organisations.

Two new research councils were established, also under the auspices of the HEA, in 2000, the Irish Research Council for Science, Engineering and Technology (IRCSET) and the Irish Research Council for Humanities and Social Sciences (IRCHSS), initially with an annual budget of around €24 m and €10 m, respectively (Dagg 2006). This was followed by Science Foundation Ireland (SFI) in 2001. Funding of €144 m was allocated via a Strategic Innovation Fund (2006–2013) to support research effectiveness and quality, as well as enhancing collaboration, improving teaching and learning, and supporting institutional reform and lifelong learning and fourth level education.

The global financial crisis of 2008 and ensuing collapse of the Irish economy and the Great Recession brought this golden decade of higher education and research investment to an abrupt end. In place of broadening the intellectual base, fundamental questions were asked about its purpose and relevance. The changed circumstances are reflected in several major policy initiatives and in an effort to rebuild the country's economic infrastructure, employability and jobs became the dominant themes—with significant implications for higher education and research, but especially for the arts and humanities.

CHANGING ATTITUDES TO THE ARTS AND HUMANITIES

In the modern era, Ireland and Irishness was a historical, linguistic, and cultural reality long before it became a political one; this is a legacy of Ireland's tumultuous history. The Irish literary scholar Kiberd (2001, p. xiii) expands on the cultural implications of this, to note that "[b]ecause there were two powerful cultures in constant contention in Ireland after 1600, neither was able to achieve absolute hegemony. One consequence was that no single tradition could ever become official". This remained so up until independence in 1922 when the balance shifted. A new vision was being articulated in the "Irish Literary Revival" by members of the Gaelic League, to define through culture a sense of Ireland distinct from its place of the United Kingdom. As a poet, playwright, and founder of the Abbey Theatre, but also a Senator in the new Saorsát Éireann (Irish Free State 1922–1937), W.B. Yeats exemplified how the political interacted with the artistic and literary to such a degree that it could be said that the reputation of Ireland and of its accumulated cultural achievements became synonymous. Eoin MacNeill, another figure from the literary revival and co-founder of the Gaelic League, went on to become the State's first Minister of Education, started his professional life as professor of Early Irish history in University College Dublin (UCD), and remained engaged with scholarship throughout his political career. The A&H were not simply the forms through which notions of Irishness were expressed; political independence and the subsequent civil war meant that the A&H had an early instrumental purpose in terms of cohering the new state and its transition toward what would become the Irish Republic (declared in 1948).

School curricula for the Irish Free State were designed with the A&H strongly in mind; Irish language, Irish music, Irish dance, Irish literature and poetry, and Irish history occupied a central role, integral to defining the new state to itself, as much as to the outside world. The *National Programme of Primary Instruction* (1922) pronounced on the importance of history as a primary school subject:

> One of the chief aims of the teaching of history should be to develop the best traits of the national character and to inculcate national pride and self-respect. This will not be attained by the cramming of dates and details but rather by showing that the Irish Race has fulfilled a great mission in the advancement of civilisation and that, on the whole, the Irish nation has amply justified its existence. (NPC 1922)

This was to be part of a radical overhaul of the primary school curriculum where the A&H were given a central role (via Irish history, language, culture, music, etc.) as a means to emphasize the distinctiveness of Irish culture, and redress an imbalance which had marginalized the importance of Irish history, language and culture in general. This was in line with the political activist and leader Patrick Pearse's desire that Ireland should "not be free merely, but Gaelic as well" (1916, p. 135). The official government policy to reinvigorate the Irish language reflected this, and remained a central element of primary and secondary education policy for many years. Indeed, it was arguably the *only* education policy up until the 1960s, excepting the maintenance and some expansion of the existing system (Walsh 2009, p. 2; Brown 1985, p. 47, 248). A counter-example to this minimalist approach was the establishment of the Dublin Institute for Advanced Studies in 1940. Modelled on the Collège de France (Ó Buachalla 1988, p. 110) and the Institute for Advanced Studies in Princeton, it was composed of a School of Celtic Studies and a School of Theoretical Physics, with a School of Cosmic Studies later established in 1947. As an example of equal importance being given to science and humanities within a government policy, it remains somewhat unique.

A divergent feature was the way in which this hegemonic, religious (which is to say Catholic), nationalist ethos pervaded and dominated public discourse. The new state viewed culture with a mixture of suspicion, caution and paternalism. One of the government's first actions was the Censorship of Film Act in 1923, followed shortly by the Censorship of Publications Act in 1929. These acts were the result of lobbying by a group calling themselves the Catholic Truth Society of Ireland (CTSI), an organisation with strong connections to the Catholic hierarchy, who believed that Ireland had been "corrupted by centuries of imperial domination and the temptations of modernity" and that "where politics and religion are in conflict religion is right and politics is wrong" (Keating 2014). There was a certain irony to this approach because the vacuum was filled by an

> Anglo-American domination of popular taste ... exercised through the cinema [almost entirely British and American]...When all this is taken into account, the accepted picture of a cultural chauvinistic statelet shutting its doors (and windows) on international culture turns out, in several respects, to be almost the reverse of the truth. Instead, Ireland, badly in need of a [sic] developing national culture of her own, was hopelessly outgunned by

external forces – mainly commercial – over which her leaders had little con-
trol, and few institutions or public bodies knew how to combat…effectively.
(Fallon 1998, p. 11; see also Byrne 1997)

There was also a strong elitism underpinning the whole approach to cen-
sorship. Hardback books (more expensive than popular paperbacks) or
membership-based film societies could easily circumvent the regulations.
By 1942, 1500 books had been banned, and in 1954 a record was set for
the number of books banned in one year at 1034. The list of censored Irish
authors reads like a who's who of Irish literature: Joyce, Beckett, Shaw,
O'Casey and others (Ó Drisceoil 2005; Brown 1985, p. 198). Another
example of this political will to exert control over the cultural sphere can
be seen in the Dance Hall Act of 1935, which prohibited "unlicensed"
dancing, prohibiting both the popular folk *sean nós* style of dancing and
commercial dance hall dancing (Kuhling and Keohane 2007, p. 90).

Economic protectionism might have seemed justifiable in the context
of the 1930s and '40s, but it gave way to a growing cultural isolation-
ism and intellectual malaise, all the stronger given Ireland's island status.
In educational terms, though the humanities were given greater empha-
sis than science in schools, these humanities were understood through
religion—namely Catholicism. In the state's eyes, this meant that the
considerable achievements of Irish writers in the English language were
underemphasised or ignored, which fed a theory "that Irishness was only
to be found within the Gaelic tradition" (Kiberd 1996, p. 555). There
were some notable exceptions to this situation, however. *The Bell*, a liter-
ary magazine, was founded in 1940 by Seán Ó Faoláin, whose own 1936
novel *Bird Alone,* was banned by the censorship board. In its first edi-
tion, Ó Faoláin set out the mission of the new magazine: "Gentile or Jew,
Protestant or Catholic, priest or layman, Big House or Small House – *The
Bell* is yours". *The Bell* was distinguished by its outspoken criticism of
censorship, Gaelic revivalist ideology, clericalism, and general parochialism
(McAuliffe 2011). To what extent this message received a wider audi-
ence is to be questioned, given the alternative cultural view of the period
provided by essayist Stephen Gwynn which suggested that "men – and
women – in Ireland read very little […] talk is their literature" (Brown
1985, pp. 42–43).

In the realm of policy, official commitment to enacting the Irish lan-
guage policy gradually waned. As far back as 1936, the Irish National
Teachers' Organisation, the largest teachers' union, noted that a stringent

interpretation of this policy was detrimental to the growth of the language, but this observation was not acted upon due to a divide between policy-makers and educationalists (Brown 1985). The benefits of living in a society in which English was the language of business and society (not to mention, after the Second Vatican Council, the language of religion for the majority of the state's Catholics) became increasingly obvious. Today, it remains an educational requirement until the junior certificate at age 15, but only 9 % of the Irish-born, adult population regard themselves as fluent or very fluent, out of a total of 47 % who regard themselves as having some proficiency in the language (Mac Gréil and Rhatigan 2009). There have been efforts to re-energise Irish via Gaelscoileanna (schools where Irish is the medium of instruction), but they are primarily a manifestation of middle-class demands for an alternative educational mode rather than a concerted effort to reinvigorate the language.

Despite Ireland's contribution to the arts, they remained rather isolated, on the "outer rim of Europe, outside most of the great movements ... follow[ing] its own rules, or rather lack of them..." (Fallon 1998, p. 237). In 1746 "a little academy for drawing and painting" had been founded in Dublin (later to become the National College of Art and Design). In 1924 it came under the control of the Department of Education, from 1936 it was able to issue diplomas, and on its two hundred and fiftieth anniversary it was given "recognised college" status by the Senate of the National University of Ireland (NUI n.d.). In 1969 a law was passed to exempt Irish artists and musicians from income tax—a move designed to encourage international artists to take up residence as well as encourage Irish artists to remain—but these initiatives had limited spill-over impact on wider society.[2] There are the state organisations such as the Arts Council and Culture Ireland, which, respectively, exist to promote and support Irish artists at home and internationally. Aosdána was established in 1981 as a peer society for artists that have produced a distinguished body of original and creative work.

The role played by humanities—not to mention the arts—has not always found sufficient support within the academy, alongside simmering misunderstandings about what constitutes arts or humanities research, and an underlying elitism. In past decades, the expectation was that though a student may pursue their undergraduate studies in Ireland, opportunities beyond this level would have to be found elsewhere.

I studied Irish and English in Trinity College. When I finished there in 1973, I wanted to do postgraduate work and I was told by everyone that

I needed to go to Oxford or Cambridge. It was accepted that you had to get out of Ireland for quality postgraduate studies. (Declan Kiberd, former UCD Chair of Anglo-Irish Literature and Drama, quoted in IRCHSS 2010, p. 7)

This left Irish higher education and research in another curious position, with a disconnect between the popular notion of Ireland as a haven for the arts, the humanities, and culture, and the reality at advanced levels of study and research.

It was only in the early 1990s, with the appointment in 1993 of the first Minister for Arts, Culture and the Gaeltacht (Ireland's Irish speaking areas), followed by publication the following year of *The Employment and Economic Significance of the Cultural Industries in Ireland*, that the arts began to move from the realm of "high culture" and benign neglect into the heartland of public policy, namely economic growth and employment (Hazelkorn 2014, p. 6). Taking advantage of rapid social structural changes and a "natural" reservoir of creativity, the government sought to carve out a niche for Ireland in the digital world as a provider/creator of cultural content (EI 1997). The creative arts and media became a critical component of city (re)building, most notably as part of the deliberate construction and marketing of Dublin's Temple Bar as the "cultural quarter", and the creation of Ireland as a "digital isle" based around the digital media/multimedia industry renamed the Digital Hub (2000) (Hazelkorn and Murphy 2002). In all these initiatives, however, it was the economic rather than cultural attributes of the A&H which were promoted (Bartley 2007, p. 38).

Status and Organisation of Arts and Humanities Research

Irish higher education traditionally "emphasised the primacy of the humanities and classical studies" and placed a "low value on technical education" (Walsh 2011, p. 366). This emphasis corresponded with its elevated position within cultural nationalism while also reflecting education's status as the preserve of the elite. This dichotomy is also reflected by how the humanities are generally perceived as a set of classical academic disciplines while the arts have either been quietly absorbed within its domain or ignored—in both cases resulting in a loss of identity. The humanities are incorporated within the "academy", for example, the Royal

Irish Academy (RIA), while the arts are overseen by the Arts Council. The latter is a government agency founded in 1951 for promoting and funding the arts albeit this involves arts practitioners and not arts research. Officially, disciplinary groupings usually divide between humanities/social sciences (HSS) and science, technology, engineering and mathematics (STEM); in this construct, the arts are usually lumped in with the humanities for data-collection purposes. More recently, policy language has been amended to reflect the arts; hence AHSS.

Some of these tensions can be further attributed to institutional differentiation and/or variances in disciplinary practice. The humanities incorporate music, philosophy, history, archaeology and literature, and so on, and have traditionally and officially been the remit of the universities. In contrast, the practice-oriented or applied nature of the visual, performing and media arts has been associated with the institutes of technology or the colleges of art and design. In this context, the former engages directly in the production of new knowledge usually communicating the outcome via traditional academic texts, while the latter produces a collection of artefacts (e.g. paintings, sculpture, music composition, performances, etc.) for exhibition and/or commercial purposes. Misunderstandings often arise because the process of "doing" or the artefact itself is equated with research. As one senior arts academic puts it,

> talking to staff in my own department ... trying to convince them that actually what they're doing is research and they often think 'well I'm just I'm giving a guitar recital, I'm giving a piano recital', you'd say well there *is* a research element in that: your preparation for it, your concept of the recital, your construction of the programme. (quoted in Hazelkorn et al. 2013, p. 81)

In this context, arts research is considered exceptional within the broader higher education context although it is equally possible to stress the commonalities between disciplines. A senior music lecturer makes this point, stressing that "a researcher is a researcher is a researcher. What is the question, the process, the problem that you are addressing? In the computing field you produce a program; in the music field you have a score. If you're a writer, a book; if you're a microbiologist, you may be disproving a theory. So what's the difference?" (Ibid. 62).

These differing perceptions can lead to the conclusion that the artistic practice lacks academic rigour or that it does not encompass research.

Thus, the Irish Higher Education and Training Awards Council (now part of QQI—Quality and Qualifications Ireland) entered the debate arguing there was no fundamental contradiction between "discipline-independent and generalised conception of research which comprehends practice-based research in the arts" (HETAC 2010). There were intense debates about what constitutes a doctoral thesis in the arts, and the appropriateness of a thesis independent of or alongside a performance or artefact. Different institutions took different stances, but the key feature of these debates beginning in the 1990s was the struggle within the academy to "normalise" arts practice. Discussions in the UK, ultimately spearheaded by the research assessment exercise followed by the establishment of the Arts and Humanities Research Board, had some spill-over influence.

Acceptance of practice-led or practice-based research has led to a wider understanding of integrating practice/art-making with theoretical exploration leading to new understandings and meanings. This has engendered a redefinition of A&H research not just in the language of measurable outputs, socio-economic value or impact but also into new fields of inquiry. Linking A&H research to new digital and computational tools and methods has also opened up new opportunities. Indeed, under the Programme for Research in Third Level Institutions (PRTLI) (2007–2013), a total of €28 m was allocated to establish the Digital Humanities Observatory, a significant national research and infrastructure programme involving six of the seven universities and two IoTs (RIA 2007, p. 4; Holm et al. 2014, p. 62).

> When it comes to this area, Ireland has made a very significant investment in the infrastructure. We're doing a lot of the work in … partnership with industry, including IBM and Google. What's interesting to me is research is going on in companies such as IBM that see the humanities – which are our central reach – as the next technical frontier. (Ohlmeyer, quoted in Fearn 2010) ·

DARIAH, the Digital Research Infrastructure for the Arts and Humanities, enhances and supports digitally enabled research and teaching across the humanities and arts. In another way, a new company with the aim to "preserve, protect and promote Ireland's folklore heritage" has emerged from the NovaUCD innovation hub.

Along with other initiatives, these developments represented the slow dissolution of traditional barriers between the arts and the academy,

and specifically between the arts, humanities and STEM subjects, bring-
ing Ireland into line with developments elsewhere (Hazelkorn 2004).
Recognition of complementarity between "practice-led research and
research-led practice" has also facilitated the arts being integrated into
the academy; for example, creative arts practice is one of TCD's desig-
nated research themes. As part of an overall review of creative arts practice
in the Dublin region (HEA 2013b), the previously independent NCAD
has become a recognised college of UCD/NUI,[3] and there are similar
desires being expressed by Dun Laoghaire Institute of Art, Design and
Technology (IADT) while the Royal Irish Academy of Music (RIAM)
became an Associated College of Trinity College in 2013. These develop-
ments signal the rising academic status and market attractiveness of arts
practice, not only in Ireland but across Europe and other countries.

FUNDING ARTS AND HUMANITIES RESEARCH

In the lead up to the EU Lisbon Strategy "to make the Union the most
competitive and dynamic knowledge-based economy in the world by
2010", European policy moved decidedly away from the information
society, which was based on mere technological developments brought
to bear on existing systems that "provid[e] little more than 'a mass of
indistinct data' for those who don't have the skills to benefit from it",
to the knowledge society which implies a contribution to the "well-
being of individuals and communities, and encompass[ing] social, ethical
and political dimensions" (UNESCO 2005). Irish policy followed suit.
Coupled with the first and subsequent reports of the Expert Group on
Future Skills Needs, various reports firmly tied Ireland's future to strategic
investment in research, science and technology as essential to develop "a
vision of Ireland as a knowledge-based society" (ICSTI 1999b, p. 2). The
National Development Plan pledged to enhance enterprise development,
and "improve economic performance, competitiveness...generate new
enterprise 'winners' from the indigenous sector [and] attract high added
value foreign direct investment" (NDP 2006, p. 13).

The aforementioned PRTLI programme, Science Foundation Ireland
(SFI) (est. 2000) and the twin research councils of IRCSET and IRCHSS
(replaced in 2012 by the Irish Research Council, IRC) provided the first
state-based funding for research. Prior to that, there had been some access
routes to EU funding with the expansion of framework programmes
beginning in the 1980s, and national targeted funding for science and

technology. Until then, the humanities had been left principally to their own devices while the arts were ignored. These developments ensured that considerable resources were invested in research, and that Ireland built up an infrastructural and human resources base over the noughties.

Humanities students have traditionally been catered for in the universities, with 92 % of full time students in 2014/15. The remaining 8 % are in IoTs although their incursion into this space has been restricted due to concerns about mission creep. On the other hand, art and design has predominantly been a feature of the IoTs and NCAD. Figure 4.1 shows how enrolments in A&H subjects have changed between 2008/09 and 2014/15, according to institution type and qualification level. The IoT sector saw a minor increase in undergraduate enrolments in the arts while universities had the greatest increase in postgraduate humanities (from 14 % to 19 %).

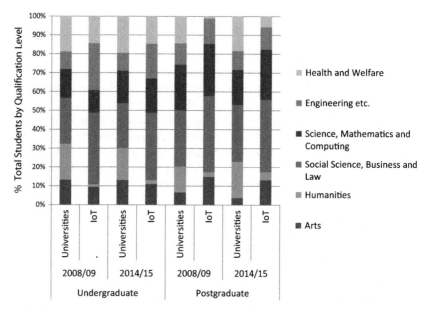

Fig. 4.1 FT students by institutional type, field and qualification 2008/09 and 2014/15 (%) (*Source*: Compiled from HEA enrolment data; "universities" include colleges and NCAD (Percentages are for FT enrolment per HEI type rather than total FT HE enrolment; social sciences, business and law includes services; engineering includes manufacturing, construction, and agriculture))

PRTLI was the main source of funding for A&H research and for research students between 1998 and 2014 (HEA 2008). The social sciences and humanities were described as one of the five areas important to Ireland's "enterprise and societal development" (DJEI n.d.). Over the whole PRTLI life-cycle, €1.2 bn was allocated, of which 14 % or €175 m went to social sciences and humanities projects (there is no discrete indication for the arts). This includes highly visible capital projects, such as the Humanities Institute of Ireland in UCD (PRTLI 3), the Trinity Long Room Hub (PRTLI 4), Maynooth University's Iontas Building for HSS research (PRTLI 4), the Arts, Humanities and Social Sciences Research Building NUIG (PRTLI 5), and large-scale inter-institutional collaborative projects, for example *Humanities Serving Irish Society* (PRTLI 4), Graduate School of Creative Arts and Media (GradCAM) (PRTLI 4), and the *Digital Arts and Humanities Structured PhD programme* (PRTLI 5).

With the onset of the economic crisis in 2008, the research funding and landscape began to change as the government pursued a more economically targeted approach. Three trends were apparent: (i) overall reduction in funding for all research due to the economic recession; (ii) reorientation towards research aligned with national priorities; and (iii) confirmation of the IRC as the major funder for A&H research excluding the HEIs themselves.

The *Research Prioritisation Exercise* (RPE) marked the end of what had been a strategy to build a broad base of expertise in favour of a "more top-down, targeted approach" (Forfás 2012, p. 8; see also Forfás and DJEI 2014). Research relevance defined principally in terms of job creation became the paramount criterion, with an emphasis on science and technology. Fourteen areas, aligned with industrial sectors, were identified; while the original intention was that 20 % should be held back for more fundamental research, in practice the percentage was lower. Almost by definition, the RPE excludes the A&H—and the social sciences. It was argued that priority areas were sufficiently broad that all disciplines could find a home either as a discipline or as part of an interdisciplinary team once they align with the priority areas, can show relevance, and meet the "excellence" criteria (Ahlstrom 2013). This contrasts with the fact that Irish HEIs achieved a high rank in the QS Subject Rankings in English language and literature, history, modern languages, etc. (QS 2014), none of which are referenced in the RPE.

In 2011, IRCHSS saw its budget cut from €18 m to €10 m. The following year it was merged with IRCSET to form the new Irish Research

Council. While the IRC budget comprised less than 5 % of the total 2013 HERD (Higher Education R&D) spend, it is responsible for the largest proportion of competitive humanities-based spending. Notably, within its reduced budget, funding for the A&H remained proportionately stable, and was relatively safe-guarded, with no increase in the science, engineering and technology programme (DJEI 2013, p. 50).

The IRC's strategy statement notes that the one of the IRC's functions is to "provide advice on postgraduate education and on more general research matters to the HEA" and that when the Minister for Research and Innovation gave it this role, it was requested that particular attention be given to the arts, humanities and social sciences (IRC 2012). Despite concerns, the merger, in 2012, of IRCHSS and IRCSET to become the IRC could be viewed in other ways, given that:

> we should be trying to move away from any sort of traditional or artificial boundary in terms of where we see disciplines located and there is a statement in fact in having a separate arts and humanities council that this is almost the "special needs" project – this is an area that needs protection. Whereas there is a statement of confidence in saying that no, we are part of a broader research council because our activity actually stands shoulder to shoulder with any other activity within the system. (Policy-maker in a state organization, quoted in Hazelkorn et al. 2013, p. 66)

In terms of new research money, the main emphasis was on *Horizon 2020* and other non-Exchequer sources (HEA 2013a, p. 63).

Innovation 2020, introduced as the country emerges from its deepest recession, has a different, more upbeat, message for a different time. Positioning Ireland as a future "Global Innovation Leader", it moves away from the shrill language of research prioritization; there are overtures towards the importance of "excellent research across all disciplines (including the arts, humanities and social science…", to interdisciplinary research, and to the importance of A&H to helping solve some of the grand challenges of our time. Prioritisation remains but with a recognition of the need to "support excellent research across the full continuum and across all disciplines" (ICSTI 2015, p. 10, 30, 44, 8).

A bigger picture underlies these changes. At one level, the shift in authority for research from the Department of Education and Skills to the Department of Jobs, Enterprise and Innovation was designed to ensure greater coherence in research and research funding following a series of

penetrating questions about the value and contribution of research raised by *Report of the Special Group on Public Service Numbers and Expenditure Programmes* (Special Group 2009). The merger of IRCHSS and IRCSET into one overarching council was part of this new approach. However, the change has signified a more fundamental restructuring of research. Previously, PRTLI represented a temporary truce of sorts between those who argued the virtue of broad-based research and postgraduate training within higher education vs. those proposing a limited number of (semi) autonomous commercially focused research institutes (DES 2011). Today, the expanded role and budget for SFI and adoption of RP as the *de facto* national research strategy—and reiterated as such in the government's submission to the EU under the smart specialisation programme—has coincided with the marginalisation of the HEA, and its parent Department of Education and Skills, in research policy. The intensity of departmental skirmishes around the new strategy for science, technology and innovation, *Innovation 2020* (ICSTI 2015), with the latter emerging as the title-holder, reflects the significance of this continuing policy shift, underlying philosophical differences and concerns that resultant loss of "territory" for one and gain for the other.

There are also deeper philosophical issues at stake here. This concerns the status of research in higher education as the essential infrastructure for human capital development vs. higher education for economic growth and jobs. The former prioritises educating undergraduates across a breadth of disciplines while the latter adopts a narrower economic-planning approach. Depending on the scenario, there are significant implications for the A&H.

INFLUENCING THE PUBLIC SPHERE

Looking back at the nation's early years, it is clear that the A&H were integral to the definition of the new state. Early interventions were consumed by a nationalist discourse, not surprising given the origins of the Irish state as the result of military conflict with Britain. During another period of crisis, what are known as "The Troubles" in Northern Ireland (1968–1998), the then Taoiseach Garret FitzGerald started the New Ireland Forum, "a group established by constitutional nationalists in the North and South to discuss ways of solving the Northern crisis" (Ferriter 2005, p. 643; see also Foster 2008, pp. 126–129). What is interesting about this undertaking is that it invited and received submissions from the public beyond its

membership of politicians, and of these a number came from the A&H, both within and outside the academy. While the success or otherwise of the New Ireland Forum (1983–1984) is a topic for debate, the salient point is that at a time and for an issue of such national importance, the A&H played a considerable role in public debate.

Contrast this dynamism with the present, and it is a very different matter. In 1994, an *Irish Times* editorial called for greater involvement by those "involved in the humanities and the human sciences, centred most obviously in the universities" suggesting that they "contribute minimally to the analysis and discussion of public policy" (quoted in Harpur 2010, p. 95); the Universities Act (1997) enshrined higher education's responsibility to "foster a capacity for independent critical thinking amongst its students" and "promote the cultural and social life of society, while fostering and respecting the diversity of the university's traditions". One might have also expected that the expansion of higher education would have facilitated a greater and broader role for the A&H in public discourse, but in the wake of the economic crisis, their omission has been quite remarkable. The media discussion of Ireland's banking and financial crisis has been dominated by economists and other social sciences, but discussion of constitutional reform (2012–2014)—a proxy for another discourse on national identity—largely bypassed the A&H. After coming to power in 2011, the government established a "constitutional convention", and while it was to have "only an advisory role and an insignificant agenda" (Whelan 2012), it was nevertheless a significant forum on public life in Ireland. When the time for submissions came, public input was canvassed, but the voices from the academy were from the social sciences (law, political science, and geography); the Convention's academic and legal team was similarly made up of those from legal and political science backgrounds. While this is understandable, given the technical (and technocratic) form the Convention took, some breadth might have been introduced if other perspectives, notably from the A&H, were present. This would have been especially welcome and relevant on the topics of repealing the blasphemy law, and social and cultural rights. Interestingly, only one voice from the humanities, the Oxford Brookes-based historian David Nash, was nominated to give evidence. In contrast, A&H are strongly represented in discussions about how best to mark the centenary of the Easter Rising (1916)—an event which ignited the war for independence, via membership of the Expert Advisory Group for the Decade of Centenaries.

Donncha O'Connell, professor of law in NUI Galway, attempted to explain this absence in terms of the way the academy is structured around narrow specialisms and is driven increasingly by performance metrics, as well as the various other professional and administrative demands that arise on a daily basis. All this, and somehow finding the time to publish, "does not leave much time for being a public intellectual. In certain situations, being a public intellectual may damage your standing as a potential earner of income for your employer by reason of a real or attributed undermining of rigour and independence"—though this doesn't seem to prevent an active engagement in other societies (O'Connell 2012, p. 23). This may derive from a relaxed attitude towards intellectual matters, especially where "academic" is a term of opprobrium rather than a descriptive word. President Michael D. Higgins (2015), a former academic himself, acknowledged that "[t]he fact that cuts of around 40 per cent to the annual budgets of the majority of our cultural institutions, leaving some of them struggling to survive, along with a reduction in funding for arts, culture and film [...] elicits little public comment or concern underlines the peripheral place the arts are too often granted in our society and in the public consciousness and media discourse". Elsewhere he described the crisis in Ireland as intellectual as well as economic (Higgins 2012). A review of the Irish banking crisis similarly noted the "lack of challenging discourse and analysis" (Nyberg 2011, p. 48), a view also reflected in a series of essays lamenting the absence of a role for the public intellectual (Corcoran and Lalor 2012). Thus, a deeper explanation may lie either in a narrow preoccupation with nationalist discourse and/or the absence of a public thirst for comment from the A&H except around such issues. A further explanation may lie in the public's tiredness with the nationalist discourse given years of conflict, although ironically this has narrowed rather than broadened the range of voices heard in contrast to when the debate was at its height several years ago.

A particular feature of public life in Ireland is the absence of a robust public sphere as a place where rational debate and civil society engage (Habermas 1991). Historically this has been split between English and Gaelic spheres, negatively bridged by mutual incomprehensibility or antipathy (Cronin 2013). While there is a strong public sector—representing the state as employer—this does not equate easily with a strong civil society. The media covers the A&H as cultural affairs and events, but these items tend to be assigned discrete roles. At the same time, as discussed above, A&H are discussed primarily within certain confines. In the media,

in the previous decade, events may have been discussed by a wide array of commentators, some from A&H. Today, the public intellectual is more or less extinct, and the competitive pressures on the media to produce material across a wide range of formats with sensationalist headlines, has led to a squeezing out of the kind of reflective analysis that the public sphere requires and that the A&H can offer. Indeed, a 2008 study of British journalism has suggested such changes has led to "pre-packaged news" and "churnalism", with journalists regurgitating wire copy and press releases, with 60 % of press articles and more than 30 % of broadcasting stories coming from such sources (Lewis et al. quoted in Jones 2015, p. 122). With this said, it must also be noted that considerable discussion is taking place in "new media", via online newspapers such as *The Journal* and *Broadsheet*, as well as on Twitter and blogs. Corcoran suggests that perhaps "the challenge is to find new ways of being a public intellectual and new ways of communicating intellectual ideas", drawing attention to the influence of TED Talks (Dublin has had its own independently organised TEDx talks since 2011), as well as the Royal Irish Academy's Dublin Talks series which ran from 2012 to 2014 (Corcoran 2015, p. 278).

Since 2000, education and research have been tied to economic performance and requirements, and more so since the onset of the Global Recession. This is often tied to globalisation or neoliberal influences (Lynch 2012), but unlike other countries, no academic department in A&H subjects have closed. Policy-makers want and expect A&H researchers, as other disciplines, to be more involved with "innovation research" (Geoghegan-Quinn quoted in UCD 2013), the agenda of the knowledge economy and the broader vision of an "Ireland, Inc." Officially, RP does not exclude the A&H, although the way in which the priorities have been framed and funded raises some scepticism. This potentially pivots the A&H away from its traditional role towards one in which it has a broader engagement with society at large.

It is not just the policy-makers who are throwing down the gauntlet to A&H researchers; some of the strongest voices have come from within their own midst, arguing that their contribution must form part of the "innovation arena" (Kelleher quoted in UCD 2013); recent humanities advocacy statements are equally confident and assertive in tone. Researchers have argued that the new environment has thrust the A&H into a new role; the opportunities provided by EU Horizon programmes and new directions in Ireland "have resulted in the humanities being offered a role

in new research environments, and a place in collaborative projects that are often multidisciplinary or transdisciplinary in character" (Conroy and Kelleher 2014, p. ix). The formation of the Irish Humanities Alliance, a formal cross-institutional response, seeking to build public awareness of the importance of humanities teaching and research in higher education and wider society, represents such an initiative.

CONCLUSION

Discussion of the A&H is all too often dominated by tones of crisis and threat, but this chapter shows that in Ireland these fears may be exaggerated. Funding structures have militated against these disciplines although this is more often for reasons of relative size of the sums involved. As in the UK, it is not "whether arts are virtuous but whether they are more virtuous than other claims on the public purse" (Knell and Taylor 2011, p. 8). Debate about the future strategy for science, technology and innovation has provided an ideal opportunity for the A&H to reframe their own discussion beyond the usual criticism of staffing issues, funding and so on, and to articulate what they do and why it is important. This includes working out "how to make industry interested. The profit motive is obvious but there can also be huge potential for enabling research which can either respond to industry's needs in a task oriented way or product development way" (Donovan quoted in RIA 2012, p. 16).

Education in Ireland has always been *for* something, but the nature of this something has changed in line with national circumstances. Discussions about how public funds should be spent are political by nature; they tend to correlate with election cycles, and focus on short- to medium-term economic results. However, research has a timeline that unfolds over longer periods, and "[d]ecisions on how to improve the educational system today will have continuing effects on the economy and the wider society for decades to come" (FitzGerald 2015). The sciences, through public engagement actions such as TCD's Science Gallery, have succeeded in raising their profile; similar work is now underway for the A&H, albeit in a less public way, via different reports and publications (RIA 2009; HEA and IRCHSS 2010; IRCHSS 2010; RIA 2011; Duncan and Rouse 2015). But more action is required, and "the more we can challenge the insidious separation of A&H from society, politics and economics, the greater the hope of rebuilding this country and society" (Woods 2014, p. 57). While

retaining disciplinary strengths, a more sophisticated understanding of research relevance and impact is essential not just as a form of performance measurement but as a way of demonstrating value to the public sphere and avoiding perceptions of special pleading.

NOTES

1. The Anglo-Irish Free Trade Agreement of 1965 exemplified this new direction in economic policy. This agreement removed trade barriers between Ireland and the United Kingdom.
2. As of 2015, this exemption "empowers the Revenue Commissioners to make a determination that certain artistic works are original and creative works generally recognised as having cultural or artistic merit." The first €50,000 per annum of "profits or gains earned by writers, composers, visual artists and sculptors from the sale of their work is exempt from income tax in Ireland in certain circumstances. For the years 2011–2014 the maximum amount which was exempt was €40,000." Accessed 25 February 2016, from: http://www.revenue.ie/en/tax/it/reliefs/artists-exemption.html
3. NCAD has had recognised college status since 1996, and an "Academic alliance" was established in 2010.

REFERENCES

Ahlstrom, D. (2013, January 7). State funds for science to be based on merit. *The Irish Times.* http://www.irishtimes.com/newspaper/ireland/2013/0107/1224328507515.html. Accessed 25 Feb 2016.

Barry, F. (2014). Outward-oriented economic development and the Irish education system. *Irish Educational Studies, 33*(2), 213–223.

Bartley, B. (2007). Planning in Ireland. In B. Bartley & R. Kitchin (Eds.), *Understanding contemporary Ireland* (pp. 31–43). London: Pluto Press.

Brown, T. (1985). *Ireland: A social and cultural history, 1922–1985.* London: Fontana Press.

Byrne, H. (1997). Going to the picture: The female audience and the pleasures of cinema. In M. J. Kelly & B. O'Connor (Eds.), *Media audiences in Ireland* (pp. 88–106). Dublin: University College Dublin Press.

Conroy, J., & Kelleher, M. (Eds.) (2014). *Restating the value of the humanities.* Dublin: Humanities Serving Irish Society Consortium.

Corcoran, M. (2015). The role of the public intellectual. In K. Rafter & M. O'Brien (Eds.), *The state in transition: Essays in honour of John Horgan* (pp. 261–283). Dublin: New Island Books.

Corcoran, M., & Lalor, K. (Eds.) (2012). *Reflections on crisis: The role of the public intellectual.* Dublin: Royal Irish Academy.

Cronin, M. (2013, March 11). Half the picture. Review of V. Morley's *Ó Chéitinn go Raiftearaí: Mar a cumadh stair na hÉireann, Dublin Review of Bookse.* http://www.drb.ie/essays/half-the-picture. Accessed 25 Feb 2016.

CSO. (2015). International Trade in Services 2013. http://www.cso.ie/en/releasesandpublications/er/its/internationaltradeinservices2013. Accessed 25 Feb 2016.

Dagg, M. (2006). Public investment in R&D in Ireland. In R. O'Toole & C. Aylward (Eds.), *Perspectives on Irish productivity.* Dublin: Forfáse.

DES. (2011). *National strategy for higher Education to 2030. Report of the strategy group.* Dublin: Department of Education and Skills.

DF. (1958). *White paper on economic development*, Pr. 4803. Dublin: Department of Finance.

DJEI. (2013). *State investment in research & development 2013–2014.* Dublin: Department of Jobs, Enterprise and Innovation.

DJEI. (n.d.). *The Programme for Research in Third Level Institutions (PRTLI).* Dublin: Department of Jobs, Enterprise and Innovation.

Duncan, M., & Rouse, P. (2015). *Creating Ireland: Research & the role of the humanities and social sciences.* Dublin: Irish Research Council.

EI. (1997). *Ireland: The digital age, the internet.* Dublin: Enterprise Ireland.

Fallon, B. (1998). *An age of innocence, Irish culture 1930–1960.* Dublin: Gill and Macmillan.

Fearn, H. (2010, December 2). Can the humanities save Ireland. *Inside HigherEd.* https://www.insidehighered.com/news/2010/12/02/ireland. Accessed 25 Feb 2016.

Ferriter, D. (2005). *The transformation of Ireland, 1900–2000.* London: Profile Books.

FitzGerald, J. (2015, March 10). How our education system affects the economy of the future. *The Irish Times.* http://www.irishtimes.com/business/economy/how-our-education-system-affects-the-economy-of-the-future-1.2132023. Accessed 25 Feb 2016.

Forfás. (2012). *Report of the research prioritization steering group.* Dublin: Forfás.

Forfás & DJEI. (2014). *National research prioritisation exercise: First progress report.* Dublin: Department of Jobs, Enterprise and Innovation.

Foster, R. F. (2008). *Luck and the Irish: A brief history of change, 1970–2000.* London: Penguin.

Garvin, T. (2004). *Preventing the Future: Why was Ireland so poor for so long?* Dublin: Gill and Macmillan.

Habermas, J. (1991). *Structural transformation of the public sphere* (trans: Burger, T.). Cambridge, MA: MIT Press.

Harpur, J. (2010). *Innovation, profit and the common good in higher education: The new alchemy.* Basingstoke: Palgrave Macmillan.

Hazelkorn, E. (1992). 'We can't all live on a small island': The political economy of migration. In P. O'Sullivan (Ed.), *The Irish in the new communities* (Vol. 2, pp. 180–200). Leicester: University of Leicester Press.

Hazelkorn, E. (2004). Art schools for tomorrow: Challenges and opportunities. *Higher Education Management and Policy, 16*(3), 135–152.

Hazelkorn, E. (2014). Making an impact: New directions for arts and humanities research. *Arts and Humanities in Higher Education, 14*(1), 25–44.

Hazelkorn, E., & Murphy, C. (2002). The cultural economy of Dublin. In M. Corcoran & M. Peillon (Eds.), *Sociological chronicles* (Vol. 3). Dublin: Institute for Public Administration.

Hazelkorn, E., Ryan, M., Gibson, A. & Ward, E. (2013). *Recognising the value of the arts and humanities in a time of Austerity.* Dublin: HEPRU Working Paper, Higher Education Policy Research Unit, Dublin Institute of Technology. http://arrow.dit.ie/cserrep/42. Accessed 25 Feb 2016.

Hazelkorn, E., Gibson, A., & Harkin, S. (2015). Irish higher education from massification to globalisation: Reflections on the transformation of Irish higher education. In K. Rafter & M. O'Brien (Eds.), *The state in transition: Essays in honour of John Horgan* (pp. 235–260). Dublin: New Island Books.

HEA. (2008). *Transformations: How research is changing Ireland.* Dublin: WG Bairds.

HEA. (2013a). *Towards a performance evaluation framework: Profiling Irish higher education.* Dublin: Higher Education Authority.

HEA. (2013b). *Review of the provision of creative arts programmes in Dublin.* Dublin: Higher Education Authority. http://www.hea.ie/sites/default/files/dublin_creative_arts_review_0.pdf. Accessed 25 Feb 2016.

HEA, & IRCHSS. (2010). *Playing to our strengths: The role of the arts, humanities and social sciences and implications for public policy.* Dublin: Higher Education Authority and Irish Research Council for the Humanities and Social Sciences.

HETAC. (2010). *Good practice in the quality assurance of arts research degree programmes by practice.* Dublin: Higher Education and Training Awards Council.

Higgins, M. D. (2012). *The role of the university at a time of intellectual crisis.* Address given on occasion of conferring with LLD: National University of Ireland.

Higgins, M. D. (2015, March 11). Cuts are regrettable given the economic benefits that flow from our creative sector. *Irish Times.* http://www.irishtimes.com/opinion/should-the-40-per-cent-cuts-to-cultural-organisations-be-reversed-readers-opinion-poll-and-comment-box-1.2135005. Accessed 25 Feb 2016.

Holm, P., Jarrick, A., & Scott, D. (2014). *Humanities world report 2015*. Basingstoke: Palgrave Macmillan.

ICSTI. (1999a). *Technology foresight Ireland – An ICSTI overview*. Dublin: Forfás.

ICSTI. (1999b). *Press release: Technology foresight report stresses the need for Ireland to become an attractive location for world-class research and development*. Dublin: Forfás.

ICSTI. (2015). *Innovation 2020. Excellence, talent, impact. Ireland's strategy for research and development, science and technology*. Dublin: Department of Jobs, Enterprise and Innovation.

IRC. (2012). *Strategy statement*. Dublin: Irish Research Council. http://www.research.ie/sites/default/files/strategy statement of the irish research council_0.pdf. Accessed 25 Feb 2016.

IRCHSS. (2010). *Mosaic: A celebration of Irish research in the humanities and social sciences*. Dublin: Irish Research Council for the Humanities and Social Sciences.

Jones, O. (2015). *The establishment: And how they got away with it*. London: Penguin.

Keating, A. (2014). The uses and abuses of censorship: God, Ireland and the battle to extend censorship. *Estudios Irlandeses, 9*, 67–79.

Kiberd, D. (1996). *Inventing Ireland: The literature of the modern nation*. London: Vintage.

Kiberd, D. (2001). *Irish classics*. London: Granta.

Kirby, P., & Murphy, M. (2011). *Towards a second republic*. London: Pluto Press.

Knell, J., & Taylor, M. (2011). *Royal society of arts: Arts funding, Austerity and the big society*. London: Arts Council England. http://www.artscouncil.org.uk/media/uploads/pdf/RSA-Pamphlets-Arts_Funding_Austerity_BigSociety.pdf. Accessed 25 Feb 2016.

Kuhling, C., & Keohane, K. (2007). *Cosmopolitan Ireland*. London: Pluto Press.

Lindsey, C. N. (1996). Statement by the HEA. In CIRCA (Ed.), *A comparative international assessment of the organisation, management, and funding of university research in Ireland, Report of the CIRCA Group Europe for the higher education authority*. Dublin: HEA.

Loxley, A., Seery, A., & Walsh, J. (2014). Investment in education and the tests of time. *Irish Educational Studies, 33*(2), 173–191.

Lynch, K. (2012). On the market: Neoliberalism and new managerialism in Irish education. *Social Justice Series, 12*(5), 88–102.

Mac Gréil, M., & Rhatigan, F. (2009). *The Irish language and the Irish people: Report on the attitudes towards, competence in and use of the Irish language in the republic of Ireland 2007–'08*. Maynooth: Department of Sociology, National University of Ireland Maynooth.

McAuliffe, C. (2011). Sean O'Faoláin, the Bell and the voice of Irish dissent. http://publish.ucc.ie/boolean/2011/00/McAuliffeC/30/en. Accessed 25 Feb 2016.

NDP. (2006). *National development plan 2007–2013: Transforming Ireland.* Dublin: Stationery Office.

Newman, J. H. (1933). *On the scope and nature of university education.* London: J.M. Dent.

NPC – National Programme Conference. (1922). *National programme of primary instruction.* Dublin: Browne and Nolan.

Nyberg, P. (2011). *Misjudging risk: Causes of the systemic banking crisis in Ireland.* Dublin: Stationery Office.

Ó Buachalla, S. (1988). *Education policy in twentieth century Ireland.* Dublin: Wolfhound Press.

Ó Drisceoil, D. (2005). 'The best banned in the land': Censorship and Irish writing since 1950. *The Yearbook of English Studies, 35,* 146–160.

O'Connell, D. (2012). Within and beyond these walls: University academics as public intellectuals. In M. Corcoran & K. Lalor (Eds.), *Reflections on crisis: The role of the public intellectual* (pp. 15–28). Dublin: Royal Irish Academy.

O'Connor, M. (2014). Investment in edification: Reflections on Irish education policy since independence. *Irish Educational Studies, 33*(2), 193–212.

O'Sullivan, D. (2006). *Culture, politics and Irish education since the 1950s.* Dublin: Institute of Public Administration.

Pearse, P. (1916). *Collected works of Pádraic H. Pearse: Political writings and speeches.* Dublin: Phoenix Publishing Company.

QS. (2014). QS world university rankings by subject. http://www.topuniversities.com/subject-rankings. Accessed 25 Feb 2016.

Rashdall, H. (1936). *The universities of Europe in the Middle Ages* (Vol. II). Oxford: Oxford University Press.

RIA. (2007). *Royal Irish academy annual review 2006–2007.* Dublin: Royal Irish Academy.

RIA. (2009). *Developing key performance indicators for the humanities.* Dublin: Royal Irish Academy.

RIA. (2011). *The appropriateness of key performance indicators to research in arts and humanities disciplines: Ireland's contribution to the European debate.* Dublin: Royal Irish Academy.

RIA. (2012). *Report on dialogue on research funding in Ireland.* Dublin: Royal Irish Academy.

Special Group. (2009). *Report of the special group on public service numbers and expenditure programmes* (Vol. 1). Dublin: Government Publications Office. http://www.djei.ie/publications/corporate/2009/volume1.pdf. Accessed 25 Feb 2016.

UCD. (2013). Commissioner calls on the humanities to play a part in innovation research. http://www.ucd.ie/news/2013/05MAY13/100513-Commissioner-

calls-on-the-humanities-to-play-a-part-in-80b-innovation-research.html. Accessed 25 Feb 2016.

UNESCO. (2005, November 3). Knowledge versus information societies: UNESCO report takes stock of the difference. Press release. http://portal. unesco.org/ci/en/ev.php-URL_ID=20493&URL_DO=DO_TOPIC&URL_SECTION=201.html. Accessed 25 Feb 2016.

Universities Act, Section 12, Government of Ireland. (1997). http://www.irish-statutebook.ie/eli/1997/act/24/section/12/enacted/en/html. Accessed 29 September 2016.

Walsh, J. (2009). *The politics of expansion: The transformation of educational policy in the republic of Ireland, 1957–1972.* Manchester: Manchester University Press.

Walsh, J. (2011). A quiet revolution: International influence, domestic elites and the transformation of higher technical Education in Ireland 1959–1972. *Irish Educational Studies, 30*(3), 365–381.

Whelan, N. (2012, February 25). Constitutional convention will have its remit severely pruned. *The Irish Times.* http://www.irishtimes.com/opinion/constitutional-convention-will-have-its-remit-severely-pruned-1.470351. Accessed 25 Feb 2016.

Wickham, J., & Boucher, G. W. (2004). Training cubs for the Celtic Tiger: The volume production of technical graduates in the Irish educational system. *Journal of Education and Work, 17*(4), 377–395.

Woods, V. (2014). Afterword: 'Are you serious?' Broadcasting the arts and humanities. In J. Conroy & M. Kelleher (Eds.), *Restating the value of the humanities* (pp. 56–57). Dublin: Humanities Serving Irish Society Consortium.

The Netherlands: Thirty Years of Crisis: The Disputed Value of Dutch Arts and Humanities Research 1982–2012

INTRODUCTION

If the Irish higher education system has its roots in the British and the Norwegian in the Scandinavian, then the Dutch system is something of a hybrid of the two, with universities seen both as important nation building projects, but also as private institutions offering a cloistered space away from the rough and tumble of political decision-making. So with the great emancipation around the turn of the twentieth century we see universities created in the Netherlands to provide elite education and hence representation for newly freed social groupings, the Calvinists and Catholics. But there is also a tradition of extremely functional universities created to meet particular kinds of technological modernisation, with the three technological universities created—admittedly at very different moments in Dutch history—to help equip the country in different ways with the technological skills and knowledge to thrive in the contemporaneous economy. Dutch higher education is therefore continually pulled between these two poles, of Calvinistic functionalism but also classical autonomy, and the humanities more than most find themselves continually pulled between these two elements.

In the period covered by this chapter, the evidence suggests that Dutch humanities has been in a crisis. After all, there have been no less than three Grand National Commissions convened to provide a solution for Dutch humanities to survive into the future (Staal, 1991, Vonhoff, 1995; Gerritsen, 2002). Interviewing various participants who had been

© The Author(s) 2016
P. Benneworth et al., *The Impact and Future of Arts and Humanities Research*, DOI 10.1057/978-1-137-40899-0_5

involved in different ways in these three Commissions did not give us a sense that these issues had led to resolutions—rather changes were made and then the goalposts shifted, leaving the humanities rather exhausted by the changes. After our research concluded, there was actual civil disobedience in the University of Amsterdam in response to the University of Amsterdam's (UvA) humanities faculty efforts sought to implement a reform programme seeking to make the faculty "fit for the future". At the heart of this crisis has lain a fundamental tension in the public value of arts and humanities. This became an existential question in the early 1980s as the Dutch labour market tanked as part of *Eurosclerosis*, with universities churning out many more humanities graduates than the labour market could reasonably absorb, even as specialist school teachers. But there was also a realisation that the humanities research in the Netherlands was in a number of areas, particularly rare languages, an almost unique repository of knowledge for which the country had a unique curatorial responsibility. So how to create employable students whilst maintaining, and increasingly creating, globally unique knowledge became the central tension within the humanities, the engine that drives this chapter.

We have further avoided addressing the consequences for this crisis in the humanities for one particular university (UvA) which occurred after our project was concluded but deserves a note, albeit as a slight aside. In 2014, UvA announced a radical restructuring of the humanities faculty, reducing the number of courses and positions, at least partly in line with the sectoral restructuring plan described more neutrally in the section, "Policy Desire for Clear Measures of Humanities' Societal Impact". Out of a lack of faith in the consultation process surrounding the decision, a group of students and staff occupied sequentially two buildings to protest about the pervasiveness of profit-led thinking in university decision-making. This led to the resignation of the university chair following an extremely heated public debate concerning the occupation, but it is perhaps noteworthy that the crisis in the humanities is such that it can lead to civic disobedience and unrest. More information on the occupation can be found in a special issue of the Open Access journal *Krisis: A Journal of Applied Philosophy*, to which we also contributed (Benneworth 2015).

But this chapter provides a neat illustration of the ways in which the search to deal with tensions drives an institutionalisation process that affected the landscape of Dutch humanities research. A "small country" mentality took over in which speciality—excellence even—was critical to what kind of research could be supported. But even against the pressures

driving academics towards "excellence" and its supposed antithesis with relevance, a set of new norms emerged in science practice in which much closer connections were sought with particular publics, creating public value. This arguably was most visible in the work of NIOT, a historical archive whose work into the Srebrenica massacre led a government to fall, but became increasingly commonplace in academics' behaviours. But policy-makers were not always quick to recognise the ways in which publics were becoming increasingly enmeshed into academic research practices, something that remained constant to the end of the research, with difficulties existing in defining humanities public value in ways that aligned with the strict austere functionalism of the then-coalition's research programme.

CLOUDS ON THE HORIZON: HOW THE PUBLIC UNIVERSITY MET THE PILLARISED DUTCH SOCIETY

In common with many university systems, what lay at the heart of the earliest Dutch universities were a set of activities which we would today understand as the "humanities". Rüegg (1992a) ties the emergence of the institution of university to a particular kind of institutional fix found by the Catholic Church in the twelfth century to provide appropriate training for priests and Church administrators. University staff at this time were employed on what were called 'prebendary stipends', providing them with the autonomy and time to carry out teaching duties, which they organised within semi-autonomous, quasi-cloistered communities such as the universities of Paris, Bologna and Oxford. Bender (1988) notes that with the rise of merchant capitalism in medieval Europe, temporal as well as spiritual authorities appreciated the value of advanced schools to train the administrators they required to run their estates and capture the benefits of city trade for their feudal estates. The nature of universities evolved from the study of philosophy and theology to incorporate the study of humans, representations and language (Rüegg 1992b). At the heart of these communities was teaching based around a classical curriculum—the *artes liberals*—skills appropriate for free citizens (as opposed to slaves) to live productive, good lives (Benneworth 2011).

The first Dutch university was created in Leiden in 1575 following the occupation of the Low Countries university city of Leuven by the Spanish with the fall of the southern Netherlands. The university at Leuven had been founded in 1425 and funded by the Duke of Brabant under papal

patronage along with a number of notable city merchants in part to ensure the region's continuing prosperity. Under Spanish occupation, the university turned away from the humanism that it had adopted in the sixteenth century, reducing its attractiveness as a centre for autonomous study. Leiden University was created in 1575, in what Grafton (1988) describes as much as a political act of victory celebration as much as an intellectual act of creating a community of scholars. The openness of the Netherlands along with its burgeoning economic success of the Golden Age allowed the foundation and growth of a number of universities from the sixteenth to the eighteenth century: Franeker (1585), Groningen (1614), Utrecht (1636) and Harderwijk (1648). During the Napoleonic kingdom (1807–1813), the universities of Franaker, Harderwijk and Utrecht were closed: following the formation of the United Kingdom of the Netherlands, the University of Utrecht was re-established and designated one of the three Rijksuniversiteiten (State Universities) in the northern Netherlands. The Amsterdam's *Athenaeum Illustre* was in parallel upgraded to the University of Amsterdam (1815), with the support of the local municipal council who both funded and were involved with the appointment of the professoriate.[1]

In this Golden Age period, the disciplinary spread of Dutch universities again expanded to include the newly emerging physical and life sciences, although these universities remained centred on law, theology and philosophy. It was in this period that in Germany the Humboldt university emerged as an organisational form for driving forward technological development and universities expanded to meet the needs of creating a new industrial elite (McClelland 1988). These pressures were not unique to Germany. In the case of Scotland when their Ancient Universities failed to respond to new technological opportunities, industrialists responded by creating new learned societies to create and circulate technological knowledge (Phillipson 1988). And in 1843, driven by fears that the Netherlands (shorn of Belgium from 1839) was failing to keep up with its economic rivals of the UK and Germany, King William II supported the creation of a new institution, inspired by the *École Polytechnique* in Paris, in Delft, that in 1863 became the first Dutch Technical University (Hospers 2002).

The foundation of the contemporary Dutch university system was laid by the 1876 *Wet Hoger Onderwijs* (Higher Education Law) and this opened the door for a revitalisation of the professoriate to encourage not merely the independently wealthy but those from more modest backgrounds and with a greater interest in social activism. This was an

indirect consequence of the Law, which sought to regulate and allow the expansion of the system. In the context of an increasingly consociational society, with specific pillars representing different communities (liberal, socialist, catholic, Calvinist, Lutheran, *cf.* Pellings 1997). The less powerful pillar communities realised the importance of universities in building a leadership cadre as part of their wider struggles for emancipation. So it was around this time that communities serving both the orthodox Protestant (*"gereformeerde"*) and Roman Catholic communities were created. The *Vrije Universiteit* (The Free University, VU) was founded by prominent *gereformeerde* politician Abraham Kuyper in 1880 to address specific doctrinal complaints from the *gereformeerde* community about theological education and evolved over time to become a comprehensive university with a medical school, fully paid for by the Dutch state.

In 1905, the St Radboud Foundation was set up to create a university specifically oriented towards the Dutch Catholic communities, primarily located in the south of the country, as part of the wider trend towards Catholic emancipation. In 1922, the first Catholic university was established in Nijmegen, and in 1927, a second institute followed in Tilburg, also in the South of the Netherlands. The Catholic University of Nijmegen (from 2004 the Radboud University, Nijmegen) began life as a comprehensive university focusing on the humanities, whilst Tilburg University was more directly specialised on humanities and social sciences, directly connected to their mission to create a highly educated Catholic elite able to participate more actively and influentially in Dutch public life.

In the post WWII reconstruction of the Netherlands, substantial numbers of engineers were required to create a mass technical workforce to drive economic growth and facilitate the necessary investments. As part of this, a second technical university was created co-located with the Philips engineering company in Eindhoven in the south of the Netherlands (Sorgdrager 1981). In 1961, the University of Twente was created in an effort both to increase numbers of engineers being trained, in new disciplinary areas, and also to try to prevent the decline of the region's textiles industry (which for the first time since King William II had supported the sector was facing devastating international competition). The final specialised university is located at Wageningen, created in 1918 out of a former agricultural college to provide research, technology transfer and extension services to support the development and growth of the Dutch agriculture and horticulture industries.

Another group of universities were created to stimulate economic impulses in their host regions (although it could be argued that such a

regional role also featured in the rationale underlying the University of Twente. In 1905, a higher trade school was created in Rotterdam to assist with the education of a technical class associated with the increasing complexity of the port activities, trade and related services. This evolved from a business faculty into a much broader university including hosting a university hospital. The University of Maastricht was created in 1976 in part to assist with processes of industrial conversion in the region of Limburg, which was heavily hit (on both the Netherlands and Belgian side of the border) in the 1960s and 1970s by the rundown and closure of the coal industry. The Open University of the Netherlands was created in 1984 in order to offer second-chance education in the Netherlands, and is also headquartered in Limburg, in the former industrial town of Heerlen.

The 14 Dutch funded universities can be divided into four groups depending on their background and the importance of humanities to their mission. For each of the four groups, humanities occupy a different institutional position within the university, and are justified in different ways within the institution (Table 5.1).

Our argument is that the sources of the crisis in the humanities in the Netherlands is that the Dutch universities were created as primarily humanistic institutions, but in the course of the last 150 years the idea of the university has evolved in which the centrality of humanism has become

Table 5.1 Role of humanities in the 14 funded universities in the Netherlands[a]

Sector	Universities included	Rationale for humanities in university
Ancient	Leiden, Groningen, University of Amsterdam, Utrecht	University originally primarily humanities. Humanities retain symbolic and prestige value alongside more useful new areas
Consociational	VU University, Radboud, Tilburg	Humanities education important for access to the professions and higher public life: creating a new intelligentsia
Socially motivated ·	Maastricht, Rotterdam, Open University	Relatively inexpensive to build up, bring student numbers and help to build profile and prestige of institution
Non-humanities	Delft, Wageningen, Eindhoven, Twente	Humanities remain tangential to university profile but can become important to some study areas e.g. philosophy of science and technology

Source: Authors' own design

[a] These are the names that are used in the report. Although the various institutions have had various names through their histories

increasingly peripheral. The formalisation and expansion of the university system created a fundamental pressure on humanities. Universities were pulled towards humanities as prestigious disciplines, and in the context of expansions where many institutions were set up in ways that did not seem entirely permanent, having humanities was seen as part of symbolically demonstrating that these new institutions were respectable universities. But on the other hand, the increasing resources pouring into universities were increasingly related to the value that they had in creating a well-educated citizenry and workforce capable of function in an increasingly technological society. Thus although universities were growing, and humanities were seen as a vital component of universities, paradoxically the outputs of those faculties, the lawyers, the priests, the philologists and the linguists were throughout this period of massification increasingly peripheral to the business of the Dutch universities.

THE PLACE OF HUMANITIES IN AN INCREASINGLY TECHNICAL UNIVERSITY ENVIRONMENT

There was internationally increasing awareness from the 1960s of the increasingly perilous situation within which the humanities were moving. Already in 1959 in the UK, C.P. Snow had pointed to the growing divide between scientific and humanities cultures in society at large. In 1964, Plumb (1964) coined the phrase in the UK of a crisis in the humanities to refer the sense of neglect overtaking the humanities in failing to persuade policy-makers that their subjects mattered. The Netherlands introduced a new Higher Education Law in 1960 that marked the start of a massification characterised by an increasingly "publicisation" of the Dutch higher education system (*cf.* Deitrick and Soska 2005), with its attendant increasing imposition of external pressures on these partly self-governing academic communities (Huisman 1995). These changes consequently exposed universities to a set of imminent pressures and direct political intervention. In the first instance, this was not necessarily problematic, with university humanities benefiting from a crisis of trust between citizen and state. But as Dutch economic problems multiplied in the 1970s, Dutch universities found themselves increasingly constrained by demands for greater pragmatism, culminating ultimately in the Dutch crisis.

The most obvious set of changes to higher education came in 1970, culminating in a new law regulating university governance that shifted power from primarily academic groupings (Senates) to Executive Boards and

Faculty structures. The background to these changes lay in an outburst of student unrest in Amsterdam and the occupation of the Catholic University of Tilburg, and then the *Maagdenhuis*, the monumental administrative seat of the University of Amsterdam (where a total of eleven student occupations have taken place through the years, including most recently in 2015 by disgruntled UvA humanities students). Partly inspired by student protests across Europe (Daalder and Shils 1982), students in the Netherlands rose up against what they felt to be the closed nature of higher education reflecting the closed, elite-centred nature of their contemporary societies (Maassen 1996). Changing universities was for these protests across Europe a first step in opening up and democratising society (Delanty 2002). In 1970, the Den Uyl Cabinet, as part of trying to placate wider societal unrest, launched a Law of Reform of University Management. This abolished the senate approach to university governance, replacing it with executive boards for each university and faculty, each overseen and regulated by Councils elected by staff and students (De Boer 2003).[2]

The Den Uyl Cabinet also sought to bring science and technology back under democratic control with a Science White Paper in 1975 that laid the foundations for an increasing control by the state over the direction and focus of science research even within universities. Critical to this White Paper was in setting a principle that in a mixed economy, the state should do little to intervene directly in firms, but rather should use public investments to encourage private sector technological investments. For the first time, programmatic research funding was introduced for universities, in energy, environment, labour market and demography, which demonstrated the essence of the problem that would become a crisis, which was that it was difficult for humanities to define its place in an instrumental funding environment.

This situation was exacerbated with the 1980 Innovation White Paper, which extended the definition of what society desired from its research to not only the domains in which knowledge should be created but also the desire for it to be commercially exploited as a means of driving economic growth. Indeed, the so-called *Nota Innovatie* (this Innovation White Paper) saw an explicit aim of science policy as increasing the orientation of Dutch university research towards society, and in particular to business. For the sake of clarity this White Paper did not rule out that the solution of technological problems required social and humanistic as well as technological knowledge. Nevertheless, for the first time it created an implicit policy understanding that the tangible value of humanities research in the

Netherlands lay in its ability to contribute to a set of problems that were emerging outside the humanistic domain, removing the locus of control in setting research questions from humanities scholars and passing them to technological researchers.

From 1981, a further additional strong steer was given from the centre for universities to concentrate on areas of critical mass and excellence, being incentivised by rewarding universities for their good performance. Whilst the two white papers were primarily organisational in their scope, this exercise was a simple administrative exercise in driving change by shifting budgets away from a simple block grant towards output-driven outcomes based on a market logic. In the first phase (*Taakverdeling en Concentratie*, Division of Labour and Concentration, TVC, 1981–1985), universities were invited to develop plans to shift tasks between universities to create concentration, in return for an increased share of an overall reducing education budget. The plans concentrated a set of cuts across all universities, across a number of discipline areas where there was felt to be an oversupply of graduates, where research was not of good quality or the social added value was in question. A further iteration of this concentration came with the Selective Contraction and Expansion Operation (*Selectieve Krimp en Groei*, SKG 1987–1991). The biggest losers in this process in terms of percentage reductions in their public funds 1983–1993 were the classical humanities universities, Nijmegen, Leiden, Utrecht, the VU, UvA and Leiden (Jongbloed and Salerno 2003).

THE "BURSTING OF THE DAM" AND HUMANITIES' CRISIS

The crisis for humanities in the Netherlands emerged out of the net effects of these cuts on the old universities. Table 5.2 shows the disciplinary focus of those cuts, primarily on the old humanities, and in particular for the *Kleine Letteren*. The *Kleine Letteren* had become such an issue in humanities that they tended to be referred to as a class in themselves, something which translates as the "small humanities". What the term referred to in the debate about the future of humanities were languages for which the Netherlands had a number of established chairs, and in some cases very high-quality research, but for whom the student intake had already by this period fallen (far) below the established norms for staff-student ratios. In such cases, the plan was to concentrate activities in a single university and close the chairs in other universities, thereby to raise the staff-student ratio and to make the degree justifiable into the future.

Perhaps an interesting (if typical) example is the case of Spanish at Leiden; the degree was to be converted from a single subject Spanish language and literature degree into a *doctoraal* (Master's equivalent) in Latin American language *and* culture, reflecting labour market demands by also equipping students to deal with a foreign society as well as simply learning a language. A growth fund was provided for this by the government and investments were made to create centres of excellence and critical mass in research in the humanities, as well as trying to stimulate more universities to move towards offering broader humanities degrees than the much narrower subjects attracting extremely limited student numbers (Table 5.2).

In reality, the TVC proposals did not represent a substantial shift in resources *between humanities and other fields*, but clearly involved a rebalancing of resources within humanities to those fields which conformed to the government's vision of what the scientific endeavour involved. Table 5.3 shows the allocation of the science budget on a disciplinary basis in the TVC round, before and after the proposed cuts. The net effect of TVC allocated the cuts in ways that more or less reflected the share of funding received, and arguably the worst hit of the disciplinary fields was dentistry and veterinary science, which lost 20 % of its overall allocation (Table 5.3).

The second round of cuts that took place was the SKG round from 1987 to 1991. The focus of this for the humanities was that labour market considerations made restructuring and profiling unavoidable, both via differentiation between institutions as well as the closure of some of the smaller departments. For each of the universities, a detailed plan was presented for all faculties. There were seven faculties affected in the SKG round, and the details are provided below (O&W 1987, authors' own translation).

- Leiden: German will be preserved: complementarity will be developed between history at Leiden and Social History at Rotterdam;
- Utrecht: Restructuring of faculty continued: new agreement follows in 1992 after evaluation; complementarity will be developed in history between Utrecht and UvA;
- Groningen: Integration of separate Romance languages courses;
- Rotterdam: complementarity will be developed between history at Leiden and Social History at Rotterdam;
- UvA: Reorganisation of study trajectories: complementarity will be developed in history between Utrecht and UvA;

• VU: Complementarity will be developed with art history at UvA and the VU;
• Tilburg: Closure, unless particular conditions are met in 1990.

Table 5.2 Final TVC proposals for the humanities, 1983

CUTS (total f. 23.477 m out of a total humanities budget of f. 267 m)

Overall	More concentration than in original plan	–
Dutch, English, history, art history	Await decision of disciplinary plan	Disciplinary plan involves creating thematic focus
Classics	More concentration than in original plan	Closure at Utrecht, co-operation with Nijmegen
Spanish	More concentration than in original plan	Closure at Leiden
Italian	More concentration than in original plan	Closure at Groningen and Nijmegen
Slavonic languages	Merger not in original plan	Concentration at Leiden
Kleine Letteren (small languages)	–	–
Modern Greek	Leave unaffected	Remains at Groningen
Scandinavian languages	More concentration than in original plan	Closure at Utrecht
Arabic, Semitic languages	Await decision of disciplinary plan	
Indian/Iranian languages	Follow original plan	Concentration at Leiden
Language/Literature science	Follow original plan	Creation of thematic focus
Phonetics	More concentration than in original plan	Concentration at Utrecht

Investments in reform (total f. 4.763 m)
Strengthening Indonesian languages at Leiden (f. 400,000 per annum for ten years)
Utrecht to receive f. 3.75 m 1984–87 to establish a liberal arts programme
UvA to receive f. 1 m pa for ten years to establish an institution for European Humanities
Leiden to experiment with *propadeuse* Spanish and *doctoraal* in Latin American language & culture
Creating centres of excellence over ten-year period on basis of a discipline plan:
 Leiden f. 200,000 pa
 Groningen f. 700,000 pa
 Nijmegen f. 463,000
 Rotterdam f. 100,000 pa
 VU f. 400,000 pa

Source: O&W (1983), authors' own translations

to the university sector in very instrumental, policy-focused ways. Those disciplines which benefited from a perception of being useful were then able to grow and thrive, whilst those that did not faced both stagnation, but also a sense that their future was worsening in that no new resources would be made available for them.

This led to a split *within* the humanities in the 1980s, between the "modern" humanities, such as international relations, media studies and communications sciences, and the traditional humanities, notably modern languages (the aforementioned *kleine letteren*) in which the Netherlands was extremely strong. The "modern" humanities in this period conformed with the idea of "useful science" in that in the 1980s, their recruitment of students was sustained and even rising. But at the same time, the smaller humanities disciplines began to become increasingly "subsidised" and protected within the institutional model with low student numbers. This created tensions between the two subfields: modern humanities faced rising student numbers and staff–student ratios, whilst the old humanities enjoyed a protected position at least partly validated and legitimated through appeals to a sense of tradition and excellence of the older disciplines. In 1987, the influential weekly news magazine *Elsevier* published an open letter from an expatriate Dutch philosopher, Frits Staal, then working at University of California, Berkeley to the Minister of Education. In this letter, he argued that the spreading of the cuts to higher education were disproportionately hitting the humanities, and a small programme of targeted investments could help reorganise the humanities in ways increasing their benefits for Dutch society.

In response, in 1989 Staal was installed as Chair of a Commission charged with two tasks, firstly developing investment proposals to strengthen and make sustainable the small languages, as well as to consider the balance of small language activities undertaken within universities and other government funded institutions. This report (*Baby Krishna* 1991) dwelt at length on the gloomy prognosis for the future of the small languages in the Netherlands, but formed the basis for a structural investment of *f.*10 m in the six humanities faculties, with half for Leiden and the other half spread between the other five universities to support the small languages. Although the ministry and universities signed a solemn covenant on the use of those funds ("Staal funding"), the funds were added to their block grant which were allocated exclusively at the discretion of university executive boards, and therefore nothing guaranteed that the humanities would benefit from it. The

claim for value made in Baby Krishna was almost a curatorial one, that there were unique knowledges for historical reasons within Dutch universities, and funding these languages despite falling student numbers was a way to preserve the legacy of past investments and retain capacity and understanding for which the Netherlands had a duty to a wider global community.

Following the publication of *Baby Krishna* and the introduction of the "Staal Funding" (the $f.10$ m, about €4.5 m) a concern remained that language and linguistics were being privileged and that was leading to a hollowing out of the other non-protected humanities disciplines. A second committee was established to address this issue, and their report foresaw that the solution to the division emerging in the humanities between the modern, market-facing humanities and the traditional, humanistic disciplines was to concentrate the latter in the established Humanities faculties and the former in the smaller specialist universities. Chaired by Henk Vonhoff, the report (Vonhoff, 1995, entitled in the original Dutch *Men weegt kaneel bij 't lood*) made two different public value claims for the humanities, the intrinsic, symbolic values of traditional humanities in parallel with the extrinsic, pragmatic (economic) value of modern humanities. The report was seen in some quarters as calling for the creation of a two-tier humanities system, between well-funded traditional humanities based on small class sizes and generous research resources, and a much more intensive, labour-market focused modern humanities. The report came to nothing, in part as a result of changes in the machinery of government with the departure of the responsible Minister (Job Cohen, see following section), but also because of resistance from supposed beneficiaries. One traditional university humanities faculty actively criticised the commission's findings in the letters page of the leading Dutch newspaper NRC Handelsblad, arguing that they were seeking to integrate employability and societal usefulness into their traditional humanities degrees, and criticising the divisive effect of the proposed division.

In response to the failure of the Vonhoff Commission to achieve change, and in particular to address the question of whether the "Staal Money" was indeed reaching the humanities (given university block grants), the Royal Dutch Academy for Arts and Sciences (KNAW) launched a further commission on the future of the humanities in the Netherlands, leading to the report "Vensters op de wereld". The Gerritsen Commission based its case for humanities having a public value on the basis of providing a way for the Netherlands to understand other times, people and places. The

report tried to square the circle of steering universities to support their humanities without impinging on the autonomy of university executive boards to allocate their resources via the block grant. Reporting in 2002, the KNAW report made a case that universities should try to find a way to put the national interest in having this collective cognitive capacity above the private interests that universities had in trying to make their humanities activities profitable. That little happened with the report can arguably be more attributed to the broader political changes in the early 2000s, following the attack on the World Trade Centre and the murders of Pim Fortuyn and Theo van Gogh, signalling a shift in the Dutch public realm away from encouraging multiculturalism and openness to a more exclusive integrationism (for more detail on this see Benneworth 2014). With such strong sentimental currents driving policy, it is perhaps unsurprising that the question of defining the real public value of humanities research in the Netherlands, remained unanswered.

POLICY DESIRE FOR CLEAR MEASURES OF HUMANITIES' SOCIETAL IMPACT

The Gerritsen report marked an acceptance by the academic community (as articulated through the KNAW Academy) that humanities had a duty to respond to public and societal demands for value in return for public funding. Certainly, Gerritsen did not attempt to invoke an intrinsic value or exceptionalist argument that humanities should be exempt from the kinds of strictures accepted in other disciplines. Gerritsen at least expressed an ambition that the societal value of humanities should not be disregarded by researchers, and whilst it was as much a report about teaching as research, the report expressed a clear position that Dutch humanities must reconfigure itself to meet these challenges, including delivering public value through its research and drop any pretence to exceptionalism. In the politically febrile period following the murder of Fortuyn, two rather unstable populist right governments came to power and teetered forward a total of five years without ever making substantive use of the Gerritsen Report's recommendations (Bosland 2010). But when early elections in 2007 brought a Grand Labour (PvdA)–Christian Democrat (CDA) coalition, the incoming education Minister Ronald Plasterk (Labour PvdA) saw in those plans the rationale to ask humanities to restructure itself to deal with these challenges, including critically the challenge of the public value of that research.

This led to the establishment under the encouragement of Plasterk of what was by our counting the fourth Commission of Inquiry into the future of the humanities, this time specifically to create a "Sector Plan" to agree funding for university humanities research conditional on restructuring of the sector. This Commission was chaired by prominent Labour politician Job Cohen, who had been the Education Minister who had established the ill-fated Vonhoff Commission. In a sign of increasing internationalisation of Dutch research, this commission published its final report in both Dutch and English languages and it is readily available to find on the internet. An implementation body was established with an annual budget of c. €15m following this report to provide additional structural resources to universities in response to delivering a number of clear goals (*Regieorgaan Duurzame Geesteswetenschappen (Regieorgaan Geesteswetenschappen 2011, 2012, 2013, 2014)*). Alongside this, the NWO research council was to offer far more responsive funding opportunities for the humanities (and also increasingly in the creative arts), and finally came the *quid pro quo* of these additional resources, namely "adequate quality assessment and differentiation". This in particular argued that the humanities need properly engage with the Dutch research quality assessment framework (the so-called Standard Evaluation Protocol, about which more later), and create clear benchmarks for what represented different quality levels of scientific and societal impact. This was attributed by our interviewees to a feeling amongst certain political elite that the real challenge for the humanities was opening them up and forcing scholars to be more accountable and accessible in return for their public funding.

In response to this last demand the KNAW's Humanities Working Group, who had been overseeing the Cohen report, established a Commission to develop appropriate quality indicators for measuring scientific and societal impact in the humanities. The Dutch research evaluation system requires all research units to undergo an evaluation once in each period, at a time and in a configuration of their choosing; however, the evaluation must follow the Standard Evaluation Protocol, which sets out a standard process in which a self-evaluation report is written, audited by an international visitation committee and graded on a scale of "1" (unsatisfactory) to "5" (excellent) (KNAW 2010). Much of the guidelines on what constituted scientific and societal impact was defined by practices in the natural and medical sciences (in terms of journal citation scores or licence income). There was thus a sense that the evaluation scores in the judgements were not "objective" and in the absence of solid criteria for

social and scientific impact, the system was open to the suspicion that international humanities scholars might be throwing their embattled Dutch colleagues a lifeline in their hour of need with overly generous ratings.[3] The Indicators Commission, overseen by Utrecht University Professor Keimpe Algre, was therefore to create a widely accepted, and ideally respected, set of benchmarks for measuring *ex post* research impact (in scientific and societal senses) that would eliminate any sense of bias, and allow the humanities to objectively demonstrate their contributions to science and society.

The Commission proceeded very quickly to propose a framework, and then on the basis of those proposals to pilot them in a number of research centres, the KNAW's own Meertens research institute and the Groningen Research Institute for the Study of Culture. Supported by the group working to implement the Cohen Report, the Algre Commission published its draft report at a well-attended seminar at the Netherlands Institute for Advanced Studies, Wassenaar, in November 2011, which the HERAVALUE team also attended.[4] The report made a range of proposals including both setting out a potential set of indicators for use by the humanities as well as emphasising the point that if their indicator set lay unused then they had failed, so there was a need to create concrete actions to implement them, as had not happened with previous reports into the humanities. The report offered a comprehensive set of indicators measuring scientific impact reflecting monograph and other scholarly habits in humanities (see Table 5.4 below). The key issue behind the framework was that it did not define specific indicators but rather gave a set of conditions for what would count as useful conditions. Indeed, the report to some extent parked that particular problem to be dealt with in the light of a national report that was later to appear on the subject of valorisation indicators for all scientific areas. The matter was passed back to the Implementation Group (the *Regieorgaan*) with the recommendation that a working group was needed to undertake more pilots, better develop concrete indicators and also to promote a wider discussion of valorisation in the humanities drawing upon discussions elsewhere in science (particularly social sciences and civil engineering).

In 2012, following the report finalisation and publication, the Implementation Group agreed to provide €300,000 to the National Humanities Deans group to continue the operationalisation and implementation of the indicators. This was approved, and a group, chaired by Professor Van Vree (Dean of the UvA) was appointed to continue that

Table 5.4 Potential indicators for valorisation

Civil-society publications	Articles in specialist publications (not being primarily scientific/scholarly journals)	List Selection of key publications
	Monographs for non-scientists/scholars and interested individuals	List Selection of key publications
	Chapters in books for non-scientists/scholars and interested individuals	List Selection of key publications
	Other civil-society output, for example collections for non-scientists/scholars and interested individuals, editorships of specialist publications, handbooks, dictionaries, editions of texts, databases, software, exhibitions, catalogues, translations, advisory reports on policy	Quantitative and/or qualitative information to be requested as determined according to the context
Civil-society use of research output	Projects carried out in collaboration with civil-society actors	Simple statement with dates (years)
	Contract research	Simple statement with dates (years)
	Demonstrable civil-society effects of research	Simple statement with dates (years)
	Other types of civil-society use, for example reviews, citations in policy reports, use of publications, media attention, books sold/ loaned	Quantitative and/or qualitative information to be requested as determined according to the context
Evidence of civil society recognition	Civil-society prizes	Simple statement with dates (years)
	Other evidence of civil-society recognition, for example civil-society appointments, invitations to give lectures, invitations for media appearances, advisory positions/ membership of advisory committees	Quantitative and/or qualitative information to be requested as determined according to the context

Source: KNAW (2012)

activity, However, after the conclusion of the HERAVALUE research project, Van Vree's group were unable for operational reasons to make progress, and in June 2014, it was stated that the group had been given until mid-2015 to advance the work for operationalising the work on acceptable indicators for humanities impact. The Implementation Group was given a further impulse by a KNAW report in 2014 that underlined

the urgency of humanities in Dutch universities working more effectively together to avoid chasing only excellence and neglecting substantial areas in the humanities. This report (*Witte Vlekken* "Blank spots") argued that more impetus should be put behind the implementation group to get the humanities to (once more, echoing the previous TVC and Gerritsen committees) do rather more work to allocate tasks between universities in a way that ensured that public investments were flowing to preserve the viability of the Dutch humanities research landscape.

All of these issues together seem to suggest that the Dutch humanities research was in some way trapped in a cycle of impossible demands, unwelcome acts and inconclusive commissions. The issues at the end of the period appear to be precisely the same as those at the start, a fragmented humanities field, too introverted and unable to steer itself to produce value for Dutch society or capable of being held accountable to government for its excellence. At least that is the impression that one would get if one's view of the public view of humanities was formed entirely by what elites said about humanities rather than to what humanities researchers were actually doing. Ironically enough, there has been a transformation in the way that humanities research was active in this period in creating value for society. This partly reflects an explosion of new media channels to reach society but also reflects at least partly a cultural change amongst research funders and researchers themselves in the way that "good research" is seen as being defined as also encompassing creating impact.

UNIVERSITY-BASED HUMANITIES AT THE SERVICE OF SOCIETY

Our research considered how "users" interacted with humanities researchers in the course of their research, and how that research flows into society. There are two ways of representing the flow of that knowledge into Dutch society that were found in the research, namely the pipeline and ecology metaphor. Each of those two metaphors is useful in understanding the relationship between the researchers, the research topics and various kinds of societal actors. Each of those also have implications for understanding how Dutch humanities research is valued by society, and identifying the characteristics of research "most valued". One can consider two ways in which users encounter research, one is through the metaphor of a linear model mediated through intermediaries and aggregators in the media, and

the other is as it is diffused and takes root through a wider social political economy. One model you could evoke is of a "filtered pipeline", that is to say that a research project is undertaken, and that it creates findings which then find a natural user (as illustrated in Fig. 5.1 below).

One concrete example encountered in the course of the study was a research project (perhaps ironically within the German-funded Max Plank Institute for Linguistics, MPIL) into "ideophones". Ideophones are words which through their form carry a natural association with some kind of contextual information; an example of these are onomatopoeia, words which sound like what they are describing such as the Dutch *Oehoe* for an Owl or English splosh. A PhD project on the subject of ideophones in one particular African language, undertaken at Nijmegen was in the field of anthropolinguistics, clearly falling within the field of humanities. This PhD was completed and was awarded the *cum lauda* distinction, pointing to the underlying excellence of that research. In the course of the research and following its completion, the research appeared in a number of media outlets, including a national radio programme, within the NRC's Saturday science supplement, and also within a TV programme. At the time of the research:

- The average daily paid circulation of *NRC Handelsblad* was 190,247 (taken from the relevant HOI figures in 2012);
- The TV programme *Labyrint* attracted 340,000 viewers. And the segment concerning the research at MPIL lasted 12 minutes (taken from the relevant Kijkcijfers figures in 2012);
- The typical market share for Radio 2 was 10.6 % in the period closest to the broadcast of the show (January–February 2011).[5]

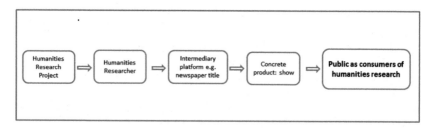

Fig. 5.1 Filters applied to humanities research projects in reaching users (*Source*: Authors' own design on the basis of interviews)

What this shows is that there was a definite audience who devoted some of their time, and signalled an interest in some way, in this research. It is of course not possible to show how this then affected their behaviour, but clearly, the public attached some value to this research.

But this was not the only means by which Dutch humanities research reached users, intermediated through gatekeepers; rather there were various forums and moments where social users encountered, and found humanities research to be valuable. On the basis of all the interviews—activities reported by academics as well as by the users—it was possible to develop the following schematic for how humanities research creates impact. What is notable in this schematic is that there are various kinds of publics that use research, depending on the different ways by which it reaches them: the expected reaction from those publics, and the potential of research to create a reaction and hence attributable impact, varies depending on those pathways. On the basis of the interviews, it was possible to see that "publics" and users were involved and influenced/affected in quite distinct ways in the humanities research process (here excluding impacts via teaching). What follows is an attempt to develop a typology from what emerged in the research:

- *Research subjects*: in several fields of humanities, publics are subjects for research, including philosophy, gender studies, area studies, museum studies, as well as providing materials, artefacts and evidence for research projects (e.g. photo archives);
- *Cultural experiencer*: publics experience humanities research through "high" cultural consumption, such as museums or galleries, intending that the experience changes the way that the visitor understands the world, and thereby produces user satisfaction;
- *Media consumer*: publics consume humanities research through its incorporation into media content which generates consumptive satisfaction for the user through acquisition of that knowledge not otherwise easily or readily accessible;
- *Habermasian democrat*: publics are involved with humanities research through debates shaping its construction and execution, for example in applied public philosophy, where public consultation and dialogue can be an important reflective methodology, but also when publics interact with humanities research, for example with web 2.0 tools;

- *Direct user*: public audiences may directly engage with humanities researchers, through correspondence, consultancy relationships (extremely rare), research ambassadors into schools and other public engagement events;
- *Citizen service user*: publics may experience humanities research which has affected the development or framing of public services, or in which humanities research has—for example, through applied philosophy—influenced wider policy debates (see Fig. 5.2).

It is important not to see these two models as representing different kinds of behaviours—they are different ways of seeing how knowledge flows. The researcher presented above according to the pipeline model also held a Science Café—making the audience attending that event (also a kind of public) direct users of his research—in his research dialogues (see Fig. 5.3). Clearly there is an issue that humanities research may make an impact that is highly diffuse, and it might be hard to make a compelling argument that that all adds up to large-scale social change. But at the same time, it is clear that other humanities disciplines have been successful in

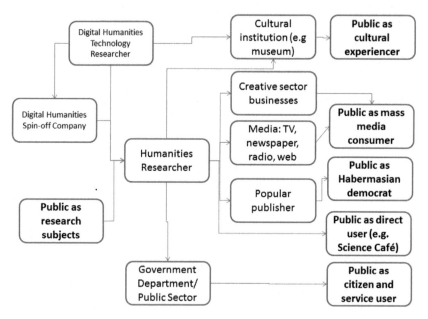

Fig. 5.2 Humanities Research at the Centre of a More Complex Ecology Model. (*Source*: Authors' own design)

Fig. 5.3 Excellent Humanities Knowledge Flowing into Public Democratic Spaces. (*Source*: Science Café Deventer reproduced with permission).

mobilising a discourse in which relatively small benefits for public users are seen as validating their overall public benefits. There are examples from the Netherlands of how Dutch humanities research has been upscaled to create high-level public benefits. Benneworth (2015) gives an example of how a Dutch historical research laboratory created to deal with the trauma of WWII occupation and collaboration by Dutch citizens provided capacity to help process the national shame associated with the Srebrenica massacre.

In the absence of a strong historical method in our project (we are after all as we note in Chap. 1 social scientists who are nevertheless trying to reconstruct a policy debate over a longer time period) it is not possible to say that humanities research has become more engaged, or placed public value more central to its interests, in recent years. Nevertheless, the following points can be made. Humanities scholars have faced pressure/encouragement from their host universities, from the KNAW and other research coordinators to ensure their research creates usefulness. The main responsive research funder, the NWO, has since 2002 in its strategic research plans placed substantial emphasis on demonstrating that research has a good chance to create social impact. The impact agenda has been an important part of attempts to modernise humanities and make a political case that even core disciplinary research has public value for society. New forums have emerged bringing humanities research to publics reflecting conscious institutional and researcher efforts to improve public engagement. One does not have to scratch too far beneath the surface in the public realm to find examples of humanities research embedded into things we might otherwise take for granted: the Dutch Rail (NS) e-ticket (OV Chipkaart) was developed in association with not only designers but also philosophers to improve usability and product functionality. How then to square an apparently satisfied and stimulated Dutch public with policy-maker dissatisfaction and the academic gloominess that are the *Leitmotif* of the last thirty years? It is to that point that this chapter now turns.

Unloved and Invisible? Ambivalence and Contradictions in the Dutch Humanities

The case of the Netherlands illustrates quite starkly that there is a fundamental tension in the way that the valorisation of research is perceived, not exclusive to the humanities, but prevalent in that area. This is not merely true in the Netherlands, and indeed the then-Provost of the arts and humanities specialist HEI Goldsmith's Professor Geoffrey Crossick put it most memorably for the case of the UK (see also Chap. 2). He took

aim at what he called a belief in the "power of widgets" (2006, 2009), looking at the epiphenomena flowing from a few research projects. He proposed what was necessary, and we here are rather liberal in our para-phrasing, as trying to understand the aggregate societal contribution of an accreting knowledge pool as knowledge echoes through the various societal conversations by which humanities as social creatures guide and direct their collectivities. The case of the Netherlands can be understood as an attempt to change a sector that by its own admission by the 1980s was rather stagnant and inward looking. This was partly a consequence of being starved of resources as financial reforms made funding follow a falling number of humanities students within an environment of more general cuts to Dutch public expenditure. In the course of the 1980s, the Dutch policy approach was in seeking to use universities as a means of driving innovation and hence national productivity growth, as a deliberate policy choice to avoid excessive interference in industry (in part a result of a series of rather disastrous interventions in declining industrial sectors).

There was a net effect that the idea of the use of universities to policy-makers became intertwined with this notion of their immediate economic value and their capacity to infuse innovation into existing businesses. But at the same time there was a parallel realisation, continually reaffirmed, that the public value of research was not just in its immediate economic benefits but also in the wider contributions it made to society. This was not always foremost in policy-makers' minds, and clearly by the time of the Cohen report, there was a strong desire by policy-makers for universities to be generating more of their own funding through research commercial-isation. But there were counter-voices in 2007. For example, the statutory Advisory Council for Science and Technology (AWT) published a report on the public value of the social sciences and humanities research in the Netherlands specifically as a counterweight to the sense that science-based models were unhelpful for humanities. Although AWT are an independent body, the inquiry was established with government approval, in response to a Parliamentary Question (from Cisca Joldersma, an MP who had pre-viously been a university Associate Professor in Social Sciences). She had argued that "When the distinctive character of humanities and social sci-ences is taken into consideration, then far more valorisation is currently taking place than we acknowledge".[6] The report itself noted that other partners in the science system were also mobilising to try to deal with this conundrum, the policy tendency to look through a highly restrictive lens at valorisation, with potentially negative consequences for the humanities (and social sciences).

The other element of this was a dawning realisation in the course of the 2000s that Dutch humanities research had actually become rather strong within Europe and globally, which had some extent of ameliorating the pressure on the subjects. There had been a modernisation of the humanities, involving internationalisation, the shift to English as the *lingua franca* of Dutch humanities publishing, the emergence of new subjects (such as digital humanities) but also a greater emphasis on valorisation of that research. In the HERA ERA-NET programme that funded the research behind this volume, humanities researchers based at Dutch institutions were proportionally the most involved in the programme when size of science system is accounted for (the UK was absolutely dominant in numerical terms). Likewise, Dutch universities do well in rankings of arts and humanities, that might be in internal terms of the comparative research productivity as captured in a fragmentary way in the research evaluation processes. But the Netherlands also performs well in international rankings for arts and humanities—in 2014, six Dutch universities were ranked in the Top 100 Globally by the proprietary *Times Higher Education* ranking of arts and humanities[7] (comparable with the 35 in the USA and 20 in the UK when controlling for system size).

One interviewee described that whole process of attempting to define indicators for the public value of humanities research as "The Search for the Golden Egg" (perhaps a Dutch equivalent of 'finding the secret of alchemy'). Policy-makers defined themselves as being enormously enthusiastic about the topic before the studies started, but once they completed and made their recommendations, the policy agenda had moved on, and there was widespread indifference. But it was not just policy-makers who were on this searching journey, but academics were also involved, and in the course of the search for a definition for public value. Along the way of the attempt to set indicators that could measure that public value, there was a widespread change in humanities research practice that saw Dutch humanities research maintaining a leading position—even accounting for its relatively small size—in the global humanities research effort. The issue of indicators has even at the time of writing in February 2016 never really been satisfactorily resolved. There has been a persistent inability to develop an indicator set that would capture as neatly as a few headline figures on spin-off companies or patent income the manifold ways that humanities research influences society. But that tension also reflects a tension within government between camps that ask the question (as one interviewee did ask rhetorically, as a leading humanities scholar) "what chimneys are made to smoke through humanities research?" and those who accept the

argument that humanities impacts are more diffuse but not necessarily less valuable to society as a whole.

The evaluation of humanities research became in one reading a battlefield where struggles much more central to Dutch life were actively contested. We were told by one interviewee within the governmental research service that there remains to this day a strong division between economism and culturism in Dutch government, and the general balance of power within the government clearly shifted since 2002 towards economism. This is of course a reflection of wider trends in Dutch society, reflecting a shifting political climate in which the Netherlands has become much more insular, and less welcoming to and secure of outsiders and difference. The Purple "Paars" period (1990–2002, named after the merging of the traditional colours of Dutch liberals, blue, and Labour, red) was a period where multiculturalism was celebrated. Since Fortuyn's murder this has given way to an emphasis on an imagined "Dutchness" expressed in terms of the (never clearly defined) norms and values so dear to Prime Minister Balkendende (2002–2010) to which all residents are compelled to subscribe. But culturism has not been completely vanquished, as the conflicts between the academy and the radical right have shown and have found expression in the emergence of historian Maarten van Rossum as a celebrity academic pundit challenging "common-sense" right-wing (i.e. vapid sloganeering) politics in the popular domain (Benneworth 2013). The conflict over indicators in the Netherlands reflects the fundamental fact that the public value of humanities research is politically constructed, contested and changing over time, and both reflects but also shapes the prevailing political weather.

Notes

1. http://www.uva.nl/over_de_uva/profiel-en-missie/object.cfm/0F882B7C-1321-B0BE-6897018007848CB3
2. http://www.parlement.com/id/vhnnmt7i60x7/wetgeving_kabinet?key=g09er8v0
3. We were told this by a couple of separate experts in evaluation rather than specific humanities experts.
4. By that point, the team consisted of exclusively Paul Benneworth, who was returning to work after being hospitalised in Korea, and still taking beta-blockers which may have affected his perception of this meeting.
5. http://www.luistercijfers.nl/luistercijfers-nederland/451-luistercijfers-januari-februari-2010-marktaandeel

6. Cited in AWT (2007, p. 10. authors' own translation), "Wanneer rekening wordt gehouden met het eigen karakter van de alfa- en gammawetenschappen dan vindt er veel meer valorisatie plaats dan we op dit moment herkennen".

7. The six universities were: Leiden, Utrecht, Amsterdam, Groningen, Radboud and the VU University Amsterdam—which corresponds to the large, older institutions with substantial "traditional" research activities. Accessed 27 February 2016, from http://www.timeshighereducation.co.uk/world-university-rankings/2014-15/subject-ranking/subject/arts-and-humanities

REFERENCES

AWT. (2007). *A radiant future – Policies for "valorisation" of the humanities and social sciences*. The Hague: The Advisory Council for Science & Technology. English language summary. http://www.awti.nl/upload/documents/publicaties/engels/a70_uk.pdf. Accessed 20 Jan 2015

Bender, T. (Ed.) (1988). *The university and the city. From medieval origins to the present*. New York/Oxford: Oxford University Press.

Benneworth, P. S. (2011, August 29–31). *Measuring societal impacts of universities' research into the arts and the humanities*. Paper presented to "Measuring the value of arts and humanities research", HERAVALUE Roundtable EAIR 33rd Forum: Bridging Cultures. Promoting Diversity: Higher Education in Search of an Equilibrium. Warsaw.

Benneworth, P. (2013). Thirty years of crisis? The disputed public value humanities research in the Netherlands 1982–2012. *HERAVALUE (Measuring the value of arts & humanities research) Country Report 1: The Netherlands*. Enschede: Center for Higher Education Policy Studies.

Benneworth, P. (2014). Tracing how arts and humanities research translates. Circulates and consolidates in society. How have scholars been reacting to diverse impact and public value agendas?. *Arts and Humanities in Higher Education*, first published on May 14, 2014 as doi:10.1177/1474022214533888.

Benneworth, P. S. (2015). The Maagdenhuis occupation. The crisis of 'soft coupling' and the new university. *Krisis: Journal for Contemporary Philosophy*, 2, 62–67. http://www.krisis.eu/content/2015-2/Krisis-2015-2-10-Benneworth.pdf. Accessed 24 Feb 2016.

Bosland, J. (2010). *De waanzin rond Wilders: psychologie van de polarisatie van Nederland*. Amsterdam: Balans.

Crossick, G. (2006, May 31). *Knowledge transfer without widgets: The challenge of the creative economy: A lecture to the Royal Society of Arts in Leeds*. London: Goldsmiths, University of London.

Crossick, G. (2009, October 16–17). *So who now believes in the transfer of widgets?*. Paper presented to Knowledge Futures Conference. Goldsmiths College, London.

Daalder, H., & Shils, E. (1982). *Universities. politicians and bureaucrats: Europe and the United States*. Cambridge: Cambridge University Press.

De Boer, H. F. (2003). *Institutionele verandering en professionele autonomie: een empirisch-verklarende studie naar de doorwerking van de wet 'Modernisering Universitaire Bestuursorganisatie'(MUB)*. University of Twente.

Deitrick, S., & Soska, T. (2005). The University of Pittsburgh and the Oakland neighborhood: From conflict to cooperation or how the 800-pound gorilla learned to sit with–and not on its neighbors. In D. C. Perry & W Wiewel (Eds.), *The university as urban developer: Case studies and analysis*. New York: M.E Sharpe.

Delanty, G. (2002) 'The university and modernity: a history of the present', in Robins, K. and Webster, F. The Virtual University: Knowledge, Markets and Management, OUP, Oxford.

Delft, D. v. (1994, October 6). Een cordon van Staal. *NRC Handelsblad: Wetenschap en Onderwijs*, p. 4.

Grafton, A. (1988) "Civic humanism and scientific scholarship at the University of Leiden" in: T. Bender (ed.), The University and the City. From Medieval Origins to the Present. New York/Oxford: Oxford University Press, pp. 59–78.

Hospers, G. J. (2002). De NHM and de Twente textiel industrie 1830–1860. (The Dutch trade company and the Twentish textiles industry). *Jaarboek Twente, 41*, 40–42.

Huisman, J. (1995). *Differentiation. diversity and dependency in higher education*. Den Haag: Lemma.

Jongbloed, B., & Salerno, C. (2003). De Bekostiging van het Universitaire Onderwijs en Onderzoek in Nederland: Modellen. Thema's en Trends. In *Interim report for the AWT*. Enschede: CHEPS.

KNAW. (2010). *Standard evaluation protocol 2009–2015: Protocol for research assessment in the Netherlands: Revised June 2010*. Amsterdam: KNAW in association with VSNU and NWO. http://www.knaw.nl/Content/Internet_ KNAW/publicaties/pdf/20091052.pdf. Accessed 27 Feb 2016.

KNAW. (2012). *Kwaliteit en relevantie in de geesteswetenschappen Naar een adequaat systeem voor de beoordeling van wetenschappelijk onderzoek*. Amsterdam: The Royal Netherlands Academy of Arts & Sciences. https://www.knaw.nl/shared/ resources/actueel/publicaties/pdf/20121018.pdf. Accessed 30 Jan 2015.

Maassen, P. A. M. (1996). *Governmental steering and the academic culture*. Utrecht: De Tijdstroom.

McClelland, C. E. (1988). To live for science': Ideals and realities at the university of Berlin. In T. Bender (Ed.), *The university and the city. From medieval origins to the present* (pp. 181–197). New York/Oxford: Oxford University Press.

O&W (1983) Taakverdeling en concentratie in het w.o., Tweede Kamer, Sitting 1982–1983, 17649 nr. 13.

O&W (1987) Taakverdeling en concentratie in het w.o., Tweede Kamer, Sitting 1986–1987, 17649 nr. 82.

Pellings, P. (1997). The evolution of Dutch consociationalism 1917–1997. *The Netherlands' Journal of Social Sciences, 33*, 9–26.

Phillipson, N. T. (1988). Commerce and culture: Edinburgh. Edinburgh university and the Scottish Enlightenment. In T. Bender (Ed.), *The university and the city. From medieval origins to the present.* New York/Oxford: Oxford University Press.

Plumb, J. H. (1964). Introduction. In J. H. Plumb (Ed.), *Crisis in the humanities* (pp. 7–11). London: Pelican Originals.

Regieorgaan Geesteswetenschappen. (2011). *Tussenrapportage 2009–10 inzake Monitoring Duurzame Geesteswetenschappen.* Utrecht: Regieorgaan Geesteswetenschappen. http://www.regiegeesteswetenschappen.nl/p/26.html?article_id=10&m=20. Accessed 29 Jan 2015.

Regieorgaan Geesteswetenschappen. (2012). *Tussenrapportage 2011 inzake Monitoring Duurzame Geesteswetenschappen.* Utrecht: Regieorgaan Geesteswetenschappen. http://www.regiegeesteswetenschappen.nl/p/26.html?article_id=12&m=20. Accessed 29 Jan 2015.

Regieorgaan Geesteswetenschappen. (2013). *Tussenrapportage 2012 inzake Monitoring Duurzame Geesteswetenschappen.* Utrecht: Regieorgaan Geesteswetenschappen. http://www.regiegeesteswetenschappen.nl/p/26.html?article_id=17&m=20. Accessed 29 Jan 2015.

Regieorgaan Geesteswetenschappen. (2014). *Tussenrapportage 2013 inzake Monitoring Duurzame Geesteswetenschappen.* Utrecht: Regieorgaan Geesteswetenschappen. http://www.regiegeesteswetenschappen.nl/p/26.html?article_id=20&m=20. Accessed 29 Jan 2015.

Rüegg, W. (1992a). Themes. In H. de Ridder-Symoens (Ed.), *A history of the university in Europe* (pp. 3–34). Cambridge: Cambridge University Press.

Rüegg, W. (1992b). The rise of humanism. In H. de Ridder-Symoens (Ed.), *A history of the university in Europe* (pp. 442–468). Cambridge: Cambridge University Press.

Sorgdrager, W. (1981) Een Experiment in het Bos: De Eerste Jaren van de Technische Hogeschool Twente 1961–1972. Samson, Alphen aan den Rijn 72]}} iversity Press, pp. 59–78.

Staal, F. (1987). De toekomst van de wetenschap in Nederland: Open brief aan Minister Deetman (pp. 62–64). Elsevier 29 augustus.

Staal., F. (1991) "Baby Krishna", the Hague: Report of the Advisory Committee of Small Languages.

Vonhoff, H. (1995). *Men weegt kaneel bij 't lood.* Utrecht: Final report of the Commission on the Future of Humanities.

Policy Challenges for Arts and Humanities Research for the Twenty-First Century

Promoting Innovation, and Assessing Impact and Value

REDEFINING THE SOCIAL CONTRACT BETWEEN SOCIETY AND RESEARCH(ERS)

Recent decades have seen changes in the relationship between the state, higher education and university-based research. These changes are often associated with a "shift from an earlier uneasy balance between professional and state control to some new combination of state and market control" (Dill 1998, p. 362). Concepts such as "managerialism" "corporatisation" and "marketisation" are used to explain and describe a process of profound reform and restructuring across public services, with particular implications for the management and organisation of higher education, and academic culture and work (Marginson and Considine, 2000; Deem and Brehony, 2005). There is a strong emphasis on entrepreneurship and industry-driven research and on accountability, transparency and performance. It is often demonstrable by the extent to which performance and productivity—at the institutional and individual level—are being measured, assessed, compared and benchmarked—initially nationally and increasingly internationally—and the results used to buttress funding decisions and/or set targets. Neave referred to the introduction of "contractualization, conditionality and output-based budgeting" as bringing about a "fundamental change in the relationship between higher education and government and by extension from the latter, society as well..." (2006, pp. 19–20). Due to increased societal complexity, evaluative processes have become a "set of approaches, models, and methods,

which help organize this sort of questioning" (Dahler-Larsen 2007, p. 615). Elsewhere, Neave suggests that the emergence of the "evaluative state" is part of a longer term rebalancing in the accountability association between higher education and the state, one that is "embedded" in the massification of higher education and the desire to ensure "more rapid responses from institutions of higher education" (1998, p. 282). The origins of these changes are associated with the political rise of neo-liberalism across the UK, Australia and the USA in the 1980s, with consequent spill-over effects internationally (Kaiser et al. 1994).

Others have taken a slightly longer perspective, situating the origins of the debate around the unravelling of the "social contract" between scientists and the US federal government towards the end of WW2 (Guston 2000). As the costs began to rise along with the realisation that scientific knowledge could be a competitive advantage, continuous investment became vital. It was in the post-WW2 era in the USA that there emerged a different approach to scientific research, one in which the concept of the "public good" emerged as the litmus test for "generating public support for the scientific community" (Guston and Keniston 1994, p. 7). The shift was marked initially by the publication of *Science, The Endless Frontier* (1945) by Vannevar Bush, Director of the US Office of Scientific Research and Development under Franklin D. Roosevelt. It closely aligned social and economic progress with the belief that "new products, new industries, and more jobs require continuous additions to knowledge of the laws of nature, and the application of that knowledge to practical purposes", thereby setting out the basis for structured governmental research funding at national level. As such, it made a political statement about the need to ensure civilian (i.e. academic) control of science, rather than its militarisation as had been the case with the Manhattan project (Geiger 1993, pp. 14–19). Science would be privileged as long as there were expectations of usefulness. Significantly, the focus was on fundamental scientific research, in which the arts and humanities (A&H) were effectively sidelined on the assumption that these disciplines did not contribute to social or economic progress (Davidson and Goldberg 2004). This "golden age"—in which "money flowed freely" and government did not "interfere" with a self-regulating scientific community—came to an end during the 1970s. By then, the Apollo space programme was ending, and the public had growing concerns about costly defence-related research during a period of budget constraints elsewhere. Questions were also beginning to be raised about heretofore unproblematic assumptions about

the "automatic" productivity of research or the integrity of researchers (Guston 2000, p. 115). Greater public scrutiny followed.

Despite differences, both the shorter and longer views signal the entry of a similar new dynamic into the relationship between the state, society and research(ers). Early on, Trow (1974, p. 91) acknowledged that once matters of higher education come "to the attention of larger numbers of people, both in government and in the general public…[they will] have other, often quite legitimate, ideas about where public funds should be spent, and, if given to higher education, how they should be spent". Subsequently, this has led to questions being raised about the purpose and focus of research, the social role of research and higher education, and correspondingly the appropriate governance models. Concepts of "public good" and "public value" have moved centre stage. How they are defined and by whom remains a matter of ongoing tension between and within the scientific community, government and civil society. Nonetheless, assessment of publicly funded research is now normally accepted—though the instruments and methodology remain contentious—in return for public investment. This is in response to a growing demand by the public for greater transparency, responsibility, and value-for-money of all public institutions.

Once research is seen to have value and impact beyond the academy, there are implications for the organisation and management of research at national and institutional levels. Because research does not exist in isolation, there is an increasing focus on what kind of research is funded, and on measuring its outcomes, impact and benefits. There has also been some significant policy and strategic rebalancing between considering research as vital for human capital development versus a tool of economic development; between an emphasis on the independence of researcher curiosity versus alignment with national priorities; between funding excellence wherever it exists versus targeting funding to strengthen capability or build scale; and between encouraging new and emerging fields and higher education institutions versus prioritising existing strengths (Hazelkorn 2014, p. 4).

The next section traces some of the interventions that have influenced the production of knowledge and the emergence of the impact agenda, followed by a section on the development and nature of the innovation demands to public research. The rest of the chapter will look at how debates about impact and public value have affected and changed research practice, with particular focus on the A&H. Drawing

on international examples, this chapter will consider different policy responses to research assessment, and the public responsibility of research and researchers.

Changing Policy Perceptions of Knowledge Production

When the OECD first published its *Frascati Manual* in 1963, it succeeded not only in copper-fastening boundaries between basic, applied and strategic inquiry but also in formalising how to measure the contribution and value of science and technology for the productive base of an economy. By adopting a relatively broad definition, it pronounced that research comprised "creative work undertaken on a systematic basis in order to increase the stock of knowledge, including knowledge of man, culture and society and the use of this stock of knowledge to devise new applications". However, by tying research to development, for example, using the shorthand R&D, it made a clear statement about the purpose of research.

Two decades later, research questions were reproblematised as "grand challenges"—further strengthening the declared purpose of publicly funded research. Whilst focused initially on solving problems of high-performance computing, in the 1980s the US Office of Science and Technology defined "grand challenges" as "fundamental problems in science and engineering with broad economic and scientific impact" (CFIR 2004, p. 2; Executive Office of the President, 1987). In so doing, the concept of "interdisciplinary thinking" and collaborative teams was embraced because the magnitude of these problems' complexity made them hard to address otherwise. Nowadays, it is fairly common for national and international organisations to structure and support large-scale research which investigates problems such as climate change, healthy living, food and water security and so on, by drawing together interdisciplinary teams spanning institutions and nations. The European Union has adopted and adapted this practice under the rubric of its framework programmes, now embedded in Horizon 2020 as a result of the Lund Declaration (2009).

Adoption of the "knowledge economy" paradigm shifted the policy dial further. Again the OECD set the agenda. *The Knowledge-based Economy* argued that while the importance of knowledge had its origins in neo-classical economics, it was now recognised that knowledge plays a vital role as a "driver of productivity and economic growth, leading to a new focus on the role of information, technology and learning in

economic performance" (OECD 1996, p. 3). The knowledge economy is the defining policy paradigm across Europe and around the world, placing greater prominence on the production of new knowledge and knowledge management as core to economic growth rather than simply envisaging access to technological tools as previously understood with the "information society" concept. Because the creation of new knowledge is primarily located within higher education, university-based research has assumed huge significance. As nations increasingly compete on the basis of their knowledge and innovation systems, academic research is no longer solely the pursuit of individual intellectual curiosity but rather an indicator of national sovereignty—hence changes in research practice, and the adoption of a wide range of metrics alongside the emergence and significance of global rankings (Castells 1996). Universities responded by asserting their own discourse around "academic science as an economic engine" (Berman quoted in Olmos-Penuela et al. 2014, p. 64) thus creating their own lexicon around technology transfer, commercialisation, patents and licences, and entrepreneurship inspired by the US Bayh–Doyle Act,[1] and underpinning the expansion of the university-research enterprise (Mowery and Sampat 2005a). By setting out such a promising role for themselves in the economy, they arguably created the basis for government to later ask for evidence.

By the end of the century, publicly funded, university-based research had come to be viewed not simply as a driver of economic growth but essential to the research-innovation ecosystem. Emphasising the interplay between university-based research and the economy benefited higher education during the "golden years" of investment, underwriting substantial hikes in public expenditure in most developed economies (OECD 2015, pp. 96–98). The prolonged effects of the global financial crisis of 2008 have amplified these links, with higher education being viewed as a vital source of economically relevant research, innovation and entrepreneurship. The extent and breadth of these influences vary across national jurisdictions and sectors. The *Lisbon Strategy 2000–2010*, for example, sought to strengthen the European Union as one of the world's most competitive economies until the Great Recession intervened; now caught in an increasingly multi-polar geopolitical environment, *Europe 2020* has ratcheted up the EU's determination to drive economic growth and create jobs with academic research at the core (Hazelkorn, 2013). Of our three case studies, Ireland (Chap. 4) adopted the most instrumentalist position, tying public funding to research which met strict relevancy criteria, in

contrast to Norway and the Netherlands which have adopted more balanced approaches (Chaps. 3 and 5).

The pronounced shift (or rebalancing, depending upon one's perspective) from basic or curiosity-driven towards application/challenge-oriented or use-inspired research corresponds with a parallel discourse around the production of knowledge, and the social role of research(ers) and higher education. For Slaughter and Leslie, this realignment of academic performance to national economic growth underscores that academic research is more "concerned with techno-science innovation and building links with the private sector than with basic or fundamental research that articulated more with learned and professional associations and less with the economy" (1997, p. 211; Slaughter 2014). Policy objectives are reflected in growing emphasis on research targets and outputs which are measurable and supported by competitively earned funding and job creation, using rankings or other international benchmarking mechanisms to set targets (Hazelkorn 2015). Trowler (2011, p. 23) sees these changes as an outcome of the "increased emphasis on HE [sic] as a private good rather than a public good..." which Readings (1996) attributes to bringing about the ruination of the university.

But this view has its critics. Over twenty years ago, Boyer (1990) famously challenged what he perceived as elitist views within and about academic practice. Writing for the Carnegie Foundation, he criticised a crude hierarchical apportioning of prestige which had emerged between fundamental and applied research. Instead, he championed what has since become known as "engaged scholarship" connecting the "rich resources of the universities with our most pressing social, civic and ethical problems..." (Boyer 1996, p. 21). In parallel, Gibbons et al. (1994) published their formative work on *New Knowledge Production*. Amplifying the "grand challenges" debate, they argued that as the site of problem formation, investigation, and so on, had moved into the public realm, research was less likely to be conducted by individuals in semi-secluded environments, seeking accountability through peer-review (Gibbons 2002, p. 59). Their "Mode 2" knowledge is defined by being "socially robust", focused on useful application, with a wide array of external partners, and achieving accountability within civil society. While the "contrast between fundamental (and scientifically excellent) research on the one hand and relevant research on the other is not a principled contrast" (Rip 2000, p. 33), the dichotomy helped force into the open the bigger question about the (social) role and purpose of knowledge and the university.

In other words, it made it harder to distinguish between science and society (Nowotny et al. 2001, p. 47).

The idea that innovation emerges from "interactions within a network of different actors" beyond the academy (OECD 2006, p. 124), derives in part from the economics of innovation (Porter 1990, 1998; Nelson 1993; Lundvall 1992) with concepts such as the "triple helix" (Etzkowitz and Leydesdorff 1997) and "knowledge triangle" (Europa 2005), while the governance literature promotes the "triangle of coordination" (Clark 1983). In their different ways, each view articulated an eco-system of interests balanced between those of the state (government and associated agencies), the market or business, and the academy. This has given way to the "engagement" agenda, using terms such as regional, civic or community engagement to describe ways in which higher education institutions interrelate with societal, civil and economic stakeholders and connect with issues, problems and organisations beyond their campus boundaries (Goddard et al. 2016, Chaps. 3 and 4). The emphasis on multi-actor environments, in which higher education-based research is a key player, challenges traditionalist views that the university is the sole benefactor of knowledge.

Others have continued this theme, arguing that the "the central task of the university in the twenty-first century is to become a key actor in the public sphere and thereby enhance the democratization of knowledge" (Delanty 2001, p. 9). Going beyond the standard dimensions of the public and private good debate, which has primarily centred on tuition fees and graduate salaries and lifestyle, Calhoun (2006, p. 27, 30) says the key question is not "who pays or who governs?" but rather "who benefits and how?"—the answer to which is "first and foremost…'the public'". By snubbing questions about the role of universities and research, the academy has, he argues, "stood in the way of focusing attention on the public purposes of universities" (Calhoun (2006, p. 36). Brewer (2013, p. 12) takes a similar approach, acknowledging that "marketization may have provoked interest in redefining our public value", but there is a necessity and urgency to engage directly with the issues and to "shift the terms of the debate away from public impact…to public value".

By taking the debate in this direction, Calhoun and Brewer both acknowledge that the public policy agenda has moved beyond the academy. Gornitzka et al. (2007, p. 7) suggest higher education has entered into a critical new period; "[b]ehind labels such as 'a Europe of knowledge' there is a search for a new pact between the University, political

authorities and society at large." Indeed, the emergence of a whole pano-
ply of transparency and accountability instruments for research as well as
teaching, at the national and the international level, suggests that higher
education is effectively losing its role as the primary guardian of quality
(Harman 2011, p. 51; Dill and Beerkens 2010, pp. 313–315; Hazelkorn
2012). In others words, a new social contract is being shaped, one in
which the state—at the national and supranational levels (Eaton 2016)—
and society are having a much greater role.

Promoting Innovation in and from Universities

Innovation is a fairly new policy domain and has only recently been tied to
research and to universities. Initially the perspective on innovation policy
was dominated by traditional political science thinking and neoclassical
economics, viewing basic research as a typical case of "market failure"
but leaving the activity more or less alone, in line with the social contract
outlined in the Vannevar Bush report (Mazzucato 2013). This was later
challenged by more systemic perspectives where the relationships between
universities and industry increasingly became seen as a source of competi-
tiveness and new job creation (OECD 1984). Competitiveness and job
creation had been put firmly on the global policy agenda by the economic
crisis in the 1970s, the first one after WW2, and university research in par-
ticular was increasingly seen as a solution to major societal problems. Over
the last decades the ubiquitous concept of innovation has been used for all
kinds of changes and interactions, making this a challenge to all disciplines
within the academy.

Innovation is a key term for understanding the new social contract
between research and society. OECD has been a driving force in the policy
changes that have put universities and their research activities at the centre
stage of much of innovation policy. In various OECD reports, hopes and
expectations to universities are laid out, successful cases are presented from
around the world, and practical initiatives and policy mechanisms are sug-
gested to all member countries (OECD 1984 is the first one solely dealing
with this topic). This coincides with the growth of the field of innovation
studies, based on an evolutionary perspective on innovation and technologi-
cal change (Fagerberg et al. 2005). Many of the important early stage inno-
vation researchers were also active in the OECD (Mytelka and Smith 2002).

The evolutionary perspective highlights the length and complicated
nature of the innovation process, and proposes that long-term changes

in technology may be a much more important factor in economic growth than what had been assumed in macroeconomic models. Research is given a prominent role as a source of new ideas and variety of options, which are then selected and developed further in firms and elsewhere. Empirical investigations of innovation were in particular oriented at high technology firms, seen as essential in creating the jobs of the future. High-tech firms seemed to cluster in particular areas near strong research universities.

Initially the OECD emphasised activities in what can be termed the boundary zone of universities. Support for commercialisation and technology transfer were seen in the famous high-tech regions like Silicon Valley near Stanford, Route 128 near Massachusetts Institute of Technology and the small town of Cambridge in the UK. The leading US and a few other universities had been pioneers in setting up a support structure for newly established firms and for attracting high-tech firms from elsewhere. They had also started technology transfer/licensing offices that would help scientists structure deals with industry and patent research results, and industrial liaison offices that could negotiate collaboration agreements with firms and help set up joint programmes and centres. From the early 1980s these instruments started to spread all over the world, sometimes initiated by universities but more often by national and regional policy-makers and public agencies with an industrial and economic growth mandate.

For arts and humanities research the new organisations probably had few repercussions, since the science parks and transfer units most often targeted technological areas such as electronics, computing, materials and the rapidly growing field of biotechnology. But with universities spending some of their own funds on these organisations, the development also signalled a worrying shift in priorities (Gulbrandsen 2011).

New concepts were developed that reflected and legitimised the rapidly spreading policy instruments and university initiatives. The researchers that were engaged in commercialisation and industry interaction became known as "academic entrepreneurs" (Stankiewicz 1986). Universities with a strong emphasis on innovation and technology transfer (or just displaying to policy-makers a strong willingness to change) were called "entrepreneurial universities", which soon became an ideal everywhere (Etzkowitz et al. 2000). For the universities, the innovation-oriented activities were seen as a potential source of income in a situation with less certainty about public funding, although few of the science parks and technology transfer offices have succeeded in this respect (Mowery and Sampat 2005b). Although innovation researchers had highlighted the long-term

and often indirect importance of universities for innovation, a rationale for many of the initiatives was also over time found in systemic perspectives on innovation that offered "system failure" as a relevant justification for policy instruments (Edquist 1997). Failure in a systemic perspective can be related to lack of contact between actors, and the university-industry interface seemed in particular to gain attention.

Still, innovation researchers expressed worries about the strong emphasis on commercialisation and its related support structure. What they saw as good for innovation and industrial development was the long-term nature of academic research, frequently detached from immediate needs and users, and the division of labour between universities and firms therefore needed to be respected (Rosenberg and Nelson 1994). Concerned about possible negative effects on independent and open research, observers also argued that policy-makers generally should not emulate the policies of the USA, including the Bayh–Dole Act 1980 which changed the ownership of publicly funded research and led to the establishment of numerous technology transfer offices (Mowery and Sampat 2005a, b). From a humanities perspective the innovation challenges were seen as part of a greater picture of "academic capitalism" with many universities increasingly and worryingly behaving like for-profit organisations (Slaughter and Leslie 1997).

Not all researchers were worried, however. Etzkowitz (1998) argued that universities were undergoing a "second academic revolution". In the first revolution, research was added to the primary teaching mission of universities and turned into a "natural" part of university missions after much debate and many protests. For Etzkowitz, the "third mission" of innovation will similarly become seen as a seamless part of university activities after a few decades of "the second academic revolution". This will be accompanied by changes in the norms of science where commercial and traditional scientific goals to some extent are combined into new configurations.

Early empirical investigations of university–industry relations did not confirm many of the worries about the negative effects of innovation activities at universities. It was generally found that involvement in commercialisation and collaboration with firms is associated with high academic quality and productivity, also within the humanities (Gulbrandsen and Smeby 2005). Some evidence indicates that there may be limits—particularly high involvement in commercialisation may have negative effects—but data from a number of countries associate success in commercialisation with elite research

especially within natural science and life science (Larsen 2011). Policy-makers' attempts at promoting innovation (and possibly other impacts) and "excellence" seem to go hand in hand, at least for some types of radical technological innovation.

Many recent empirical investigations of universities and innovation have highlighted that innovation is more closely tied to activities at the individual researcher level than to support units in the border zone of universities such as science parks and technology transfer offices. Innovation and impact have been tied to "productive interaction" between academics and external stakeholders (see next section) which happens in many different ways. Studies have mapped the prevalence of more than twenty different "channels" of interaction ranging from traditional publication and dissemination activities to consultancy, training and commercialisation (see Abreu and Grinevich 2013; Perkmann et al. 2013). Results are consistent across countries: commercialisation activities are the least common forms of interaction regardless of academic discipline, and various forms of dissemination and popular science publishing are the most common ones. Engagement in different types of training is also more common than collaborative research with external partners. In addition, studies have shown that the interaction activities judged to be most important by firms as well as academics are also fairly common forms of informal personal interaction as well as scientific and popular science publication (Bekkers and Bodas Freitas 2008).

Although there are significant differences in the more detailed patterns of external interaction between disciplines, these studies have highlighted that arts and humanities research is as connected to external stakeholders as research in other fields (Hughes et al. 2011; Thune et al. 2014). Even in a rather narrow focus on interaction with private and commercial actors and technological innovation, subfields within the arts in particular but also some within humanities have as broad and intense connections as those found in most technological and natural science disciplines (Hughes et al. 2011). Firms engage with arts and humanities for a variety of reasons and are often in contact with many different disciplines.

The perspective on the role of research in innovation has therefore shifted in several ways. First, the attention is much more oriented at the daily tasks and activities of academics rather than the rare occurrences of patenting, licensing and the creation of spin-off companies. Still, there seems to be a continuing tension here between the desires of policy-makers to promote commercialisation and the rarity of these activities

as demonstrated in a large number of empirical investigations. Second, the concept of academic entrepreneurship has changed correspondingly to include a much wider range of activities and interactions (Abreu and Grinevich 2013). Also the term innovation is used also for non-commercial changes, for example related to environmental issues and improvements in policy, making innovation relevant for all academic disciplines including arts and humanities (Gulbrandsen and Aanstad 2015). Third, innovation has been partly replaced by the term "impact" to denote this shift, where innovation is one out of several types of impacts of research.

Before turning to an in-depth discussion about impact assessment, it can be noted that the wider policy discussion about innovation remains very active. The most discussed book on innovation in the last years has been Mazzucato (2013), shifting the attention from the entrepreneurial university and firm to the "entrepreneurial state". Mazzucato shows how publicly funded research is the foundation of the innovative activities of the leading firms across a range of industries from computers and mobile phones to pharmaceuticals and new energy technologies. Even countries such as the USA which formally subscribes to a non-interventionist approach to industrial policy, has created numerous public support programmes and agencies that in practice take high risks not just in research but also in demonstration, development and the creation of markets. On the one hand Mazzucato's analysis highlights the "preparedness" function of long-term research in a range of disciplines, just like many of the early contributions in innovation studies. This perspective is largely in line with traditional views on the value of arts and humanities research. On the other hand, her arguments also justify an active and experimental state that can and perhaps should steer and "nudge" research in specific directions where the challenges and potential impacts are believed to be the highest.

Assessing Research Impact

Impact assessment forms a fundamental part of the new social contract, although Brewer (2013) suggests there is a distinction between "impact" and "public value". For him, the former shows research has use beyond itself and is usually measured in terms of economic impact whereas public value is a much broader concept, encapsulating how research enables and promotes understanding about society and the world around us, developing a process going beyond formalised and ritualised practices. The challenge for *this* distinction derives from its own normative-ness,

and ability to fulfil legitimate public desires and requirements about institutional and research(ers) performance and student learning. Ultimately, measuring performance via impact is a political project.

First, discussion of research impact, relevance and value should be placed within the larger context of governance within twenty-first-century societies. Confidence in self-regulation is under scrutiny and strain in other domains—in banking and financial services, multinationals, including energy companies, and in government, at local, national, European and international levels. On the basis that "global problems demand global solutions" (Coen and Pegram 2015), supranational organisations are playing a greater role regulating the global market; higher education is a particular example with respect to concerns about cross-border education and accreditation. Similarly, in an effort to balance the (self)interests of university autonomy and academic freedom with those of society—particularly in circumstances where pursuit of "world-classness" has become an over-determining attribute (Hazelkorn 2015, pp. 205–222)—democratic governments have strengthened their role in defining and advocating for the "public good" (Marginson 2011, p. 430). Even though universities derive less (core) funding from the public purse these days, they still have a public-facing role.

Second, the impact agenda flows from acknowledgement that academic research is not solely the pursuit of individual intellectual curiosity but is driven by national priorities tied to strategies of economic growth and competitiveness. Rebalancing research agenda-setting has been a significant game-changer. Vannevar Bush's relationship between research and the national interest has been reinterpreted over the decades, with efforts made to emphasise and support synergies and interactions between different disciplines and forms of research (NSTC 1993). But the idea that knowledge (only) gains legitimacy and social value through its utility has been a continual theme, helping to seal a new social contract between the taxpayer, structured government financing and the research community (Belfiore and Bennett 2007; Gornitzka et al. 2007; Olmos-Penuela et al. 2014). The extent to which "politicians should be involved in decision making about research funding" remains controversial (Nurse 2015, p. 8). Within the academy, discussion of the benefit or legitimacy of prioritising needs (and thus resources) is most mature in the health sciences for obvious reasons. Even when dealing with questions that quite literally may imply life or death, there is a recognition that the responsibilities of healthcare professionals also involve a responsibility to resources which come from the public purse.

Third, the impact agenda is a response to public demand for greater evidence that publicly funded research is making a contribution to society, adding value or simply doing what it purports to do, in return for continued taxpayer support. In this vein, performance-based funding and performance agreements are a familiar aspect of higher education funding in many jurisdictions around the world (de Boer et al. 2015; Benneworth et al. 2011). Put another way, whereas research activity was historically measured and compared according to input factors (e.g. research income earned, number of doctoral students, etc.), the emphasis, as in other domains, has shifted to looking at outputs and outcomes (e.g. publications, citations) and impact and benefit (e.g. on public policy and/or behaviour, economic or environmental development, and so on). Most of the discussion and criticism has focused on the mechanics of measurement—the over-reliance on quantitative indicators, for example—and the resulting bureaucratisation of the process. This is probably inevitable given the substantial changes that evaluation and assessment have brought not just to individual researchers, but also to research practice and research management and organisation. However, such discussion quickly becomes technocratic without necessarily engaging with the macro drivers.

Fourth, one of the primary objectives of impact assessment is that it provides a mechanism to "gain a more thorough knowledge of the relationship between actions and effects" (ESF 2012, p. 3). It may be all-encompassing, embracing scientific, technological, economic, social, political, environmental, health, cultural and/or training effects. A mismatch has arisen between professional understanding of impact and the particular form it takes, with researchers often perceiving it as an instrument of new public management, having a deleterious effect on their research or requiring a different skill-set (Watermeyer 2012). The timeline by which "impact" is evident or visible is contestable and difficult to ascertain, and there are discipline-specific challenges (Morton 2015). An alternate view suggests that the impact agenda is waiting to be captured by the academy as a tool of/for "soft power"; it's a powerful and valuable source for affirming the diversity of research(ers), and the multidisciplinary and multi-impactfulness of knowledge (Kings College London and Digital Science 2015, p. 6). Bollen et al. (2009) conducted an exercise in which they illustrate the extent to which humanities research serves a purpose in the wider knowledge economy not just in terms of knowledge creation within its own fields but also in its interactions with fields which have hitherto been regarded as beyond its purview, which "correct[s] the

underrepresentation of the social sciences and humanities that is commonly found in citation data". As such, this can be a diplomatic way to engage not only policy-makers but also wider society and other researchers, for which "impact" may be(come) the "mediating discourse" (European Commission 2014).

The European Union presents an interesting example of these themes. Higher education was central to European policy-making since the formative days of the European Coal and Steel Community in 1955, but indirectly as the EU does not have authority for education (Corbett 2005). However, after embracing the "knowledge economy", and then in response to the internationalisation of the higher education market and criticism of the position of Europe's universities in global rankings, higher education and university-based research took on greater significance. The Lisbon Strategy (2000) focused on European competitiveness, research investment and improving excellence (Dale 2010). Over the intervening years, high-level communications have stressed improving excellence and performance, with increasing stridency and directness (Europa 2003, 2007, 2010, 2011). One such report argued that "universities should be funded more for what they do than for what they are, by focusing funding on relevant outputs rather than inputs", openly questioning the social contract that has underpinned public support for higher education heretofore (Europa 2006, p. 7, 3). Initiatives such as the U-Map and U-Multirank, profiling and ranking tools respectively, accompanied by well-funded targeted actions to recast research in Europe as European research, have made a major impact on shifting the policy debate at national/member state and institutional level (Hazelkorn and Ryan 2013). Europe's interventions reaffirm the policy direction, under the theme "responsible research and innovation", and promulgate the necessity for public communications and researcher integrity, alongside the introduction of impact weighting on Horizon 2020 projects.

ARTS AND HUMANITIES RESEARCH

The A&H are widely acknowledged as playing an important role in underpinning the formation of new ideas, contributing to culture and identity, encouraging creativity and innovation, enhancing civil society and underpinning democracy, with implications for society and individuals. They "contribute to a growing body of knowledge on human experience, agency, identity and expression, as constructed through language,

literature, artefacts and performance" (Bakhshi et al. 2008, p. 1). But in the infamous "two cultures" debate, C.P. Snow (1961) provocatively argued—to which F.R. Leavis (1962) responded—that a better, and more secure, future could be brought about (only) through science and technology, a view not divergent from that of the aforementioned Bush. As Small (2013, pp. 30–47) points out, this exchange simply exposed existing tensions between world visions and value systems between the A&H and the sciences, and questioned different forms and formats of expression. These differing perspectives have become more animated in recent years in response to the omnipresence of the knowledge economy paradigm and government and societal responses to the prolonged depth of the Great Recession, in which the A&H as disciplines and research fields have felt increasingly isolated. Both sides of the Atlantic have seen news headlines such as "Humanities Fall from Favor" (sic) (Levitz and Belkin, 2013) or "Humanities Overlooked by Politicians" (Corbyn and Fearn, 2008); even Obama was caught up in the debate when he (jokingly) criticised art history students: "I promise you folks can make a lot more, potentially, with skilled manufacturing or the trades than they might with an art history degree" (Jaschik 2014).

Small suggests there are five ways that the value of the humanities has been argued: the humanities have distinctive "meaning-making" practices of a culture which sets them apart from other disciplines; the humanities are useful to society; they have intrinsic worth; they contribute to individual and collective happiness; and they are required for the healthy functioning of democratic society. Belfiore and Bennett (2007) suggests three different sets of arguments, defined as the positive, negative and instrumentalist positions. For the sake of brevity, the issues are discussed as a binary.

The intrinsic perspective claims that A&H have "transformative powers" with the capacity to bring "the light of civilization to as yet uncivilized countries overseas" (Belfiore and Bennett 2007, p. 138), what Small terms the "democracy needs us" argument. As such, they have a virtue in-and-of themselves often expressed as "arts-for-arts sake". Ancient Greece might unwittingly have set the foundations for today's culture wars. Emphasising ethics, metaphysics and natural philosophy, both Plato and Aristotle aimed to educate citizens who would become "good and harmonious member[s] of society" (Pedersen quoted in Moynihan 2016, p. 13). However, whereas the former claimed there should be no privileged role for the arts, the latter suggested the arts granted people particular benefits of healing and "catharsis" (Belfiore and Bennett 2007, p. 143). The significance of the

arts as a civilising and democratising force have persisted, and becoming an enduring component of the academy since its earliest days (Bric 1999, p. 7). The creation of US liberal arts colleges in the seventeenth century and after has drawn heavily upon a classical legacy (Geiger 2011, p. 39). During the industrial revolution, Morris (1886, pp. 313–314) argued passionately that art had the capacity to "increase the happiness of men," while conversely, without art, "restlessness [would] make...them hapless men and bad citizens". More recently Nussbam (2010, p. 7) has proclaimed the A&H were associated with "the ability to think critically...to transcend local loyalties and to approach world problems as a 'citizen of the world' and finally...to imagine sympathetically the predicament of another person." McCarthy et al. (2004, p.xi) similarly calls attention to the A&H's "measurable benefits, such as economic growth and student learning" for all society not just those involved in the arts (see also Anders 2015). While universities may differ in the emphasis they place on different disciplines, A&H research has been supported in the belief that society benefits from the pursuit of knowledge and the scholarship generated (Commission on the Humanities and Social Sciences 2013; Schwartz 2013).

While many of these arguments form a vital part of government cultural and educational policies, and public discourse, their certainty faces challenge from the dominant policy paradigm, with its strong focus on demonstrating value via measurable (quantitative) impact (Belfiore and Bennett 2007, p. 135; Smith 2015; Brown 2011). As nations prioritise economic recovery and growth, "highly applied skills suited to profit-making" and employability, there is a move to "cut away all useless things in order to stay competitive in the global market" (Nussbaum 2010, p. 2). An instrumentalist, "ivory tower" argument, has been built around the notion that the A&H are too "remote from the problems of the societies that fund their dilettante pleasures" (Olmos-Penuela et al. 2014). There is a deep concern that such disciplines poorly prepare students and graduates with the skills required for employability in the twenty-first century.

But the A&H also face challenges from within. An alternate view suggests the A&H are an indulgent extra, aloof from the real problems of society. A historical distinction between artisans as people who made things and (fine) artists who created works of aesthetic beauty elevated the arts to a level of exceptionalism. Williams suggests this view purported to grant to the arts attributes which "distinguished them from other human skills" (1963, pp. 15–16). This view was taken by figures such as Matthew Arnold and F.R. Leavis who extolled a view of culture as something which

depended upon and prospered because of an elite minority (Williams 1963, pp. 246–256). In a policy environment in which public value has come to be interpreted as "better meet[ing] society's needs", the A&H are "looking for ways to explain their value" (Ruark 2011).

THE POLICY CHALLENGE

Distinctive A&H research processes, their outputs, outcomes and impact are not easily measured or assessed within the conventional research assessment framework, derived primarily from scientific practice (Belfiore, 2014). For example, A&H scholars often identify their research in terms of their methodology, research methods and modes of inquiry as distinct from those of other fields. Grierson and Brearley (2009, p. 5) suggest that to "name methodologies appropriate to creative arts projects is to establish a way of claiming alternatives to the more orthodox social sciences or scientific research paradigms."

A&H also tends to be conducted by individual researchers, working on self-defined projects, which reflect their own rather than external interests. Thus, they are usually disciplinary rather than problem- or issue-based, and individualistic rather than collaborative, and curiosity- rather than use-inspired. This accounts for the fact that journal articles, which may represent several years of scholarship, constitute only 20–35 % of humanities research output compared with 45–70 % in the social sciences, to say nothing of other fields in the sciences (RIA 2011). In comparison, the arts produce major art works, compositions and media productions. Together A&H produce a wide array of outputs, often considering matters of national relevance and published in the national language, thereby calling into question "long-held assumptions concerning the hierarchy of activities in which peer-reviewed journal articles and monographs are accepted as superior to all other research outputs" (RIA 2011, p. 4). Explaining the origin of these differences, Benneworth (2011) suggests that "until the late 19th and early 20th century, all science – including arts and humanities – was principally the work of individual scholarship". However, research practices changed for other disciplines as the research university cum graduate school model, a.k.a. the Humboldtian model, took hold, "particularly in engineering as the scale of research activity grew, but arts and humanities has remained a field rooted in this individual scholarship". This has continued as funding for the bio and life-sciences fields have come to dominate (Tijssen 2016).

A distinction often arises between what is called creative or professional practice and arts-based research or the work of artists and practitioners on the one hand, and that of art critics, art historians, musicologists, and so on, on the other. The former produces a collection of artefacts (e.g. paintings, sculpture, music composition, performances, etc.) often for exhibition and/or commercial purposes while the latter produces more conventional academic texts. Commentary about an artefact, e.g. about an exhibition or concert, is a form of peer review or evidence of peer esteem—a vital measure of impact but not to be confused with evidence of research output.

Increasing acceptance of practice-led research has fostered wider understanding and acceptance of integrating practice and art-making with theoretical exploration in order to lead to new understandings and meanings. This has benefited the arts albeit there is an important distinction between creative practice and arts-based research and scholarship. The former involves the production of arts-based artefacts, often for commercial purposes, but without any attempt to engage academically with the issues. Biggs (2007, p. 189) warns that to "have a research outcome consisting solely of visual artefacts without any additional texts" is not sufficient because the process of producing the artefact evokes experiences which are "subjective and non-transferable", which is contrary to research. In other words, research requires "not just a novel artefact that has not existed before, but new knowledge that has not existed before" and that the knowledge contributes to the field and "not just to the personal development of the artists". Archaeology exemplifies a similar set of issues, as both an academic and a professional discipline with academic, cultural and commercial dimensions. Archaeological academic research seeks to create knowledge about the human past while "consultancy research [is] undertaken by individuals and companies on development-led projects such as infrastructural projects and general building construction" (RIA 2011, p. 8).

The extent to which there is a distinctive A&H research practice is also contested. One view says "research is a continuum" (Dolan 2008, p. 9) with no fundamental difference in the nature of the research enterprise in STEM disciplines on the one hand and the humanities on the other. Indeed, closer inspection reveals that disciplines share more in common than not. Tinkler (2008, p. 16) shows overlap between creative arts and design, with the humanities and the social sciences. It is true that "we accept the number and prosaic wording more easily than the poetic

discourse, dance, or performance" (Chenail 2008, p. 9), yet the social, lab and engineering sciences are equally practice-based, drawing on field work or experimentation to test theoretical propositions. A senior science scholar observed: "what the creative arts people probably didn't realise is that as a scientist you kept doing an experiment over and over, and fine-tuning it until you got the result. And [in] …the diaries of the artists… you can see the experimentation happening…" (quoted in Hazelkorn et al. 2013, p. 65). The shift to application or context-driven research may further reduce boundaries by opening up fertile feedback loops between research in the arts and humanities, and the cultural services industries, for example. Evidence of genuinely cross-disciplinary work with the emergence of the digital humanities, and its various cognate activities, has also begun to challenge traditional practices.

This discussion illustrates the diverse methodologies, outcomes and outlets employed by A&H researchers, and the challenges associated with ascribing a "one-size-fits-all" approach to capturing the quality and impact of A&H research. It also identifies challenges associated with accounting for and measuring impact using tools normally associated with a linear model of R&D. Different approaches may also be required depending upon whether the needs and priorities are those of the academy with its "emphasis on academic publication, [or]…museums and state monument services [which] may prioritise exhibitions, monument management and presentations, and the development of heritage policy" (RIA 2011, p. 8). Thus, despite policy imperatives and intellectual desires to broaden assessment methodologies to incorporate the A&H and better impact indicators, the methodological and technical capacity to capture the increasingly more diverse, interdisciplinary and inter-sectoral landscape of new knowledge production remains a challenge (Tijssen 2016).

A significant academic and policy literature has emerged about research assessment practices, methodological issues and challenges, pointing out the appropriateness or otherwise of these approaches for the arts and humanities (Mustajoki 2013; AUBR 2009; Wilsdon et al. 2015; Crossick 2006; The British Academy 2007). Issues identified include, inter alia:

- Humanities researchers have different publication patterns to those in the natural and life sciences;
- Citation usages in the humanities differ to those in the natural and life sciences;

- Arts and humanities scholars produce a wide range of research outputs which makes it difficult to adequately capture its quality and impact;
- Traditional measurements of research activity often rely on research income/expenditure which can disproportionately disadvantage arts and humanities research because the overwhelming majority of costs are for the individual researcher, and there are often little capital or equipment costs.

As discussed at the beginning of this chapter, accelerating competition at national and institutional levels for a greater share of the global knowledge economy has focused attention on the importance of university-based research, which has correspondingly seen a steady rise in methods to evaluate and assess research activity. There has been a shift to matters of public accountability and value-for-money, with a focus on the relevance and value of publicly funded research for society and the economy. This is evident in the way the definition of research has changed, from being defined as "original investigation undertaking in order to gain knowledge and understanding" (RAE 2001, 2008) to "a process of investigation leading to new insights effectively shared" (REF 2014; Oancea 2016). These developments have provoked an international conversation, within/between the academy and policy arenas, and the development of new mechanisms by which to capture and assess impact and benefit.

Measuring impact is now a component of many government funding schemes (Grant et al. 2010), and commonly used in particular disciplines, such as health or agriculture (HRB 2008; Donovan and Hanney 2011). Traditionally, academic impact has been measured in terms of citations—the extent to which academic papers are taken up by others, contributing incrementally to the overall body of world knowledge. Nowadays, reflecting what we know about knowledge production, there is desire for more active involvement of end-users, as definers of the research problem, co-producers of knowledge, and beneficiaries—in other words, to what extent is the research making a difference beyond oneself. This means impact is defined not by the researcher but as part of a process, using the concept of "productive interactions" (Spaapen and van Drooge 2011). The challenge is finding the appropriate mechanisms and indicators (qualitative and quantitative) by which to do this meaningfully because, as Oancea (2016) cautions, failure to do so may

mean "high-stakes assessment simply captures assessment-driven hyper-activity". To illustrate the complex and multi-faceted networks and relationships of knowledge generation, uptake, use and impact, case studies and/or testimonials are used to show impact on public discourse, human behaviour, societal change, policy-making, technological developments, and so on (Morton 2015; Molas Gallart 2015). A difficulty with this approach is that it tends to see knowledge impact as something generated, defined and pushed out by the academy rather than developed as part of more complex interactions in the co-production of knowledge. Molas-Gallart (2012) also suggests difficulties can arise because navigating through the labyrinth of case studies can be both inefficient and subjective, while Spaapen and van Drooge (2011, p. 218) mention "conflicting narratives [whereby] [s]takeholders and researchers might come up with different and competing views".

The UK has arguably developed the most sophisticated impact policy instrument (see Hazelkorn et al. 2013). The REF (Research Excellence Framework) has been managed by HEFCE (Higher Education Funding Council for England), along with its predecessor the RAE (Research Assessment Exercise), since the mid 1980s. Impact is broadly defined as: "any effect on, change or benefit to the economy, society, culture, public policy or services, health, the environment or quality of life, beyond academia". A pilot initiative developed in Australia in 2006 as part of the Research Quality Framework (RQF), relying primarily on impact defined by the beneficiaries, was ultimately dropped (Morgan et al. 2013). The US STAR METRICS is a collaborative effort undertaken by research institutions and federal agencies to assess the impact of federal investment in research and development (NIH, 2010); although the American Academy of Arts & Sciences (AAAS) favoured a system which would take proper account of the A&H, the current system relies primarily on traditional quantitative indicators (Gumport and Jennings 2005).

Amongst the case study countries in this book only Ireland has no national assessment of research; a biennial inventory performs a simple counting exercise, using traditional science-based definitions for principal investigator, postdoctoral fellows and doctoral students to assess critical mass. In response to the economic collapse in 2008, national research policy adopted an instrumentalist approach, focusing funding and assessment towards projects with "demonstrated relevance to the priority areas, clarity of deliverables and, where appropriate, end-user engagement" (usually interpreted as industry) was evidenced (Forfás 2012, p. 14). In recent

years, as the economy has improved, policy discourse has sought a better "balance" across disciplines and towards "frontier" research, on the basis that "benefits across all areas of excellent research can be acknowledged whether these are in education, culture, policy development, health, environment, society, the economy or indeed in contributing to the public good and the global knowledge pool" (IRC 2015, p. 2). *Innovation 2020*, the government's new strategy for science, technology and innovation, commends this approach within limits, and promulgates a formal research assessment process to include impact—as yet undefined but mooted to include a broader set of internationally benchmarked indicators (ICSTI 2015, p. 74, 80). Tensions between different research agencies will determine how A&H research is measured and assessed.

In contrast, both the Netherlands and Norway have formal processes, with practices and methodologies that seek to highlight the impact and value of research on society, though there are still some unsatisfactory consequences for the A&H. In the former, the three Dutch organisations responsible for publicly funded research—the Royal Netherlands Academy of Arts and Sciences, Association of Universities in the Netherlands, and the Netherlands Organisation for Scientific Research—have defined the Standard Evaluation Protocol. This is primarily a tool for self-improvement underpinned by a sophisticated approach to assessing quality, productivity, relevance (scientific and socio-economic), vitality and feasibility. The 2015–2021 version employs a narrative to explain "what relevance, to, impact on or added value for society the research unit's work has (had) or is being (has been) demonstrated at regional, national or international level" (SEP 2015, p. 27; Spaapen et al. 2007; Committee on Quality Indicators in the Humanities 2011).

In Norway, a new model for result-based university research funding was established in 2006 with the objective to stimulate increased research activities and allocate resources to centres performing excellent research. The emphasis on national thematic and technological priority areas has meant that A&H research has not been given a specific role or place within the assessment model. All disciplines are expected to contribute to research goals though it is recognised that a targeted initiative is required to boost the contribution of the humanities along with a need to develop more appropriate indicators that can "measure the societal impacts of research and the appropriateness of funding instruments" (Forskningsradet 2015, p. 38). Whilst acknowledging that the distinctiveness of A&H research probably requires some self-reporting rather than

over-reliance on quantitative measurements or international databases, the A&H will need to identify ways to better integrate with innovation efforts.

What is still missing in many of the debates about innovation and the impact of research in these countries is the relationship between research and education, an explicit topic in the upcoming Norwegian White Paper on the humanities but not dealt with in earlier policy documents. In arts and humanities, as in most other fields, indirect impact through students and teaching may be the most important and pervasive effect of research on society. This aspect is still lacking in most of the indicators and peer review based measurement systems. Another challenge is that the concepts of innovation and impact have been greatly expanded, disguising the heterogeneous ways in which academics engage in efforts to put their knowledge to use. To some extent this is a problem for the development of nuanced and targeted policy mechanisms, but it is also a challenge for researchers who continuously need to develop the vocabulary to describe the social contract and contribution of research.

REASSERTING THE PUBLIC INTEREST IN RESEARCH

Any perusal of public policy, across most countries around the globe, bear witness to the way in which the public interest plays an increasingly more prominent role in driving the accountability agenda. This is particularly the case with publicly funded research. While research assessment has been around for decades, the arrival of global rankings—which primarily focus on measuring and comparing university-based research—have become a popular policy instrument and institutional tool to gauge world class excellence, benchmark performance and provide accountability. In many instances, rankings have been subsumed within other assessment processes, at the national or institutional level, not least because they are perceived as being simple and cost-effective. At the same time, the growing use of open source and digital repositories, and the rapid expansion of social networking and web-based tools challenge the traditional proprietary embrace of the academy. In this environment, peer-review is no longer the sole or even primary method by which research is assessed. End-user or stakeholder esteem is fast becoming an inevitable component.

Variances in the policy environment and state behaviour, however, provide some clues as to how researchers and the wider society have responded. Each of the three target countries have expanded their research assessment processes and methodologies to grapple with the broader questions of societal impact. National research programmes include a societal

component. As discussed in the individual chapters above, the role of arts and humanities research in the Netherlands and Norway is, at least verbally, more widely acknowledged and appreciated than in Ireland where the support has been more equivocal. The Research Council of Norway engaged directly with the new policy agenda, emphasising its contribution to climate, polar and petroleum research, with a focus on innovation (Metris-No 2012), whereas Irish researchers sought to defend their more classicist approach contributing, it is argued, to being isolated in the process (O'Donnell 2011). The atmosphere thawed once research began to make itself relevant to the state's major project: economic recovery. Cultural roots also help explain why Ireland, with an ambiguous relationship to intellectual curiosity, and the Netherlands, with an enduring commitment to A&H research, are situated at opposite ends of the policy spectrum while Norway sits in the middle (Hazelkorn 2014, p. 11).

While there may be an awareness that A&H research is usually funded almost exclusively from the public purse, that this relationship requires or implies some reciprocal obligations sometimes goes unacknowledged. Discussion of research impact has often taken the form of an apologia or defence of intrinsic value (see Bate 2011). But, distinctiveness is not (no longer) a sufficient basis for exempting the A&H from public scrutiny. Alternatively, forward-looking and constructive engagement with these difficult questions via demonstrating impact may provide the best opportunity for A&H researchers to have their specific local and national conditions and concerns acknowledged within the broader governance perspective—winning accolades as it does so. Indeed, it is now quite common for national agencies to grasp the opportunity of "impact" to promote the public value of research through publications and exhibitions. The knowledge economy remains the animating principle for research coordination across Europe, but deep commitment to the social and cultural aspirations of the EU provides a strong basis of sustained support for the A&H. Rethinking the impact agenda as a tool by which to reinforce not just the European dimension but the specificity of national culture could prove extremely beneficial.

NOTE

1. The Bayh–Dole Act fundamentally changed the US system of technology transfer by enabling universities to retain title to inventions and take the lead in patenting and licensing groundbreaking discoveries; this approach is now being followed in other countries.

References

Abreu, M., & Grinevich, V. (2013). The nature of academic entrepreneurship in the UK: Widening the focus on entrepreneurial activities. *Research Policy, 42,* 408–422.

Anders, G. (2015, August 17). That 'useless' liberal arts degree has become tech's hottest ticket. *Forbes.* http://www.forbes.com/sites/georgeanders/2015/07/29/liberal-arts-degree-tech/#6271f3965a75. Accessed 27 Feb 2016.

AUBR. (2009). *Assessing Europe's university-based research.* Brussels: DG Research. https://ec.europa.eu/research/science-society/document_library/pdf_06/assessing-europe-university-based-research_en.pdf. Accessed 26 Feb 2016.

Bakhshi, H., Schneider, P., & Walker, C. (2008). *Arts and humanities research and innovation.* Bristol: Arts and Humanities Research Council.

Bate, J. (Ed.) (2011). *The public value of the humanities.* London: Bloomsbury Academic.

Bekkers, R., & Bodas Freitas, I. M. (2008). Analysing knowledge transfer channels between universities and industry: To what degree do sectors also matter? *Research Policy, 37,* 1837–1853.

Belfiore, E. (2014). 'Impact', 'value' and 'bad economics': Making sense of the problem of value in the arts and humanities. *Arts and Humanities in Higher Education, 14*(1), 95–110.

Belfiore, E., & Bennett, O. (2007). Rethinking the social impacts of the arts. *International Journal of Cultural Policy, 13*(2), 135–151.

Benneworth, P. (2011, May 31). Why should humanities researchers be in universities anyway. *Heravalue Blog.*

Benneworth, P., de Boer, H., Cremonini, L., Jongbloed, B., Leisyte, L., Vossensteyn, H. & de Weert, E. (2011). Quality-related funding, performance agreements and profiling in higher education. In *Universiteit Twente, Enschede.* Centre for: Higher Education Policy Studies (CHEPS).

Biggs, M. (2007). Modelling experiential knowledge for research. In M. Mäkelä & S. Routarinne (Eds.), *The art of research: Research practices in art and design.* University of Art and Design: Helsinki.

Bollen, J., Van de Sompel, H., Hagberg, A., et al. (2009). Clickstream data yields high-resolution maps of science. *PLoS One, 4*(3), 1–11.

Boyer, E. L. (1990). *Scholarship reconsidered. Priorities of the professoriate.* Princeton: Carnegie Foundation for the Advancement of Teaching.

Boyer, E. L. (1996). The scholarship of engagement. *Journal of Public Service and Outreach, 1*(1).11–20. http://www.compact.org/wp-content/uploads/2009/05/boyer-1996.pdf. Accessed 26 Jan 2016.

Brewer, J. D. (2013). *The public value of the social sciences: An interpretive essay.* London: Bloomsbury Academic.

Bric, M. J. (1999). The Humanities and the Social Sciences: A Case for a Research Council. A Report to the Minister for Education and Science. Dublin: Higher Education Authority.

British Academy. (2007). *Peer review: The challenges for the humanities and social sciences: A British academy report.* London: The British Academy.

Brown, M. (2011, April 11). The sciences vs. the humanities: A power struggle. *Chronicle of Higher Education.*

Calhoun, C. (2006). The university and the public good. *Thesis Eleven, 84*(7), 7–43.

Castells, M. (1996). *Rise of the network society, The information age: Economy, society and culture.* Malden: Blackwell Publishers.

CFIR – Committee on Facilitating Interdisciplinary Research. (2004). Facilitating interdisciplinary research, National Academy of Sciences, National Academy of Engineering, Institute of Medicine. http://books.nap.edu/openbook.php?record_id=11153&page=2. Accessed 31 July 2009.

Chenail, R. (2008). But is it research? A review of Patricia Leavy's method meets art: Arts-based research practice. *The Weekly Qualitative Report, 1*(2), 7–12.

Clark, B. R. (1983). *The higher education system: Academic organization in cross-national perspective.* London: University of California Press.

Coen, D., & Pegram, T. (2015). Wanted: A third generation of global governance research. *Governance, 28*(4), 417–420.

Commission on the Humanities and Social Sciences. (2013). The heart of the matter. *The humanities and social sciences for a vibrant, competitive, secure nation.* Cambridge, MA. http://www.humanitiescommission.org/_pdf/hss_report.pdf. Accessed 26 Feb 2016.

Committee on Quality Indicators in the Humanities. (2011). Quality indicators for research in the humanities. *Humanities.* Amsterdam: Royal Netherlands Academy of Arts and Sciences. http://www.vsnu.nl/files/documenten/Domeinen/Onderzoek/SEP2015-2021.pdf. Accessed 26 Feb 2016.

Corbett, A. (2005). Universities and the Europe of knowledge. In *Ideas, institutions and policy entrepreneurship in Europe union higher education policy, 1955–2005.* Basingstoke: Palgrave Macmillan.

Corbyn, Z., & Fearn, H. (2008, September 18). Humanities overlooked by politicians. *Times Higher Education.* https://www.timeshighereducation.com/news/humanities-overlooked-by-politicians/403618.article. Accessed 26 Feb 2016.

Crossick, G. (2006). Knowledge transfer without widgets: The challenge of the creative economy. *Lecture to the Royal Society of Arts,* Leeds. http://www.goldsmiths.ac.uk/warden/creative-economy.pdf

Dahler-Larsen, P. (2007). Evaluation and public management. In E. Ferlie, L. E. Lynn Jr., & C. Pollitt (Eds.), *The Oxford handbook of public management.* Oxford: Oxford University Press. doi:10.1093/oxfordhb/9780199226443.003.0027.

Dale, R. (2010). *Constructing universities' responses to Europe's Lisbon agenda: The roles of the European commission in creating the Europe of knowledge.* Research paper 19. London: Centre for Learning and Life Chances in Knowledge Economies and Societies, Institute of Education.

Davidson, C.N., & Goldberg, D.T. (2004). A Manifesto for the humanities in a technological age. *Chronicle of Higher Education.* http://uchri.org/media/pdfs/Manifesto_Humanities.pdf. Accessed 27 Feb 2016.

de Boer, H., Jongbloed, B., Benneworth, P., Cremonini, L., Kolster, R., Kottmann, A., Lemmens-Krug, K., & Vossensteyn, H. (2015). *Performance-based funding and performance agreements in fourteen higher education systems. Report for the Dutch Ministry of Education, Culture and Science.* Enschede: Centre for Higher Education Policy Studies (CHEPS).

Deem, R., & Brehony, K. J. (2005). Management as ideology: The case of 'new managerialism' in higher education. *Oxford Review of Education, 31*(2), 217–235.

Delanty, G. (2001). The university in the knowledge society. *Organization, 8*(2), 149–153.

Dill, D. D. (1998). Evaluating the 'Evaluative State': Implications for research in higher education. *European Journal of Education, 33*, 361–377.

Dill, D. D., & Beerkens, M. (2010). Reflections and conclusions. In D. D. Dill & M. Beerkens (Eds.), *Public policy for academic quality. Analyses of innovative policy instruments* (pp. 313–335). Dordrecht: Springer.

Dolan, C. (2008). *Feasibility study: The evaluation and benchmarking of humanities research in Europe.* Humanities in the European Research Area (HERA). http://www.heranet.info/system/files/hera_report_-_evaluation_and_benchmarking_of_humanities_research_in_europe.pdf.

Donovan, D., & Hanney, S. (2011). The 'payback framework' explained. *Research Evaluation, 20*(3), 181–183.

Eaton, J. (2016). The quest for quality and the role, impact and influence of Supra-National Organizations. In E. Hazelkorn (Ed.). *Global rankings and the geo-politics of higher education understanding the influence and impact of rankings on higher education, policymakers and society.* London/New York: Routledge, Taylor & Francis. Forthcoming.

Edquist, C. (1997). *Systems of innovation: Technologies, institutions, and organizations.* London/New York: Routledge.

ESF. (2012). *The challenges of impact assessment: A report by the ESF MO forum on evaluation of publicly funded research – Working group 2: Impact assessment.* Strasbourg: European Science Foundation. http://www.dfg.de/download/pdf/dfg_im_profil/zahlen_fakten/programm_evaluation/impact_assessment_wg2.pdf. Accessed 27 Feb 2016.

Etzkowitz, H. (1998). The norms of entrepreneurial science: Cognitive effects of the new university-industry linkages. *Research Policy, 27*(8), 823–833.

Etzkowitz, H., & Leydesdorff, L. (1997). *Universities and the global knowledge economy: A triple helix of university-industry-government relations.* Andover, UK: Thomson Learning.

Etzkowitz, H., Schuler, E., & Gulbrandsen, M. (2000). The evolution of the entrepreneurial university. In M. Jacobs & T. Hellström (Eds.), *The future of*

knowledge production in the academy. Buckingham: The Society for Research into Higher Education and Open University Press.

Europa. (2003). *The role of the universities in the Europe of knowledge. Communication to the council and the European Parliament.* Brussels: European Commission.

Europa. (2005). "Communication from the Commission to the European Council. Implementing the renewed partnership for growth and jobs. Developing a knowledge flagship: The European Institute of Technology", COM/2006/0077 final. Brussels: European Commission.

Europa. (2006). *Delivering on the modernisation agenda for universities: Education, research and innovation. Communication to the council and the European Parliament.* Brussels: European Commission.

Europa. (2007). *Council resolution on modernising universities for Europe's competitiveness in a global knowledge economy.* Brussels: European Commission.

Europa. (2010). *Europe 2020 flagship initiative. Innovation union. Communication from the commission to the European parliament, the council, the European economic and social committee and the committee of the regions.* Brussels: European Commission.

Europa. (2011). *Supporting growth and jobs – An agenda for the modernisation of Europe's higher education systems. Communication from the commission to the European Parliament, The council, The European economic and social committee and the committee of the regions.* Brussels: European Commission.

European Commission. (2014). *Research meets diplomacy: Europe as a global actor.* Brussels: European Commission.

Executive Office of the President. (1987, November 20). A research and development strategy for high performance computing. Office of science and technology policy, US Government. http://www.nitrd.gov/pubs/bluebooks/1994/section.2.1.html. Accessed 27 Feb 2016.

Fagerberg, J., Mowery, D. C., & Nelson, R. R. (2005). *The Oxford handbook of innovation.* Oxford: Oxford University Press.

Forfás. (2012). *Report of research prioritization steering group.* Dublin: Forfás. because as assessment simply captured assessment-driven hyperactivity process. Knowledge by benchmarked s this approach albeit it.

Forskningsradet. (2015). *Research for innovation and sustainability. Strategy for the research council of Norway, 2015–2020.* Oslo: Research Council of Norway. http://www.forskningsradet.no/en/Article/Main_strategy/1193731376993. Accessed 27 Feb 2016.

Geiger, R. L. (1993). *Research and relevant knowledge: American research universities since World War II.* Oxford: Oxford University Press.

Geiger, R. L. (2011). The ten generations of American higher education. In P. G. Altbach, P. J. Gumport, & R. O. Berdahl (Eds.), *American higher education in*

the twenty-first century. Social, political and economic changes (3rd ed., pp. 37–68). Baltimore: Johns Hopkins University Press.

Gibbons, M., Limoges, C., Nowotny, H., Schwartzman, S., Scott, P., & Trow, M. (1994). *The new production of knowledge: The dynamics of science and research in contemporary societies.* London: Sage.

Gibbons, M., (2002). "Engagement as a Core Value in a Mode 2 Society", in Bjarnason, S. & P. Coldstream (Eds.). The Idea of Engagement. Universities in Society, London: Association of Commonwealth Universities, 48–70.

Goddard, J., Hazelkorn, E., Kempton, L., & Vallance, P. (Eds.) (2016). *The Civic University: The policy and leadership challenges.* Cheltenham: Edward Elgar. Forthcoming.

Gornitzka, Å., Maassen, P., Olsen, J. P., & Stensaker, B. (2007). 'Europe of knowledge': Search for a new pact. In P. Maassen & J. P. Olsen (Eds.), *University dynamics and European integration.* Dordrecht: Springer.

Grant, J., Brutscher, P.-B., Kirk, S. E., Butler, L., & Wooding, S. (2010). *Capturing Research Impacts: A review of international practice.* Cambridge: RAND http://www.rand.org/content/dam/rand/pubs/documented_briefings/2010/RAND_DB578.pdf.

Grierson, E., & Brearley, L. (2009). *Creative arts research: Narratives of methodologies and practices.* Rotterdam: Sense Publishers.

Gulbrandsen, M. (2011). Kristian Birkelands spøkelse: Universitetet i Oslo og innovasjon. In P. Anker, M. Gulbrandsen, E. Larsen, J. W. Løvhaug, & B. S. Tranøy (Eds.), *Universitetet i Oslo: Samtidshistoriske perspektiver* (pp. 275–366). Oslo: UniPub.

Gulbrandsen, M., & Aanstad, S. (2015). Is innovation a useful concept for arts and humanities research? *Arts & Humanities in Higher Education, 14*(1), 9–24.

Gulbrandsen, M., & Smeby, J.-C. (2005). Industry funding and university professors' research performance. *Research Policy, 34,* 932–950.

Gumport, P. J., & Jennings, J. D. (2005). Toward the development of liberal arts indicators. In M. Richardson (Ed.), *Tracking changes in the humanities. Essays on finance and education* (pp. 113–166). Cambridge, MA: American Academy of Arts and Sciences.

Guston, D. H. (2000). *Between politics and science. Assuring the integrity and productivity of research.* New York and Cambridge: Cambridge University Press.

Guston, D. H., & Keniston, K. (1994). Introduction: The social contract for science. In D. H. Guston & K. Keniston (Eds.), *The fragile contract. University science and the federal government* (pp. 1–41). Cambridge and London: MIT Press.

Harman, G. (2011). Competitors of rankings: New directions in quality assurance and accountability. In J. C. Shin, R. K. Toutkoushian, & U. Teichler (Eds.), *University rankings. Theoretical basis, methodology and impacts on global higher education* (pp. 35–54). Dordrecht: Springer.

Hazelkorn, E. (2012). European 'transparency instruments': Driving the modernisation of European higher education. In A. Curaj, P. Scott, L. Vlăsceanu, & L. Wilson (Eds.), *European higher education at the crossroads: Between the Bologna process and national reforms* (Vol. 1, pp. 339–360). Dordrecht: Springer.

Hazelkorn, E. (2013). Higher education's future: A new global order? In R. Pritchard & J. E. Karlsen (Eds.), *Resilient universities* (pp. 53–90). Frankfurt am Main: Peter Lang Publishers.

Hazelkorn, E. (2014). "Making an impact: New directions for arts and humanities research", Arts and Humanities in Higher Education, 14(1), 25–44. http://doi.org/10.1177/1474022214533891

Hazelkorn, E. (2015). *Rankings and the reshaping of hieher Education: The battle for World Class excellence* (2nd ed.). Basingstoke: Palgrave Macmillan.

Hazelkorn, E., & Ryan, M. (2013). The impact of university rankings on higher education policy in Europe: A challenge to perceived wisdom and a stimulus for change. In P. Zgaga, U. Teichler, & J. Brennan (Eds.), *The globalization challenge for European higher education: Convergence and diversity, centres and peripheries* (pp. 79–100). Frankfurt am Main: Peter Lang.

Hazelkorn, E., Ryan, M., Gibson, A., & Ward, E. (2013). *Recognising the value of the arts and humanities in a time of Austerity. Ireland report for the HERA-VALUE Project.* HEPRU Working Paper Series No. 1, Dublin: Higher Education Policy Research Unit, Dublin Institute of Technology. http://arrow.dit.ie/cgi/viewcontent.cgi?article=1042&context=cserrep. Accessed 27 Feb 2016.

HRB. (2008). *Making an impact–The economic and social benefits of HRB-funded research.* Dublin: Health Research Board.

Hughes, A., Kitson, M., & Probert, J. (2011). *Hidden connections: Knowledge exchange between the arts and humanities and the private, public and third sectors.* Cambridge: CEBR/Bristol: Arts & Humanities Research Council.

ICSTI – Interdepartmental Committee on Science, Technology and Innovation. (2015). *Innovation 2020. Excellence, talent, impact. Ireland's strategy for research and development, science and technology.* Dublin: Department of Jobs, Enterprise and Innovation.

IRC. (2015). *Submission to the consultation on a new national strategy for science, technology and innovation.* Dublin: Irish Research Council.

Jaschik, S. (2014, January 31). Obama vs. Art history, *inside higher Ed.* https://www.insidehighered.com/news/2014/01/31/obama-becomes-latest-politician-criticize-liberal-arts-discipline#sthash.YPVvHhvt.otMBWLGw.dpbs. Accessed 27 Feb 2016.

Kaiser, F., Maassen, P., Meek, V. L., van Vught, F. A., de Weert, E., & Goedegebuure, L. (Eds.) (1994). *Higher education policy: An international comparative perspective.* Oxford: International Association of Universities and Pergamon Press.

Kings College London & Digital Science. (2015). *The nature, scale and beneficiaries of research impact: An initial analysis of Research Excellence Framework (REF). 2014 impact case studies King's.* London: HEFCE. http://www.hefce.ac.uk/media/HEFCE,2014/Content/Pubs/Independentresearch/2015/Analysis,of,REF,impact/Analysis_of_REF_impact.pdf. Accessed 27 Feb 2016.

Larsen, M.-T. (2011). The implications of academic enterprise for public science: An overview of the empirical evidence. *Research Policy, 40,* 6–19.

Leavis, F. R. (1962). Two cultures? The significance of C. P. Snow, reprinted in Leavis, F. R, (2013). *Two cultures? The significance of C.P. Snow.* Cambridge: Cambridge University Press.

Levitz, J. & Belkin, D. (2013). "Humanities Fall from Favor". The Wall Street Journal, 6 June, http://www.wsj.com/articles/SB10001424127887324069104578527642373232184

Lisbon European Council. (2000). *Presidency conclusions, March 23 and 24.* Brussels: European Commission.

Lund Declaration. (2009, July 8). *Europe must focus on the grand challenges of our time. Swedish EU Presidency.* Lund, Sweden. http://www.se2009.eu/polopoly_fs/1.8460!menu/standard/file/lund_declaration_final_version_9_july.pdf. Accessed 10 Aug 2015.

Lundvall, B. A. (Ed.) (1992). *National systems of innovation: Towards a theory of innovation and interactive learning.* London: Pinter Publishers.

Marginson, S. (2011). "Higher education and public good". Higher Education Quarterly,65(4),411–433.http://doi.org/10.1111/j.1468-2273.2011.00496.x

Marginson, S., & Considine, M. (2000). *The enterprise university: power, governance and reinvention in Australia.* Cambridge: Cambridge University Press.

Mazzucato, M. (2013). *The entrepreneurial state. Debunking private vs. public sector myths.* New York: Anthem Press.

McCarthy, K.F., Ondaatje, E.H., Zakaras, L., & Brooks, A. (2004). *Gifts of the muse. Reframing the debate about the benefits of the arts.* Santa Monica: Rand Corporation. http://www.rand.org/content/dam/rand/pubs/monographs/2005/RAND_MG218.pdf. Accessed 27 Feb 2016.

Metris-No. (2012). *New SSH policy developments. Metris Report for Norway.* http://www.metrisnet.eu/metris/index.cfm/report/findByStructureAndCountry/28/81. Accessed 26 Apr 2014.

Molas-Gallart, J. (2012, October 25–26). Towards a policy, public and university consensus on humanities' public value. Keynote Presentation to HERAVALUE conference, *Measuring the Public Value of Arts and Humanities Research: From theoretical challenges and practical problems towards a policy, public and university consensus, Dublin Institute of Technology.*

Molas-Gallart, J. (2015). Research governance and the role of evaluation: A comparative study. *American Journal of Evaluation, 14,* 111–126.

Morgan Jones, M., Castle-Clarke, S., Manville, C., Gunashekar, S., & Grant, J. (2013). *Assessing research impact. An international review of the excellence in*

innovation for Australia trial. Cambridge: RAND Europe. http://www.rand. org/pubs/research_reports/RR278.html. Accessed 27 Feb 2016.

Morris, W. (1886). The aims of art. In: L. Archie & J.G. Archie. (2006). *Readings in the history of aesthetics: An open-source reader*, v. 0.11 chapter 19. http:// philosophy.lander.edu/intro/artbook.pdf. Accessed 27 Feb 2016.

Morton, S. (2015). "Progressing research impact assessment: A 'contributions' approach", Research Evaluation, 24(4), 405–419. http://doi.org/10.1093/ reseval/rvv016

Mowery, D.C. & Sampat, B.N. (2005a). "The Bayh-Dole act of 1980 and university-industry technology transfer: A model for other OECD governments?" In: A. N. Link & F. M. Scherer (eds.). Essays in honor of Edwin Mansfield: The economics of R&D, innovation, and technological change. Boston: Springer US, 233–245 http://doi.org/10.1007/0-387-25022-0_18

Mowery, D. C., & Sampat, B. N. (2005b). Universities in national innovation systems. In J. Fagerberg, D. C. Mowery, & R. R. Nelson (Eds.), *The Oxford handbook of innovation* (pp. 209–239). Oxford: Oxford University Press.

Moynihan, A. (2016). *Normative Isomorphism: Is Irish academic work-life the same in different institutional types in the universal phase of higher education?* PhD Thesis, Dublin: Dublin Institute of Technology.

Mustajoki, A. (2013). Measuring excellence in social sciences and humanities: Limitations and opportunities. In T. Erkkilä (Ed.), *Global university rankings. challenges for European higher education* (pp. 147–165). Basingstoke: Palgrave MacMillan.

Mytelka, L. K., & Smith, K. (2002). Policy learning and innovation theory: An interactive and co-evolving process. *Research Policy, 31,* 1467–1479.

Neave, G. (1998). The evaluative state reconsidered. *European Journal of Education, 33*(3), 265–284.

Neave, G. (2006). "Redefining the social contract", Higher Education Policy, 19(3), 269–286. http://doi.org/10.1057/palgrave.hep.8300130

Nelson, R. R. (1993). *National innovation systems. A comparative analysis.* New York/Oxford: Oxford University Press.

NIH. (2010). *STAR METRICS: New way to measure the impact of federally funded research.* Washington, DC: National Institutes of Health. http://www.nih. gov/news-events/news-releases/star-metrics-new-way-measure-impact-federally-funded-research. Accessed 27 Feb 2016.

Nowotny, H., Scott, P., & Gibbons, M. (2001). *Re-thinking science. Knowledge and the public in an age of uncertainty.* Cambridge: Polity Press.

NSTC – National Science and Technology Council. (1993). *Science in the public interest.* Washington, DC: U.S. Government Printing Office. http://clinton1. nara.gov/White_House/EOP/OSTP/Science/html/Sitni_Home.html. Accessed 27 Feb 2016.

Nurse, P. (2015). *Ensuring a successful UK research endeavour.* London: BIS. https://www.gov.uk/government/uploads/system/uploads/attachment_data/file/478125/BIS-15-625-ensuring-a-successful-UK-research-endeavour.pdf. Accessed 27 Feb 2016.

Nussbaum, M. (2010). Not for Profit. Why Democracy Needs the Humanities. Princeton: Princeton University Press.

O'Donnell, R. (2011). *Making the case for the role of arts, humanities and social sciences.* Dublin: Presentation to HERAVALUE seminar.

Oancea, A. (2016, February 3). Research impacts: networks and narratives. Presentation at the Launch of the Centre for Global Higher Education, UCL Institute of Education, London. http://www.researchcghe.org/researchers-reveal-future-challenges-for-global-higher-education. Accessed 27 Feb 2016.

OECD. (1984). *Industry and university: New forms of co-operation and communication.* Paris: Organisation of Economic Co-operation and Development.

OECD. (1996). *The knowledge-based economy.* Paris: Organisation of Economic Co-operation and Development http://www.oecd.org/sti/sci-tech/1913021.pdf.

OECD. (2006). *Competitive cities in the global economy.* Paris: Organisation of Economic Co-operation and Development.

OECD. (2015). *OECD science, technology and industry scoreboard 2015. Innovation for growth and society.* Paris: Organisation of Economic Co-operation and Development.

Olmos-Penuela, J., Benneworth, P., & Castro-Martinez, E. (2014). "Are sciences essential and humanities elective? Disentangling competing claims for humanities' research public value", Arts and Humanities in Higher Education, 14, 61–78. http://doi.org/10.1177/1474022214534081.

Pedersen, O. (1997). *The first universities: Studium Generale and the Origins of University Education in Europe.* Cambridge: Cambridge University Press.

Perkmann, M., et al. (2013). Academic engagement and commercialisation: A review of the literature on university-industry relations. *Research Policy, 42,* 423–442.

Porter, M. E. (1990). *The competitive advantage of nations.* New York: MacMillan.

Porter, M. E. (1998). Clusters and the new economics of competition. *Harvard business review,* November–December, 77–90.

RAE (2001, 2008). Research Assessment Exercisse, UK. http://www.rae.ac.uk/2001/; http://www.rae.ac.uk

Readings, B. (1996). *The university in Ruins.* Cambridge/London: Harvard University Press.

REF (2014). Research Excellence Framework, UK. http://www.ref.ac.uk

RIA. (2011). *The appropriateness of key performance indicators to research in arts and humanities disciplines: Ireland's contribution to the European debate.* Dublin: Royal Irish Academy.

Rip, A. (2000). Fashions, lock-ins and the heterogeneity of Knowledge production. In M. Jacob & T. Hellström (Eds.), *The future of knowledge production in the academy* (pp. 28–39). Maidenhead: Open University and SRHE.

Rosenberg, N., & Nelson, R. R. (1994). American universities and technical advance in industry. *Research Policy, 23*, 323–348.

Ruark, J. (2011, March 29). Defenders of the humanities look for new ways to explain their value. *Chronicle of Higher Education.* http://chronicle.com/article/Defenders-of-the-Humanities/126930/. Accessed 27 Feb 2016.

Schwartz, D. R. (2013, December 7). Why study the arts and the humanities? *Huffpost College.* http://www.huffingtonpost.com/daniel-r-schwarz/why-study-the-arts-and-th_b_4059078.html. Accessed 27 Feb 2016.

SEP. (2015). *Standard evaluation protocol, 2015–2021. Protocol for research assessments in the Netherlands.* Voorburg: VSNU, KNAW, NWO.

Slaughter, S. (2014). Retheorizing academic capitalism: Actors, mechanism, fields, and networks. In B. Cantwell & I. Kauppinen (Eds.), *Academic capitalism in the age of globalization* (pp. 10–32). Baltimore: Johns Hopkins University Press.

Slaughter, S., & Leslie, L. (1997). Academic capitalism. In *Politics, policies and the entrepreneurial university.* Baltimore: Johns Hopkins University Press.

Small, H. (2013). *The value of the humanities.* Oxford: Oxford University Press.

Smith, S. (2015). *Manifesto for the humanities. Transforming doctoral education in good enough times.* Anne Arbor: University of Michigan Press.

Snow, C. P. (1961). *The two cultures and the scientific revolution. The Rede lecture 1959.* New York: Cambridge University Press.

Spaapen, J., & van Drooge, L. (2011). Introducing 'productive interactions' in social impact assessment. *Research Evaluation, 20*(3), 211–218.

Spaapen, J. Dijstelbloem, H. & Wamelink, F. (2007). *Evaluating research in context. A method for comprehensive assessment.* The Hague: Consultative Committee of the Sector Councils for Research and Development.

Stankiewicz, R. (1986). *Academics and entrepreneurs.* New York: St. Martin's Press.

Thune, T., Aamodt, P.-O., & Gulbrandsen, M. (2014). *Noder i kunnskapsnettverket: Forskning, kunnskapsoverføring og eksternt samarbeid blant vitenskapelig ansatte i UH-sektoren. Report 23/2014.* Oslo: NIFU.

Tijssen, R. J. W. (2016, February 5). Are world university rankings up to date? *University World News.* http://www.universityworldnews.com/article.php?story=20160202143021671. Accessed 27 Feb 2016.

Tinkler, J. (2008). *Maximising the social, policy and economic impacts of the humanities and social sciences.* Report to British Academy from LSE Public Policy Group, London. http://www.lse.ac.uk/government/research/resgroups/LSEPublicPolicy/pdf/Maximizing%20the%20impacts%20of%20HSS%20research,%20Research%20Report,corrected%20Final%20Version,%20July%202008.pdf. Accessed 27 Feb 2016.

Trow, M. (1974). Problems of the transition from elite to mass higher education. Reprinted in Burrage, M. (Ed). *Martin Trow. Twentieth-century higher education. From elite to mass to universal.* Baltimore: Johns Hopkins University Press.

Trowler, P. (2011). The higher education policy context of evaluative practices. In M. Saunders, P. Trowler, & V. Bamber (Eds.), *Reconceptualising evaluation in higher education. The practice turn* (pp. 18–32). Maidenhead: Open University and SRHE.

Watermeyer, R. (2012). Issues in the articulation of "impact": The responses of UK academics to "impact" as a new measure of research assessment. *Studies in Higher Education, 39*(2), 1–19. doi:10.1080/03075079.2012.709490.

Williams, R. (1963). *Culture and society, 1780–1950.* Middlesex: Penguin.

Wilsdon, J., Allen, L., Belfiore, E., Campbell, P., Curry, S., Hill, S., Jones, R., Kaine, R., Kerridge, S., Thewell, M., Tinkler, J., Viney, I., Wouters, P., Hill, J., & Johnson, B. (2015). *The metric tide: Report of the Independent Review of the Role of Metrics in Research Assessment and Management.* http://doi.org/10.13140/RG.2.1.4929.1363

Conclusions: Towards a Better Understanding of the Public Value of Arts and Humanities Research

INTRODUCTION

This volume aims to give a better answer to the question of what is the public value of arts and humanities research than that which currently exists. The debate to date has been characterised by a surprising mix of woolliness and aggression between its participants and at the same time a disjuncture in the positions that makes resolution seem impossible. An opposition has been drawn between "ivory tower academics" and "Gradgrind bureaucrats" unable to appreciate the importance and indeed the correctness of the other sides' perspective. Our first belief in the project was that through a decoding of these positions and a careful triangulation is that it would be possible to draw inferences about the nature of the underlying referent in this debate, that of public value. But what is clear in the empirical chapters—and also to some extent in the preceding policy debate—is that such a straightforward resolution is not possible. Humanities in the three countries—and others as well if we are to believe Belfiore (2013)—appears stuck in a paradoxical situation, in a perpetual crisis in which it continually falls short of meeting the demands placed on it by society.

It does not appear possible to give the final answer to a definition of "the public value of arts and humanities research" that triangulates somewhere between these two positions, possibly also encompassing the public's own interest and involvement. But then, maybe that is not surprising in seeking to say something definitive over a group of subjects that are characterised by an absence of disciplinary finality (Hessels and Van Lente

© The Author(s) 2016
P. Benneworth et al., *The Impact and Future of Arts and Humanities Research*, DOI 10.1057/978-1-137-40899-0_7

185

2008) providing as much insights into the questions asked as to providing definite answers to them. However, we here wish to make a contribution, which perhaps mirroring the nature of the researchers we have been studying, comprises two steps: firstly answering our question, and then reflecting on the nature of the question we ask. In this chapter, we offer a new definition of the public value of arts and humanities research, as the circulation of research in networks to users with identifiable interactions creating things that make a good society as public benefits from private assets. This draws on our case studies where we trace the way that individual pieces of research can upscale through society to create impacts, the impacts that allow society to do more of the things that they in some way deem "good" (they provide useful capacity), and that publics signal that they value these impacts.

In this chapter, we identify a number of areas to which we believe the debate about the public value of arts and humanities research could productively turn. There is a clear need to challenge in a practical sense the instrumentalisation of the idea of research value, in which it can be reduced to a purely economic value, assuming that what matters to society can be measured in an economic sense; properly capturing socio-environmental value means developing alternative aggregate signalling measures for research evaluation. There is also a clear set of implications for higher education policy studies, in which research impact is often reduced to a post hoc set of evaluatory compliance practices rather than embedded within the ways that academics carry out their research (and teaching activities). Finally, we are struck with the pluriform ways in which publics themselves actively engage with arts and humanities research and note that this is rarely considered as the basis for evaluation tools and measures, that is to say, engagement as governance process, and here there is a need to engage with debates on citizen scientific involvement, as manifested, for example, in debates around responsible research and innovation (Owen et al. 2012).

Our final concern in this book has not been to busy ourselves exclusively with the exceptionalism of arts and humanities research, but instead to see the challenge of arts and humanities research's public value as an extreme (and very interesting) example of a wider science policy problem. Although Crossick (2009) pointed out that traditional innovation indicators are not a particularly good measure of the value of STEM, they remain casting a long shadow over science policy debates at a variety of levels. In the last section of our book, we therefore turn to the wider question of

how do publics really value all kinds of scientific research more generally, beyond the purely economic "benefits" it brings to society (Veldhoen and Van der Ende 2003). We note that arts and humanities research is debate-leading with reference to STEM in three key areas. First, we look at the ways that acting as a speculative expert can facilitate societal knowledge exchange conversations. The second area of importance is the role of "grey literature" (technical press) in allowing non-scientific conversations with an underlying scientific value. Finally, we highlight dissolving the barriers of expertise to allow publics more influence over the definition of what counts as research of wider public interest.

Defining the Public Value of Arts and Humanities Research

In this volume we have been concerned with challenging and opening up a dominant discourse in the field of science and research policy related to the way that scientific research benefits society. To do this, we have sought to highlight some of the tensions and contradictions emerging from the discourse related to the inapplicability of this model for arts and humanities research. We thereby seek to contribute to resituating arts and humanities research within current research and science policy debates. There is a more general problem within research and science policy, in seeking to develop measures for the value of research, that treats the idea of "utility" is a stable concept rather than a policy concept that is highly context dependent. What we have been able to observe in the three national situations was place-specific stabilities where a temporary stability was achieved or at least believed in because of its positive consequences. Traditionally, these temporary stabilities have involved the development of proxies (Molas Gallart 2014) making it practically possible to develop simple measures of that value that finesse the issue of arriving at a final definition. And for arts and humanities research, the problem is that there are no proxies that can be adopted that finesse the issue, such as financial value, because they are such poor substitutes for "what matters" about that research.

We have come some way to being able to empirically demonstrate and to theorise that the concept of public research utility is not a stable theoretical concept but rather a discourse that is performed (performatively constructed) by policy actors in different arenas, and with various degrees of remove from the actors on whose behalf they purport to speak. These arenas may often be public, such as in the media, and this may in turn

create a superficial impression that these are contributions to a public debate. But when those "performances" are brought together it creates confrontations and disagreements that can be misunderstood as discussions that actually involve the public in expressing an opinion on the public value of research. The intractability of the question of whether arts and humanities research can have public value that policy can count therefore becomes conflated with the question of whether that research does have an underlying value.

These "performances of research utility" (the public value debates) cannot be resolved logically and that creates a self-perpetuating perception that arts and humanities research is systematically less useful than sciences research. However, from our perspective, what our policy debates also highlight is that arts and humanities research is more advanced in this regard than STEM which has not been forced to reach that stage of a deeper process of really thinking about what it is about their research that is really important to society. We have thus take an apparently straightforward research question, highlighted that there is no straightforward answer, and nevertheless, by following the tensions in the system by which national policy networks attempt to determine the value of arts and humanities research (A&HR), provide insights into that value. On that basis, we can make three more general claims about these valuing processes that form the basis for this volume's contribution.

Multi-scalar Slipperiness

The first area where we made a contribution regarded the understanding of why there was no agreement possible concerning the public value of arts and humanities research. Our original hypothesis was that agreement would be found where there was a compatibility between the different purposes and meanings of value constructed by actors in their own networks. Our original project method was to explore a constructive process where we assumed that a formative debate led to a stable agreement on the value of humanities research. From our starting point, our assumption seemed reasonable—that there would be a formative debate that had led to agreement about what mattered about humanities research. But over the course of the project's first year, not only were we not able to find consensus, but we were able to establish that there was so much disagreement within public discourse without any kind of resolution that this appeared to be a permanent, stable situation.

We started within the discourse of singular research utility, but encountered, followed, analysed and critiqued its assumptions in order to explain and interpret the contradictions that were encountered. We discovered the problem that each of the actors had their own "policy concept" of research's public value, a definition related to their own interests. The idea of policy concept differs from that of a theoretical concept in that it is neither rigorous nor coherent but provides stability for decision-making within a single sphere (Böhme and Gløersen 2011). When different versions of the same policy concept come into conflict, it is not possible to resolve them using rational thought, because they are incoherent bundles of facts, concepts, beliefs, assumptions and value judgements that have an instrumental rather than intellectual purpose.

Central to this disagreement was a fundamental dissonance between two "voices" in these debates which were both true, and yet contradictory and irresolvable. The first was that there was a widespread acceptance that humanities research was useful—this had been taken to its logical conclusion in the UK, where at least two key publications, *The Public Value of Humanities* and *Hidden Connections: Knowledge Exchange between the Arts and Humanities and the Private, Public and Third Sectors* provided a robust evidence base for two things. Firstly, individual research projects created outputs that were clearly valuable—for example, they informed a TV programme that attracted an audience of a million viewers, something indicating that the audience clearly value that research. Secondly, arts and humanities researchers were active in the kinds of behaviour that created outputs that the publics valued, albeit in many kinds of arena.

The second voice in this debate often heard was from policy-makers, that research had to be accountable to society for its behaviour, certainly in times of economic crisis more than normally, but also as a more general point of principle. This meant that all researchers needed to be able to demonstrate the value of their research to publics, in turn requiring indicators and measures comparable between disciplines, which could highlight which disciplines and researchers were performing well. Attempts to avoid measurement and comparison were invoked by those who did not want to be held to account to publics: an unwillingness to be held publicly accountable is suggestive of public value not being a serious consideration for researchers. So if arts and humanities research was to seriously make a contribution, then there needed to be transparent and comparable indicators for research's public value.

We argue that this circular dissonance is critical to understanding the policy debate from a scientific perspective. Despite a logical resolution between the two positions (indicators based on real research projects), several attempts to develop these indicators had failed to develop an indicator that could carry legitimacy with both the researchers and "accountability principles" (policy-makers concerned with ensuring governance arrangements providing accountability in public expenditure). In the course of the case studies, it was clear that the idea of humanities' research value was being used to communicate a range of very different notions. These could be understood as a set of polar opposite claims, firstly between those that argue that arts and humanities research is itself an achievement, part of a civilised society, and those that claim that humanities' value only comes through its societal contributions. There are those that argue that science must progress through following the excellent research questions, and those who see that in times of crisis, research questions must be set with some reference to the eventual contributions that research will make. Finally, there are those that argue that attempts to count arts and humanities research's contributions will always make it seem less valuable than science and technology as against those that argue that arts and humanities research must account to society for the funds it receives.

We therefore hypothesise that it was a structural dissonance that prevented logical resolution of these positions, and that attempts to answer and resolve these tensions from a mono-conceptual position would fail. To further nuance this, we drew on research in territorial development relating to "policy concepts"—policy concepts are "ideas" which emerge in policy where different actors have very different interests in the same field, and use it in very different ways (Böhme and Gloersen 2011). This means that concepts circulate which are theoretically "slippery"—they cannot be resolved by recourse to logic, but ultimately require choices to be made in implementation. The effect of making a choice is, however, to exclude the other potential uses of that concept and thereby limit the concept of value.

Debates concerning policy concepts cannot be analysed on the basis of the relative rational merits of the cases presented, but need to be understood in terms of the underlying purposes of the decision-making process. It is both true that policy-makers need simple metrics to judge between disciplines, and that simple metrics cannot capture the public value that arts and humanities research delivers. This is not logically reconcilable. What looks like an argument or debate we reframe as an intellectual dissonance, and to resolve that dissonance conceptually it is necessary to look

to how this dissonance is resolved in practice in policy terms. This reframing contributes to an emerging literature within cultural policy studies reflecting the need for hybrid policy concepts that bridge across stakeholders' needs rather than dividing the debate into irreconcilable polar opposites such as excellent vs relevant research or intrinsic vs extrinsic public value.

This provides a means for explaining our initial finding, the deep-seated contradiction between the different perspectives of value, and to provide the context for the remainder of the project, which was to attempt to find ways to resolve these dilemmas, that is to say the fact that different actors use different policy concepts of measuring research value that are not necessarily logically compatible. In response to this we both framed the question of the public value of (arts and humanities) research as an unstable concept, requiring further solution, as well as creating the basis for a detailed empirical study of the legitimacy processes of public value. Understanding the public value of arts and humanities research therefore necessitates understanding two things: firstly, the communities involved in these framing discussions about the public value of humanities research, and then how those communities mobilised legitimacy for those claims, and their purposes in making these claims.

Public Signalling Behaviours

The second contribution was in taking forward debates about contributions and public values. Related to the idea of discursive communities from the previous subsection was the relation of these discursive communities to wider publics in whose interests claims of public value were being made. The second contribution was bringing the idea of "publics" to the fore as active agents in these otherwise elite discursive processes. We studied a set of elite (or peak) decision-making and governance processes in different spheres of national research systems.

The three case studies involved exploring the process of how groups made claims about the public value of their research and attempted to legitimate their position by references in different ways to the public. This methodology was used as the basis for an extensive, exploratory study of the circulation of concepts of public value of arts and humanities research in three national contexts (Norway, the Netherlands and Ireland). Each of these national studies involved substantial numbers of interviews with stakeholders in these discussions, researchers and direct users (firms,

culture providers, government clients), as well as academic leaders and university managers, policy stakeholders (ministries, advisory bodies, formal Commissions, research and funding councils) and societal representatives (arts councils, museum networks, print and broadcast media). These also used extensive documentary analysis to chart the formal and informal ways that ideas of public value were debated and mobilised—but also constructed and framed through the media reporting of both humanities research as well as these public debates.

These processes made various reifications of publics in ways that fitted with their policy concepts: academics and universities regarded publics as their ultimate funders to whom they must be in some way accountable, policy-makers regarded publics as rational tax-payers seeking to maximise economic efficiency (and in some cases more looking to cut costs than fund positive outcomes), and civil society groups regarded publics as being specific constellations of themselves and their own users and members. But in reality, these "publics" were highly simplified abstractions which did not bear any resemblance to the real interests of particular groups external to the debates, which very occasionally reared their heads and made their true feelings heard.

Indeed, in following these elite, discursive processes, it was possible to trace the ways that these decision-making processes encountered "publics" in a variety of different guises and the ways in which these publics signalled their interest in and valuing of that arts and humanities research. The most valid of these for policy communities was in audiences whose interest was reducible to an economic value, using direct visitor expenditure for cultural facilities, or the opportunity cost of leisure time for media (TV, radio, newspaper, website). There are a wide range of aggregation actors by which actors come together to collectively signal their interest in arts and humanities research, and whilst the individual level of interest may be low (an individual watching TV for ten minutes), when aggregated against the full public, this starts to signal a substantial public interest in that arts and humanities research that is not immediately reducible to purely economic values.

In the context of the contemporary discourse, this notion of "the public" has become reduced to a very simplistic "public" with two main characteristics. The first is that the public has a utility set that can be reduced to a set of rational choices expressed in economic valuations and that measuring those economic values in some ways is an adequate way to understand public value. The second is that the public's interest in the

policy process is to ensure that taxes are spent as efficiently as possible, and that they agree that efficiency demands transparency and comparability demonstrated through the use of measurement and indicator technologies. Taken together, the "public" is seen as having an interest in only that kind of research which produces a direct "economic" return to public investments.

The contemporary debate has adopted this reductionist agenda in an unselfconscious way, making these positions unchallengeable, and framing those that attempt to challenge them seen as unwilling to be held publicly accountable, and therefore working against creating public value from research. The policy prescriptions for this are to encourage or even require researchers to focus on creating economic value, and rewarding that activity as measured through a particular set of indicators, including numbers of spin-off companies, patents and licences. The effect in aggregate is to create a "common-sense" position where public value of humanities research has to be measured, and those measures need to produce direct economic value. Our contribution to this has been firstly to demonstrate how this position has emerged through a series of logical elisions as debates have moved across a range of public policy arenas. Nowhere in research policy communities do academics argue that the public value of arts and humanities research *should* be measured in terms of these narrow indicators, but only at the higher discursive level of science policy in general, where actors talk about creating value from research being best illustrated by economic value measures.

Our second claim to contribute to contemporary academic debates has been to reinsert the notions of "public" into public value: we have managed to identify how these supposed measures of public value are in fact notions of elite value—they have value to a particular group, politicians involved in science policy, who are talking about a single dimension of the public interest, namely public accountability, and assuming that it is only direct expenditure on research outputs that equates to public utility. In our research, we focused on this issue of signalling behaviours by publics, and argued that market transactions are just one way that "publics" signal that they value something—and we identified in all three countries market transactions related to arts and humanities research, including purchasing books, newspapers and magazines carrying arts and humanities research, paying for entry to events showcasing research content, and spending leisure time "consuming" that research through TV and radio programmes.

Our research contributes to an ongoing debate about how to capture the "public value" of humanities research. O'Brien (2010) talked of a shift from looking at economic impact to economic value, using pricing mechanisms as a way of allowing comparison between different kinds of outputs and outcomes. Our research contributes to a continuing evolution in this shift from "economic value" to "public value" without relying on a pricing mechanism. The key issue here is allowing the comparison of very different kinds of signalling behaviours which are not optimally captured through the use of prices—even shadow prices. Shadow prices can be calculated, based on notion values for leisure time and the amount of leisure time "users" spend consuming those research outputs—if 340,000 people watch a Dutch TV show about linguistics that lasts 25 minutes, the value of that can be calculated at just over €700,000 (see Chap. 5). But time (which you can at least price) is not the only kind of signalling made, and the challenge for future research is to identify more systematically the full range of activities by which publics signal their preference or value for arts and humanities research. Only once that full range of signalling behaviours is understood can a wider and more systematic notion of "public value" be advanced. This notion of signalling behaviours clearly helps to contribute to current debates (e.g. Belfiore and Upchurch 2013) on the "public value" of arts and culture more generally beyond a purely economic frame.

Contribution to Societal Capacity

Our third area of contribution was in identifying the social benefits of arts and humanities research in terms of an innovation discourse, and critically creating a linkage between individual research projects and wider societal change. In each of the national case studies, we studied the debates relating to the value of arts and humanities research, and in particular in the different ways in which versions of the public were mobilised, enrolled and ultimately transformed through these discussions. In all cases, we encountered a core group of stakeholders who were wrestling with a variant of the same problem, which was a shared belief that arts and humanities research was useful, and the need to find measures which conveyed that utility to actors outside that core community of practice. In two of the three countries, there was an additional problem that government fiscal crises had created a policy environment where particular kinds of messages could not easily be heard. Research community stakeholders therefore faced the

challenge of finding compelling messages which met a very high standard, that showed that humanities research was a priority for government spending at a time of austerity.

Part of what you might refer to as the "A&HR cultural cringe"—their apparent lower utility than STEM subjects—is that they are not seen as fuelling innovation as a driver of wider societal change. In following the public value policy discussions, we encountered a series of examples where excellent research outputs were translated and transformed by a series of actors, creating clear public benefits, where there were signalling behaviours that demonstrated that publics valued that research. On the basis of a comparative set of examples of research producing societal impact, we were able to improve the conceptualisation of the idea of public value of arts and humanities research in a way that progressed beyond the limitations of the "policy concept".

Our analysis was that the current debates were limited by the economic lens: the one incontrovertible advantage of an economic valuation method is that it can claim to convey aggregate public benefit, tracing the ways that individual economic transactions (preference signals) ripple out through the market to have an overall effect on economic activity levels. A pharmaceutical patent may be licensed by a company that creates a product that generates sales—at every stage of this process there is an economic exchange that creates this activity, which can be summed to demonstrate the economic "impact" of the research. Private benefits are "up-scaled" to create collective goods that offer a public benefit, and the case studies suggest that these public benefits can also emerge for humanities research, although there is a question of how to understand these benefits. But there is an assumption that in the absence of these direct economic benefits produced through arts and humanities research via patents and spin-offs that there are not comparable societal impacts.

Our case studies provided us with the means to better conceptualise a more general process for how arts and humanities research, and indeed research more generally, creates societal benefits beyond the level of the immediate consumer. There is an "intrinsic" public value in the humanities research, in that it creates unactivated potential which can then later be deployed and the way that these boundaries have been redrawn in the field have meant that it has become far more central to the way that humanities is operating. We here draw upon the implicit multi-level distinctions in the "economic" model:

- Micro-level individual economic transaction (the researcher creates a spin-off company);
- Meso-scale of the impacts in the various supply networks (e.g. company employees who spend their wages in the economy); and
- Macro-scale (how all these expenditure activities ripple out to the economy).

From our case studies we are thus to create a comparable conceptual framework for societal benefits more generally, applicable to all forms of research (cf. Benneworth 2014). There was a tendency to focus on the micro-level of the transaction by which individual users experienced that research, such as through the readers of a newspaper article, and not to consider these wider network and equilibrium effects. The real value of the humanities research is not that a newspaper reader is entertained for ten minutes, but that there are societal improvements. These may be measurable in terms of economic preference in pricing, but also may be extended to cover other kinds of societal development, what Corea (2009, p. 50) refers to as "a shift away from conditions of life perceived as unsatisfactory towards those that are significantly preferable". From our case studies it is possible to develop a multi-scale model drawing of how individual transactions (i.e. arts and humanities research projects) created activities that up-scaled and created new innovative capacities for societal action not previously present, involving:

- Individual transactions between scholars/research with "aggregation actors" (e.g. the media), who embedded the ideas in artefacts and services;
- Intermingling of publics with those actors through mass behaviour transactions (e.g. Audiences watching TV programmes);
- Circulation of those ideas in society by influencing and shaping public discourses, behaviours, and institutions (those TV programmes shaping public understanding of an issue).

Our research allowed us to place some flesh on the bones of the different levels involved and to conceptualise it related to the theoretical approaches best suited to the different scales of the processes by which the public value of that research is determined at those various scales. Of the four scales, there is already a well understood technology transfer/ knowledge exchange set of theories for how research passes to users, with work from their ERIC and Siampi projects mapping what Spaapen et al.

(2011) call "productive interactions" between researchers and users (*cf.* Molas Gallert and Tang 2011). This is the level at which the most obvious element of the knowledge exchange takes place, between the researcher and the user, but there are three other levels that influence the process, and three other areas of literature currently have their own debates concerning the public contributions which arts and humanities research can make.

There is the *individual* level of understanding the relationship between scientific excellence and societal relevance, and in particular how outcomes can be ascribed to particular projects as they can, for example, to scientific publications, and the extent to which scientist behaviour influences these outcomes (Hughes et al. 2011; Castro-Martinez et al. 2011). There is the *network* level understanding how concepts and findings from research circulate in wider communities separate from the researchers themselves; at this scale, essentially private benefits become collective benefits as they create capacity for wider actions, and the challenge is in preventing market failures whilst delivering accountability (Bozeman 2002; Bozeman and Sarewitz 2011). The final level is the *societal* level where there is considerable debate about the role of culture in contributing to a good society, stressing that part of this capacity comes from having a frame of understanding capable of looking beyond narrowly defined economic values and encompassing the other things societies can agree matter (Belfiore and Bennett 2008; O'Brien 2010; Sandel 2012).

The multi-scalar model of the public value of A&HR (research, transferred to users, embedded in networks, institutionalised in society) does not just provide a means of measuring public value through identifying three key processes. This model also has a knowledge architecture, establishing that the public value of arts and humanities research needs to be understood at four different scales each with their own very different ways of conceptualising research.

- Individual, there is an active debate within cultural studies regarding the duties of A&H scholars to society and the ways in which research can produce benefits.
- Transfer activity, there is likewise a strong community theorising ways of evaluating the societal impact of A&HR.
- Circulation of knowledge in networks, there is a strong public policy literature concerned with understanding how essentially private benefits create "public" benefits and how political institutions negotiate defining who privately benefits from public expenditure decisions.

- Society, there are a series of debates about cultural policy and phi-
losophy, concerned with notions of a good society, how people value
culture and cultural political economy.

These different scales have very different dynamics and loci, and the
involvement of the researcher in those processes varies greatly between
the scales. In the economic case, the dynamics and relationships between
the elements are well understood within policy spheres, whilst the macro-
benefits of societal knowledge are much harder to describe. However, the
research found good examples where humanities research created societal
capacities beyond the market; a good example was the case of Norway,
where humanities research and scholars played an important role in the
nation coming to terms with the Utøya terrorist attacks (Table 7.1).

There is a degree of contingency to this individual process, and those
scholars who find the publics paying attention to their conversations in
some way are at the whim of the caprice of what publics find interesting

Table 7.1 Multi-scalar model of research creating public value

Process scale	Knowledge process	Conceptual framework for understanding "value"	Value determination process
Individual	Co-creation of new knowledge	The societal analogue for scientific excellence, directly related to individual research projects—measures of "goodness"	Are researchers making their findings as accessible as possible?
Micro	Knowledge exploitation/transfer	Users taking knowledge and research from researchers and embedding it in their own products, processes and techniques	Is there evidence that users are engaging/exploiting findings?
Meso	Embodiment in network behaviour	Maximising incentives for creating public benefits from private activities, via autonomy and accountability	Are the findings disseminating and exploited via networks?
Macro	Becomes knowledge commons	Creating and empowering societal capacities to live a "good life", particularly outside direct economic sphere	Are networks changing in ways that promote a "better" society?

Source: Authors' own design

(Collini 2009). But we are struck, for example, by the case of a Hegelian political philosopher who had previously found media attention as part of a campaign to criticise and attack the UK's arts and humanities funding council's 2010 research strategy for explicitly seeking to promote a party-political philosophy (the Big Society). This researcher—then a US expat and going through the frustrations of naturalisation—then wrote a pair of reports on the UK's citizenship test, which with a neat turn of phrase ("no better than a bad pub quiz") managed to capture some media attention. His position as a commentator on citizenship being established, when the refugee and migration crisis hit in late 2015 he found himself in overwhelming demand as a commentator for a range of quality media outlets. Born in America and by now a skilled media commentator, he found himself likewise in demand for commentary on America's presidential nominations. It is therefore important to be careful in ensuring that one understands the demand side of this systemic set of processes as much as the supply side.

Taking a multi-scalar approach to this issue of the public value of humanities helps to provide an insight into the problematic of the "policy concept" of public value. Disagreements emerge between different scales of argument—one argument made is that measures are necessary to provide accountability, whilst researchers themselves feel uncomfortable with the idea of utility being imposed on them. But the former is a meso-scale requirement whilst the latter is a micro-scale requirement, and there is indeed no evidence that would justify imposing a requirement on *all* researchers to be more engaged as a prerequisite for maximising the public spill-over benefits from arts and humanities research. Our scalar framework therefore provides a means to disentangling the complex debate over the public value of arts and humanities research, and contributing to its resolution by ensuring that there is a scalar consistency in this debate. This model allows us to offer a new definition of the public value of AHR, which brings multiple, messy complex publics back into the notion of public value, at the same time stressing the (indirect) links between research and new societal capacities. We defined public value as:

> *the circulation of research in networks to users with identifiable interactions creating things that make a good society as public benefits from private assets*

The value of this approach is in developing an alternative perspective on measuring the public value, by emphasising the different stages of the process, from the individual knowledge co-creation/transfer, to the circulation of that knowledge in consumer networks, to its embedding

and institutionalisation at the level of society. This model is directly comparable with the multi-scalar model for how STEM research creates benefits (knowledge transfer leads to new firms and products, they create jobs and spending, and spending leads to economic growth). It also provides a theoretical basis for measuring A&HR impact as the flow level through each of these three upscaling processes.

Future Directions for Understanding Arts and Humanities Research Public Value

Arising from our research and these findings, we argue that there are three additional areas where there would be value to further elucidating a number of salient themes that arose in our study. The first relates to the instrumentalisation of arts and humanities research, and in particular a desire to reduce everything to economic outcomes; this seems to be at odds with a desire to drive development in terms of social and environmental as well as economic outcomes but achieving this needs a deeper understanding of where that research instrumentalisation arises. The second is that there is a need for new kinds of management practices within universities to properly capture the way that arts and humanities researchers work with their publics in creating particular kinds of knowledge, and to demonstrate that as institutions and HE systems that they value academics who are creating quality research through various kinds of engaged practices with users. Thirdly, there remains a problem in dealing with the diversity of these engaged practices and their orientation towards knowledge creation activities; there is strong public support for this diversity and a key question is understanding how to encourage more activity without driving a process of homogenisation which once more runs the risk of making user engagement and public value creation seem like an alien norm rather than at the heart of the arts and humanities research process. Further reflection on these three topics is provided below.

Challenging the Instrumentalisation of Arts and Humanities Research

This book has been directly concerned with the instrumentalisation of arts and humanities research and, in particular, that instrumentalisation the disciplines experience when placed at the service of the economy. The object of study has been the wider political and policy system which

regulates science activities in arts and humanities research but at the same time renders its context-specific choices into seemingly common self-prescriptions and timeless truths. This volume has sought to place this instrumentalisation into perspective, by highlighting the different levels of regulation and policy intervention, and the involvement of different communities in those levels. There is a need to ensure that assumptions that are made at one scale are not unproblematically transferred to other levels as assumptions. In our own conceptual framework, instrumentalisation arises when assumptions from higher scales are imposed on the individual scale (e.g. the meso-scale assumptions about what the public values or public accountability). This creates a contradiction with the individual scale, and therefore prevents the emergence of stable constructs that meet both needs of publics but which also hold confidence in the scholarly community.

The other element of the relevance of our findings have been in terms of the issue of the combination of knowledge and creativity in ways that drive innovation processes. Our research has traced through a concrete series of examples the ways in which humanities research becomes codified and embedded in intermediate artefacts that create new forms of societal capacity—that is, social innovation. Our multi-scalar framework for research impact therefore provides a means of conceptualising that process in a way that avoids a pseudo-linearity which has the potential to drive instrumentalism (i.e. an elision between the objective "good research can have societal value" to the normative "all research must produce societal value"). Arts and humanities research is transformed between these scales, and in the transformative upscaling, its character is also changing the relationship to the originating scholars' changes.

The public policy corollary of this is that policy should focus on the various elements of the upscaling process, and not just the first step from the scholar to the direct user. We are not saying that this does not take place, and we do see arts and humanities research councils responding by creating pathways for their research to create impact. Although the UK was not directly one of our case studies, we were struck by the UK's Arts and Humanities Research Council's New Generation Thinkers scheme. This scheme selected a number of early career arts and humanities researchers to work with the BBC to bring their work to a wider audience, in the first instance via the cultural radio broadcaster Radio 3. In our work we encountered one such New Generation Thinker, Sophie Coulombeau, who won an award on the basis of her excellent fundamental research into

202 P. BENNEWORTH ET AL.

the practices around which women changed their names when marrying. Her Radio 3 piece was showcased on the BBC News website, and it became for a short period the most-read piece on that website, indicating that the public had a very high level of interest in and value for her research.[1] Other research councils do have such schemes (such as Bessensap in the Netherlands), but they are very much in their infancy compared to the activities that exist to promote the exploitation of STEM subjects.

As important to producing social innovation—creating these new societal capacities—is the way that individual users are able to circulate and embed their knowledge (the knowledge they produce or co-produce) in wider networks, and how these networks become institutionalised into organisations and cultures that extend the capacities to a more societal level. Effective public policy measures supporting social innovation, and leveraging the benefits of arts and humanities research into social innovation—needs to develop good understanding of these processes as well as identifying policy measures that can support these upscaling processes, from the user to the network and from the network to the institutional/societal level. This helps to set out a future research agenda for understanding the contributions of arts and humanities research to social innovation processes, which avoids the pitfall of assuming an individual, single-scale relationship between the researcher and the social innovation.

The Relevance for University Management

A second major issue which arose in the course of this volume was the way the issue of the public value of arts and humanities research was dealt with inside the university sector, and in particular, the way that public value was managed alongside the notion of scientific excellence. Our starting point was the widely stated position that there was a trade-off or incompatibility between these two, and that the pursuit of scientific excellence would necessarily come at the expense of societal value, what some other social science fields have referred to as the "relevance or rigour conundrum" (Butler et al. 2015). Policy communities with whom we spoke referred repeatedly to the idea of an "ivory tower" to describe supposed undesirable behaviours of arts and humanities scholars privileging their own internal disciplinary discussions over creating knowledge that had a more wider societal use. In all three of the national discussions, there was a duality in the discussions, between the fear of the "ivory tower academic", and a

parallel acknowledgement that some humanities researchers were undertaking work with extremely high-level impact and societal value.

There was in practice not a simple divide made within arts and humanities academics between scientific excellence and societal value, and that one came at the exclusion of the other. The starting point for that was that all the arts and humanities research had an inherent materiality to it which created dependences on "real" phenomena; these real phenomena in turn had their own stakeholders who represented a user community, and critically, who influenced in various ways the ways that the academic field set their research questions. This was most obvious in the creative and performing arts, or humanities working with corpuses produced by third parties. But it was possible to trace, for even the most theoretical and notionally detached scholars the ways that societal referents shaped their scholarly loci: an example might be the theoretical philosopher who was influenced by applied philosophers dealing with questions about the ways that society could purposively shape science and technology advances towards the "good society".

Secondly, there was not a linear pathway by which arts and humanities research created societal benefits, even though our multi-scalar model appears to suggest that there is the same kind of pipeline for arts and humanities research creating societal benefits as there is for pharmacological research leading to a new drug and its associated economic benefits. An important element of the arts and humanities research project was the circulation of knowledge in communities, and cross-fertilisation and flow of knowledge between these communities, linked by critical hinge actors. Scholars themselves were hinge actors, when involved in their disciplinary discussions as well as public engagement activities (and like Hughes et al. (2011) we found a high prevalence of humanities scholars in public engagement and outreach activities).

But there were other knowledge actors—including government and societal actors, who engaged with scholars in knowledge-creating communities, creating and circulating new concepts and artefacts that embodied and codified that research—but at the same time transforming it and detaching it from its distinctive scholarly form. Over time, these circulation processes extended and upscaled—through, for example, government policies, the media or the creation of new cultural "heroes"—creating new societal capacities and values. We were struck, for example, when an entrepreneur we met in a Dutch football canteen in early 2016 explained a current Dutch political crisis around broadcasting as a consequence of the way the Upper

House of Parliament was created by the first Dutch king in the 1840s to protect his Royal Privileges. That historical fact forms part of the formal Dutch canon of historical thought (Bouwman 2014), the canon being assembled by a group of historians led by the Royal Netherlands Academy of Arts and Sciences of whom one member was interviewed in our research. But at the same time this circulation-transformation process of a piece of research into a piece of common knowledge served to hide this academic contribution, and created an attributional problem for those that would count it.

The third finding was that there were a variety of tensions or pressures which academics experienced which influenced their participation in these knowledge circulation networks and which influenced their perceptions of societal value. Some of these were technological, and in particular the emergence of new digital humanities technologies which were changing the nature of research, as well as the relationship to societal stakeholders as well as utility. There were also organisational pressures within universities, as university managers sought to meet outside stakeholder expectations for efficiency and critical mass, with public value being something university managers used in their external accountability negotiations. Within universities, tensions emerged where there were strong pressures on academics to undertake one particular element of the knowledge circulation activities—namely publication—and "success" was measured in ways that did not necessarily correspond with their own norms and habits in knowledge circulation. There was also a cultural issue of a pessimism noted within the sector in comparison to other "more useful" disciplines: those that were engaged with users were able to articulate much more clearly that use-in-practice, but there was a fear that "use-in-measurement" would work to the disadvantage of arts and humanities research.

A key finding from HERAVALUE was a map of a more complex set of academic identities around engagement than more commonly supposed. All academics had identities that were shaped by their relationship to two archetypes of knowledge circulation communities, scholarly and user. The biggest distinction in identity was between those that were secure in both these communities, who had stable identities, and those who were peripheral to or at the fringe of one of these communities, who had "liminal" or edge identities. For those with stable identities, who were positive about user involvement, some had more traditional identities, where scholarly output was important, but user knowledge communities still provided important knowledge inputs to them; for others where users were a more central part of the knowledge creation process, there was a more modern

identity. Of the liminal identities, who tended to be more negative of the idea of utility, there were those researchers who were unstable in their own research communities, who experienced discussions of "utility" as a threat to excellence, but in many cases these scholars did not understand use through engagement with users. And there was a group of users engaging with humanities researchers who saw their potential but felt that the scholarly dimension undermined utility. At the same time, all these identities had commonalities—they believed humanities needed to be useful, particularly to important societal challenges, but rejected instrumentalist policies that encouraged compliance behaviour. These identities are summarised in the diagram below (Fig. 7.1).

In this volume we have been able to map and analyse the individual scale of "useful knowledge creation"—highlighting that academic research is situated within multiple communities, and that usefulness arises when circulating knowledge from the academic community is transmitted into circulation in the user community. This provides the basis for the dynamics

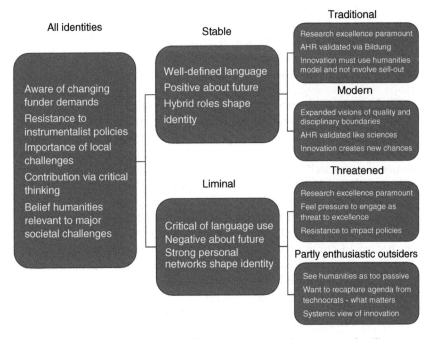

Fig. 7.1 The division of scholarly identities and attitudes to societal utility

of first scale of the scalar model of societally useful knowledge—the individual/micro-scale. A critical element of this is the cross-network nature of this particular scale—so activities are shaped by pressures in the various networks within which academics sit—their disciplinary networks, their institutional (university) affiliations, and users with whom they co-create knowledge (in varying degrees). This is helpful in understanding where first order measures of that public value might be developed: at the level of the research project this relates to the use of co-creation methodologies, and the value of research findings to be taken up within other networks. But more work is required to understand the higher levels of activity.

How Do the Public Really Value Arts and Humanities Research?

A third and for us certainly highly surprising main message from all three countries in our research is that arts and humanities are generally very highly valued by all external stakeholder groups representing civil society. This value was not questioned, contextualised or relativised in the way we have seen done by policy communities and most interviewees upheld that arts and humanities research's importance did not rest upon its direct relevance or instrumental usefulness. Signs and examples of value were abundant: high student numbers, great public interest in history, literature, language, art, architecture and more, growth of cultural industries, new media and technologies.

Underneath this general agreement on value our analysis points at several nuances and moderating remarks. First, many external stakeholders did not distinguish clearly between arts and humanities as disciplines or repositories of knowledge and as research activities. For some, arts and humanities research was concretely linked to the need for certain types of knowledge and competences that hard science disciplines cannot offer, such as in-depth understanding of culture, language and history—but not to research *per se*. A few interviewees did not really distinguish clearly between humanities and social science either, as long as the interaction or channel of communication provided them with a knowledge or evidence base that they found useful for various purposes. Second, the clearest awareness of arts and humanities as scientific disciplines and research units were, not unsurprisingly, found in the cultural sector/industries. Here a significant share of civil society representatives have a humanities background themselves, some even with a PhD degree working in industry, the media or other sectors. Third, there appeared to be a dynamic

to the examples and stakeholder groups enrolled when discussing value. The strong historical linkage between the humanities and teacher training seems to have been reduced, and examples related to immigration, terrorism and globalisation have joined traditional examples related to particularly strong aspects of national culture and genres of arts.

The heterogeneity of civil society stakeholders (which we distinguished in the Dutch chapter between civil society as research subjects, cultural experiencers, media consumers, Habermasian democrats, direct users and citizen service users) implies that there are multiple ways in which they link up with arts and humanities research. Some have a direct need for arts and humanities research to make market risk assessments, to understand particular phenomena better, to build international and professional networks, and to legitimise certain courses of action. In the cultural industries arts and humanities research may be direct content providers, for example, for radio and television programmes, for newspapers and printed and online media, for museums and exhibitions, and for non-profit organisations. But many stakeholders also pinpointed the indirect societal contribution of arts and humanities research: related more abstractly to knowledge and evidence bases, to values such as "bildung" and freedom of expression, and to societal functions such as democratic debate, critical perspectives, context provision and interpretative power. There may therefore be value in trying to understand these outcomes as direct and indirect contributions in innovation systems (cf. Cagnin et al. 2012), or with the metaphors "pipeline" and "ecology".

There are fundamental differences in how the pipeline and ecology knowledge exchange processes are organised, but also large variation between the civil society stakeholders that use arts and humanities research directly:

- Traditional commissioning of research, such as from industry, ministries and public agencies. Some of these are long term in nature, others based on more immediate needs (e.g. a large company considering entering a foreign market).
- Research collaboration, most often supported by research council funding, and with both academic AH researchers and external organisation personnel engaged in research efforts.
- Wider financial support for research and dissemination, where, for example, we found guest professorships, student research grants, support for digitalisation and public availability of knowledge bases, and more.

- Support for direct dissemination such as external seminar and lecture series, specific printed media series, TV and radio programmes and so on.
- Joint membership in boards, committees, reference groups and other arenas. This seemed fairly common.

One particular aspect that we found intriguing was the increasing involvement of various sorts of intermediaries in the knowledge transfer process. Although there were few signs of technology transfer offices having active strategies for arts and humanities research valorisation, we saw similar organisations supporting broader forms of knowledge transfer, interest organisations surrounding specific causes, archives, museums, events and stakeholder groups; new types of programmes and funding mechanisms, and much more. There were many helpers, but the resulting "innovation system" or ecology remained rather fragmented with lots of independent actors and weak forms of accountability. There may be many good reasons why such a system emerges and can work well, but it creates significant problems of measurement and valorisation.

The multitude of linkages corresponds well to what has been found in investigations of channels of interaction between universities and society in science and engineering. Another aspect of arts and humanities research that conforms to findings from other disciplines is the interactive and frequently personal nature of contacts. Most relations did not involve simple transfer of academic knowledge, but a wider process of interaction and iteration that can often last for a very long time. This does not mean that all arts and humanities research is directly discussed with a wider public or with societal participants, but just as there are direct and indirect ways in which arts and humanities research makes an imprint in society, there are similarly complex ways in which society effects researchers and their interests and perspectives. The personal aspect was not least mentioned by media interviewees, highlighting how their use of arts and humanities research often relies on a very small set of academic gatekeepers. Just as studies of academic patenting has shown that only a small proportion of scientists patent at all, and only a fraction of those patents generate any economic value, visible arts and humanities research value demonstrating processes seem just as skewed.

Thus we would seek to position ourselves to reject the view that arts and humanities research is fundamentally different from other fields of research when it comes to societal linkages and engagement in innovation.

The heterogeneity of linkages and the heterogeneity between arts and humanities disciplines, institutions and individuals (who still seem quite free to choose between distinct styles of societal engagement) corresponds well to what has been found in other fields. There are some differences, of course, the main ones are that some channels of interaction are rarely seen in arts and humanities research, such as patenting and licensing, and other channels are probably more common than in most other fields. The best example of the latter is probably the contact with the media; and the person-based and weakly institutionalised interaction may also be a more prevalent trait of arts and humanities research.

Does this mean that arts and humanities research never was significantly different in the way it comes into use than much other research, or that a process of convergence has taken place? We have no definite answer to this question, but our findings may indicate that policy mechanisms can be seen as drivers of convergence. The many initiatives and intermediaries often seem based on an "assisted linear model" of knowledge transfer that is also clearly seen in many of the attempts to generate value from life science, natural science and engineering disciplines. This process probably has both advantages and disadvantages. It allows arts and humanities research to benefit from a general policy interest in issues like innovation, research for societal challenges and the "knowledge triangle". Some activities may even become more easily measureable. But there are at least two central problems. First, from a societal perspective heterogeneity in the research community is beneficial, and convergence might contribute to reducing this heterogeneity (both in terms of perspectives, values and interaction mechanisms). Second, much research has shown that an assisted linear model has many weaknesses even when applied to the hard sciences, and there are few reasons to believe it will work any better in arts and humanities research. Our study of civil society does not strongly support the idea that what is needed the most is more actors that try to push academics into more direct forms of interaction, although clearly, activities offering more of a pull to civil society actors to use that research could under the right circumstances have that value.

How Do the Public Really Value Research in Society?

So what are the consequences of all of this for science policy studies more generally, in understanding how to account for the publics in scientific governance processes? We here understand scientific governance processes

as not just the formal decisions by which "big" decisions are taken about the nature of science but the micro-scale of decisions shaping scientific directions (Olmos-Penuela et al. 2015). One of the contributory factors about science as a progressive approach is that scientists build on each other's contributions (Boyle 1665), and by building on "good" contributions, knowledge builds up. What is important within this system are the criteria on which decisions are taken on what is "good science" (in terms of being worthy as serving as a foundation for future research). We interpret the increasing desire for science to contribute to solving societal problems as a desire to include this more meaningfully in some way as a decision in scientific governance. But at the same time we note that scientific governance is a devolved process, in which diverse fields, national systems, cultures and norms build up interpreting and implementing the rules of what is good—so what we currently often talk about as an abstract pillar of the science system, peer review, really only became widespread after WWII, (POST 2002; Charles et al. 2003).

If public engagement and working towards societal goals is to become more important to the business of science, then it must become embedded in the everyday decision-making practices of scientists. On the one hand, individual scientists must have an individual value for themselves in working towards solving questions with public value attached. On the other hand, scientists need to receive positive reinforcement that the research that they undertake with external partners represents a good foundation for future work, that it is rigorous as well as excellent. And in that sense, the case of arts and humanities research is very different to that of other disciplines, where there is a tendency to believe that relevance to societal question comes at the expense of rigour. With arts and humanities research, what we have seen is that the early steps of the societal conversation on which the later diffusion of that knowledge is predicated forms an integral part of that knowledge creation process. Although there may be an antipathy for the articulation of these processes in the dry bureaucratic language of the evaluation system, there is certainly not an antipathy for the underlying processes by which researchers engage with societal users as the first step of their knowledge starts to "ripple" outwards and make waves in the societal knowledge reservoir.

There are a number of features that we have seen as being important to arts and humanities research engaged practices of which other disciplines are also making use, and which could consequently be better represented within research governance systems and practices. The first is

the role of trade literature as a space for active debates that contribute to the production of knowledge and the reappropriation of those context-specific, relevant discussions back into the academic knowledge corpus. There are a number of literature newspapers (*London Review of Books*, *New York Review of Books*) which serve as a site for debates between academics, authors and others active in this field (such as professional critics). The unfolding direction of these debates play a regulating role in shaping the underlying academic through a close interrelation of the different communities, with ideas coming from "publics" mediated back into the field through these grey literatures. In other disciplines, "grey publishing" is regarded as falling firmly under the rubric of ex post dissemination rather than part of the overall knowledge-creating conversation—although Hagendijk and Kallerup (2003) do highlight that scientists do on occasion use specialised media to have such debates. We therefore argue that there is a need for a better understanding of the role that these "relevant" publishing outlets play in contributing to the "rigorous" academic debate, and then for that more nuanced understanding to play a more significant role in the incentives scientists face in publishing and their career progress.

The second element of the involvement is the role of the arts and humanities researcher as an "expert" in a broad area of expertise. This is something that tends not to exist in STEM, where scientists place much more emphasis on their research findings being the story, rather than a means of providing depth to understanding a free-standing story. In this chapter we have presented examples from the UK where arts and humanities scholars have both produced media items reporting their research but also where those scholars have served as experts based on their more general interests. In this latter case what is interesting has been that serving as a public intellectual has also had an impact on their overall research direction, as they have moved from a more historical to a more contemporary implementation of political philosophy. This is a form of academic freedom, feeling the responsibility to engage with society as a consequence of being the beneficiary of public funding, but also because of the interesting arenas to which it brings the researcher. There are very strong governance incentives for scientists in STEM to avoid this kind of speculative engagement, particularly because of a number of scandals where serious academics have seen their reputations besmirched through association with underlying scandal (see for example Bucchi 1998). But at the same time a complete aversion to this kind of interaction undermines an important link to potential sources of public interest that may help

pull those scientists towards other areas of societal use beside their own underlying research.

The final element is that of the underlying modesty of arts and humanities research humanities scholars because of the absence of disciplinary finality in their work (Hessels and Van Lente 2008). It has become common to criticise the public value of humanities scholars because they cannot give, say, a definite answer to the question of how a cease-fire will work in a civil war on the basis of their studying reconciliation regimes in Northern Ireland or South Africa. But one effect this has is that it brings the public onto the same level with these scholars as an antecedent for a meaningful dialogue and exchange about potential use, cognateness and desirability. This stands in sharp contrast to the privileges and rights to expertise which STEM researchers draw around themselves and which have the effect of excluding public knowledges (whilst proving strangely unresistant to corporate lobbying effects). By the time science reaches its publics, there is an absence of the kinds of public-shaping influences that could make that research more useful (Nature 2004). Publics play much less of a role in the constructive challenge of STEM research throughout the research cycle, from ideas through to implementation, and yet at the same time we are seeing a growing resentment at the negative public consequences that technology development is producing within society. Some serious reflection is therefore required within STEM on how to remove this self-reinforced certainty without hindering the selection of good science for a more general public benefit.

NOTE

1. Coulombeau, S. (2014). "Bloody hell" available online at https://twitter.com/SMCoulombeau/status/528559977418752000 (Accessed 29 February 2016).

REFERENCES

Belfiore, E. (2013). The 'rhetoric of gloom' vs. the discourse of impact in the humanities: Stuck in a deadlock? In E. Belfiore & A. Upchurch (Eds.), *Humanities in the twenty-first century: Beyond utility and markets* (pp. 17–43). Basingstoke: Palgrave Macmillan.

Belfiore, E., & Bennett, O. (2008). *The social impact of the arts: An intellectual history*. London: Palgrave Macmillan.

Belfiore, E., & Upchurch, A. (Eds.) (2013). *Humanities in the twenty-first century: Beyond utility and markets*. Basingstoke: Palgrave Macmillan.

Benneworth, P. (2014). Tracing how arts and humanities research translates, circulates and consolidates in society. How have scholars been reacting to diverse impact and public value agendas? *Arts and Humanities in Higher Education*, first published on May 14, 2014 as doi:10.1177/1474022214533888.

Böhme, K., & Gløersen, E. (2011). Territorial cohesion storylines: Understanding a policy concept. *Spatial Foresight Brief*, 1. http://spatialforesight.lu/tl_files/files/editors/dokumente/Brief-2011-1-111025.pdf. Accessed 29 Feb 2016.

Bouwman, B. (Ed.) (2014). *De canon van Nederland – Onze geschiedenis in 50 thema's*. Amsterdam: Meulenhoff.

Boyle, R. (1665). The introduction. In *Philosophical transactions of the royal society of London* (Vol. 1, pp. 1–2). London: Royal Society of London.

Bozeman, B. (2002). Public-value failure: When efficient markets may not do. *Public Administration Review, 62*(2), 145–161.

Bozeman, B., & Sarewitz, D. (2011). Public value mapping and science policy evaluation. *Minerva, 49*(1), 1–23.

Bucchi, M. (1998). *Science and the media*. London and New York: Routledge.

Butler, N., Delaney, H., & Spoelstra, S. (2015). Problematizing 'relevance' in the business school: The case of leadership studies. *British Journal of Management, 26*, 731–744.

Cagnin, C., Amanatidou, E., & Keenan, M. (2012). Orienting European innovation systems towards grand challenges and the roles that FTA can play. *Science and Public Policy, 39*, 140–152.

Castro-Martínez, E., Molas-Gallart, J., & Olmos-Peñuela, J. (2011 September, 15–17). *Knowledge transfer in the social sciences and the humanities: Informal links in a public research organization*. Paper presented at Atlanta Conference on Science and Innovation Policy, Atlanta, Georgia.

Charles, D. R., Perry, B., & Benneworth, P. (2003). *Regions and science policy*. Seaford: Regional Studies Association.

Collini, S. (2009, November 13). Impact on humanities: Researchers must take a stand now or be judged and rewarded as salesmen. *Times Literary Supplement*.

Corea, S. (2009). Promoting development through information technology innovation: The IT artifact, artfulness, and articulation. *Information Technology for Development, 13*(1), 49–69.

Crossick, G. (2009). "So who now believes in the transfer of widgets?" paper presented to Knowledge Futures Conference, Goldsmiths College, London, 16th-17th October 2009.

Hagendijk, R., & Kallerud, E. (2003, March 2). Changing conceptions and practices of governance in science and technology in Europe: A framework for

analysis. STAGE, Discussion Paper. http://www.stage-research.net/STAGE/downloads/StageDiscussPaper2.pdf. Accessed 12 Nov 2010.

Hessels, L. K., & Van Lente, H. (2008). Re-thinking new knowledge production: A literature review and a research agenda. *Research Policy, 37*(4), 740–760.

Hughes, A., Kitson, M., & Probert, J. (2011). *Hidden connections: Knowledge exchange between the arts and humanities and the private, public and third sectors.* Cambridge: CEBR and Bristol: Arts & Humanities Research Council. http://www.cbr.cam.ac.uk/fileadmin/user_upload/centre-for-business-research/downloads/special-reports/specialreport-hiddenconnections.pdf. Accessed 29 Feb 2016.

Molas-Gallart, J. (2014). Research evaluation and the assessment of public value. *Arts and Humanities in Higher Education, 14*(1), 111–126.

Molas-Gallart, J., & Tang, P. (2011). Tracing 'productive interactions' to identify social impacts: an example from the social sciences. *Research Evaluation, 20*(3), 219–226.

Nature Editorial. (2004, October 21). Going public: Should scientists let the public help them decide how government research funds are spent?. *Nature, 341*(7011), 883. http://www.nature.com/nature/journal/v431/n7011/full/431883a.html. Accessed 29 Feb 2016.

O'Brien, D. (2010). *Measuring the value of culture: a report to the Department for Culture Media and Sport.* London: DCMS.

Olmos-Penuela, J., Benneworth, P., & Castro-Martínez, E. (2015). What stimulates researchers to make their research usable? Towards an 'openness' approach. *Minerva, 53*(4), 381–410.

Owen, R., Macnaghten, P., & Stilgoe, J. (2012). Responsible research and innovation: From science in society to science for society, with society. *Science and Public Policy, 39*(6), 751–760.

Parliamentary Office of Science and Technology. (2002b, November). Peer Review. *Post Note* (p. 182). London: POST.

Sandel, M. (2012). *What money can't buy.* London: Alan Lane.

Spaapen, J., van Drooge, L., Propp, T., et al. (2011). Social impact assessment methods for research and funding instruments through the study of productive interactions between science and society. Report, SIAMPI final report.

Veldhoen, L., & van der Ende, J. (2003). *Technische Mislukkingen, de Planta-affaire, instortende bruggen, vliegdekschepen van ijs.* Amsterdam: Donker.

INDEX

Note: Page numbers followed by 'n' refer to notes.

© The Author(s) 2016
P. Benneworth et al., *The Impact and Future of Arts and
Humanities Research*, DOI 10.1057/978-1-137-40899-0

.

Printed by Printforce, the Netherlands